THE CINEMATIC APPARATUS

THE CINEMATIC APPARATUS

Edited by

Teresa de Lauretis
and
Stephen Heath

St. Martin's Press New York

© Teresa de Lauretis and Stephen Heath 1980

All rights reserved. For information, write:
St. Martin's Press, Inc., 175 Fifth Avenue, New York, NY 10010
Printed in Great Britain
First published in the United States of America in 1980

ISBN 0–312–13907–1

Library of Congress Cataloging in Publication Data

Main entry under title:

The Cinematic apparatus.

 Papers and discussions from a conference held
Feb. 22–24, 1978 by the Center for Twentieth
Century Studies, University of Wisconsin—Milwaukee.
 Bibliography: p.
 Includes index.
 1. Cinematography—Congress. I. De Lauretis,
Teresa. II. Heath, Stephen. III. Wisconsin.
University—Milwaukee. Center for Twentieth
Century Studies.
TR846.C53 778.53 80–36875

ISBN 0–312–13907–1

Contents

vi *Contents*

List of Plates

Preface

The papers and discussions collected in this volume constitute one record of a conference on 'The Cinematic Apparatus' held from 22 to 24 February 1978 by the Center for Twentieth Century Studies of the University of Wisconsin–Milwaukee. The conference could not have taken place without the support, from inside the University, of the College of Letters and Science nor without that, from outside, of the National Endowment for the Arts (through Don Druker) and of the Cultural Services of the French Embassy (through Jean-Loup Bourget and Hugues de Kerret). The organisation was done by Teresa de Lauretis and Stephen Heath in conjunction with Charles Caramello, Robert Dickey, Divina Infusino, Jean Lile and Carol Tennessen at the Center and with a coordinating committee composed of David Bordwell, Douglas Gomery, Patricia Mellencamp and Kristin Thompson. Robert Dickey, who designed and built the conference space, was also responsible for much editorial work in connection with the present volume.

The summer following the conference saw the death of the Center's Director, Michel Benamou. In the midst of his other activities and projects, he had been instrumental in introducing, continuing and in every possible way encouraging work on cinema and film at the Center. We can do no more here than state the loss his death represents and our sorrow at that loss.

It must be stressed that this volume constitutes *one* record of this conference. Over the three days, much took place; films were screened and debated, and wide-ranging and various discussion occupied a large part of the time. Only a little of this could be directly included here and we have thus tried to construct as coherent an account of the diversity as is compatible with the constraints and demands of publication in book form, using some papers distributed in advance of the conference (Comolli, Heath), some given during it, either wholly or in part (Allen, Anderson and Anderson, Doane, Gidal, Gomery, Lederman and Nichols,

Turim, Wollen), some subsequently revised or recast in new directions or engaging new areas (Andrew, Thompson) and some written quite specifically after the conference as reflections on and developments of issues raised (de Lauretis, Rose), together with one or two moments of discussion that bear particularly on problems encountered in the succession of the papers. The reader may, in fact, follow fairly closely something of the effective movement of the conference – its displacements of interest in the conception of the cinematic apparatus, its returns on notions of technology and the technological in the course – from the perspective – of those displacements. The 'cinematic apparatus' is a term that can pull at once towards the technology of cinema as usually defined (the various machines and techniques involved in the making and screening of films) and towards more recent attempts to understand and describe cinema as a particular institution of relations and meanings (a whole machinery of effects and affects): one aim of the conference, one part of its work, was to set those two directions together, to grasp at least the points at which they come apart, the problems thus found.

In this respect too, a central feature of the conference was discussion, with the participation of the makers, of a range of examples of current film-making practice, in differing degrees independent of the normal commercial circuits of production and distribution. The films thus screened were *La Cecilia* (Jean-Louis Comolli, Italy/France, 1976), *Woman/Discourse/Flow* (Steven Fagin and Aimee Rankin, USA, 1978), *Riddles of the Sphinx* (Laura Mulvey and Peter Wollen, Britain, 1977), *Condition of Illusion* (Peter Gidal, Britain, 1975). Something of the presence of films and discussion can be felt at many points in different papers and the discussion following the papers by Turim and Gidal is given especially in connection with this.

Finally, it is important to emphasise that this volume is, as it were, a constant reference to the participation and contributions of everyone who attended and worked in the conference, including, in addition to those already named or who appear as contributors of papers or discussion in this volume: Rose Avila, Serafina Bathrick, Peter Baxter, Robert Bell, Nick Browne, Mike Budd, Ron Burnett, Keith Cohen, Rob Danielson, Marty Dolan, Joseph Donohoe, Régis Durand, Patricia Erens, Pamela Falkenberg, David Fishelson, Simonne Fischer, Bette Gordon, Dana Gordon, Claudia

Gorbman, Inez Hedges, Ken Hope, William Horrigan, Bruce
Jenkins, Cathy Johnson, Virginia Kelly, Dan Kirihara, Mary Jo
Lakeland, Jayne Loader, Judith Mayne, Margaret Morse,
Roswitha Mueller, Mark Oppenheimer, Laura Oswald, Chris
Privateer, Strother Purdy, Marcelle Rabbin, Phil Rosen, Jonathan
Rosenbaum, Tony Safford, Paul Sandro, Peter Schofer, Don
Skoller, Janet Staiger, Phil Vitone, Ann West, Miriam White . . .

Teresa de Lauretis and

December 1978 Stephen Heath

1. The Cinematic Apparatus: Technology as Historical and Cultural Form

Stephen Heath

In the first moments of the history of cinema, it is the technology which provides the immediate interest: what is promoted and sold is the experience of the machine, the apparatus. The Grand Café programme is headed with the announcement of 'Le Cinématographe' and continues with its description: 'this apparatus, invented by MM. Auguste and Louis Lumière, permits the recording, by series of photographs, of all the movements which have succeeded one another over a given period of time in front of the camera and the subsequent reproduction of these movements by the projection of their images, life size, on a screen before an entire audience'; only after that description is there mention of the titles of the films to be shown, the '*sujets actuels*', relegated to the bottom of the programme sheet.[1] This machine interest and its exploitation can be traced in a variety of effects and repercussions, from, say, Edison's lack of concern in the development of projecting apparatus (a business strategy based literally on selling the machine, projectors for audience viewing representing less of a market than kinetoscopes for individual, parlour viewing) to the relatively long-lived assumption that the industry was effectively one of cinema rather than films, the latter being elements of the experience of the machine, a uniform product to be sold by the foot and the reel (an assumption which, paradoxically, unwittingly, Edison had in fact seen beyond, fearing also that projection with its large group diffusion would lead to audience saturation and falling attendances for the interchangeable foot/reel productions).

As though returning to something of those first moments,

theoretical work today has increasingly been directed towards posing the terms of the 'cinema-machine', the 'basic apparatus', the 'institution' of cinema, where 'institution' is taken more widely than the habitual notion of the cinema industry to include the 'interior machine' of the psychology of the spectator, 'the social regulation of spectatorial metapsychology', the industry of the 'mental machinery' of cinema, cinema as 'technique of the imaginary'. The last emphases are derived from Christian Metz's essay 'Le signifiant imaginaire' which is decisively representative of this current turn of theory.[2] Metz's focus is the psychoanalytic constitution of the cinematic apparatus, cinema as, exactly, 'imaginary signifier': 'with that formula, my aim is to designate the still poorly known set of paths by which the "exercise of cinema" (the social practice of a certain specific signifier) takes its roots in the large anthropological figures that the Freudian discipline has so much helped to clarify: what relations does the cinematic situation have with the mirror phase, with the infinite movement of desire, with the position of voyeurism, the primal scene, the twists and returns of disavowal, etc.?'; '[the various studies undertaken in "Le signifiant imaginaire"] were located at once on a site – in a "moment" rather – that was not exactly that of the film, nor exactly that of the spectator, nor again that of the code (the list could be extended): I placed myself as though up-stream to these distinctions, in a sort of "common trunk" which covered all that at the same time, which was nothing other than the cinema-machine itself envisaged in its conditions of possibility.'[3]

The site or moment is a return to the machine, the apparatus: the facts of the Lumière programme are taken up, examined, by Metz himself and by others—*camera, movement, projection, screen*. Or rather, the facts become new facts, the terms are recast under the pressure of a theoretical discourse that inserts new concerns, different conceptions for an understanding of what the programme indicates as 'this apparatus'. The shift is there, of course, in the use of the term 'apparatus' itself: from the stress on the technological, though in its account of the functioning of the machine to furnish life-size reproduction of movement already beyond anything of a 'purely technical' limit, to that on the metapsychological, though in its account of the specific structurings and positions and relations inevitably engaged in aspects of the technical mechanism of cinema.

The question can be posed, however, or can seem to be posed, as to the status of the latter engagement. In the initial—now 'classic'—

elaborations of a semiology of cinema, the situation of the technological was clear, even if potentially problematic: 'the cinematic object is, in fact, immense and heteroclite, sufficiently large for certain of its dimensions—for example the economic and the technological—to exclude themselves from the field of the semiological purpose.'[4] The field of a semiology of cinema, its 'delimitable object', is the analysis of cinematic language, where language is to be understood not as the technico-sensorial unity immediately graspable in perceptual experience, the combination of matters of expression, but as a particular combination of codes. Specificity is defined not by technology or technico-sensoriality but in terms of codes, this particular combination; some of the codes being themselves specific to cinema, a point at which the technico-sensorial can reappear in the analysis inasmuch as the specificity of the specific codes can be seen to be connected with certain traits of a matter of expression or the combination of matters of expression, derives from the particular nature of the technico-sensorial unity. (Consider here Metz's discussion of the specificity of cinema vis-à-vis the audio-visual generally and television more especially.)[5]

Apart from this reappearance, the technological emerges only briefly—once the analysis of codes has been established as the central concern of a semiology—in reference to 'technological codes': 'technological codes which are involved in the very functioning of the cinematic apparatus (of the camera), which are its *programme* (in the sense that one speaks of the programming of a computer) and which constitute the very principle of its construction, operation, adjustments. These technological codes, although they have machines as their "users", have been constructed by men (inventors, engineers, etc.); moreover, the structures which they impose on the information are again treated and mastered—but this time at the level of the decoding—by other humans, the cinema spectators who perceive the projected images and understand them. Among these codes, there is one which is so important it is even commonly considered to be the very principle of the cinema, its very definition: this is the complex system according to which the cinematic equipment (recording camera, film strip, projector) *"reproduces movement"*. . . . In this technical code (which is indeed the very code of the cinemato*graph*), the photogramme is the minimal unit, or at least one of the minimal units.'[6] The scope of the emergence, however, is limited. The discussion of technological codes effectively serves to exclude further the technological from the

semiological purpose: it comes in the middle of a consideration of
the common notion of the photogramme as the minimal unit of
cinematic language which it helps to correct, the photogramme is a
unit of a technological code, and to redirect, cinematic language is a
combination of signifying systems or codes and analysis is thus not
concerned with identification of 'the minimal unit of cinema'.

Located on a site or in a moment that is not that of the code, the
subsequent attention to the cinematic apparatus, rather than to the
cinematic language, might be taken as refinding the instance of
technology, its insistence in a new form. In one sense, that attention
does, as was said, come back to the first moments of cinema, to the
basis of the apparatus itself; it stands up-stream to film, spectator,
code, implicates large anthropological figures (the recourse to
Plato's myth of the cave is indicative[7]), engages something of a
primal scene of cinema (a history that is always there before the
meanings of its films and as their ultimate return): in short, raises
the psychoanalytic evidence of 'the apparatus'. Technology—
apparatus—mental machinery: the question of technology, clearly,
is no longer the old question, the whole notion of an 'instance' of
'technology' cannot be assumed, has to be interrogated critically
from the concerns of the analytic description of cinema as technique
of the imaginary, from the questions then posed as to the cinematic
apparatus as historical and ideological form. Those questions today
rest open, distant even, relatively unbroached by this current work
insofar as its account of the apparatus has intimated problems of
technology, history, ideology, and left them in its margins. What is
probably Metz's own most direct statement in this area is thus, in
fact, prior to the focus on the cinema-machine, at the close of a more
classically semiological discussion of special effects and in the form
of a straightforward adoption of position in a classic debate: 'In my
view, *the technical* does not designate a kind of enclosed area sheltered
from history. It is true that the technical, by the very fact that it
works, proves the scientific (and not ideological) truth of the
principles that are its foundation. But the *how* of its functioning (the
ways in which the machine is regulated), which is distinct from its
why, is nowise under the control of science and brings into play
options which can only be of a socio-cultural order.'[8]

If it is conceded that there is no such thing as history in general,
that history is a theoretical object distinct from what is declared
'historical' as a result of its occurrence in such and such a place at

such and such a time, that facts are constituted as 'facts' from the point of their theoretical-discursive articulation,[9] those concessions are often in practice forgotten and the histories written in the same way, as of 'History', with questions of understanding collapsed into the mechanical assertion of chains of cause and effect, facts discovered and appealed to in the unconsidered ease of a blind circularity.

Historical considerations of technology are no exception to these practical failings; indeed, they are particularly encouraged in them by virtue of the status of technology as grounded in science and thus, given the powerful imaginary of the latter, in an evident reality of functioning progress (invention, modification, improvement, and so on), analysable in terms and with the factual guarantee of scientific development. Hence the force of the isolation of technology, its production in the histories as a self-generating instance, with the consequent assumption of either *technological determinism* ('research and development assumed as self-generating; the new technologies are invented as it were in an independent sphere, and then create new societies or new human conditions . . . a self-acting force which creates new ways of life') or *symptomatic technology* ('similarly assumes that research and development are self-generating, but in a more marginal way; what is discovered in the margin is then taken up and used . . . a self-acting force which provides materials for new ways of life'): 'Most histories of technology, like most histories of scientific discovery, are written from these assumptions. An appeal to "the facts", against this or that interpretation, is made very difficult simply because the histories are usually written, consciously or unconsciously, to illustrate the assumptions. This is either explicit, with the consequential interpretation attached, or more often implicit, in that the history of technology or of scientific development is offered as a history on its own.'[10] Corollary with such an isolation is the simple acceptance of technical terminology, of the terms proposed by the established technology itself, as adequate analytic tools, their immediate and uncritical translation into theoretical concepts, as though productive in themselves of knowledge.[11]

The posing of the problem of determination is crucial to the understanding given in the constructed history. Technological determinism substitutes for the social, the economic, the ideological, proposes the random autonomy of invention and development, coupled often with the vision of a fulfilment of an abstract human

essence – and some of the wildest versions of this latter are to be found in accounts of the (then aptly named) 'media': 'through the art and technology of expanded cinema we shall create heaven right here on earth'.[12] Yet such a determinism cannot be merely, mechanically, overturned, to leave technology as a wholly controlled function of some other instance. The process of cinema, to take the example of concern here, is that of a process through which in particular economic situations a set of scattered technical devices becomes an applied technology then a fully social technology; and that social technology can, must, be posed and studied in its effects of construction and meaning. That formulation, however, is itself still problematic: the process is that of a relation of the technical and the social *as cinema*. The fantasy of the conventional histories with their autonomous instance of technology and their endless problem of the 'invention' of cinema is exactly that cinema exists in the technological; cinema, however, is not a technological invention but a multiply determined development, a process; to say that 'film belongs in the first place to its inventors'[13] is not merely arguable on its own terms (Lumière and even Edison in this field, to take the two habitual 'founders of cinema', were exploiters and businessmen, developers rather than inventors) but limiting on, and ideologically so, a historical materialist understanding. Cinema does not exist in the technological and then become this or that practice in the social; its history is a history of the technological and social together, a history in which the determinations are not simple but multiple, interacting, in which the ideological is there from the start – without this latter emphasis reducing the technological to the ideological or making it uniquely the term of an ideological determination. Approaches to this complexity are what is at stake finally in, say, the introduction of the notion of 'signifying practice' by Jean-Louis Comolli in his series of articles on 'Technique et idéologie' ('a materialist history of the cinema is impossible without the concept of *signifying practice*'[14]) or the implications of the description of the basic cinematic apparatus given by Jean-Louis Baudry ('the question can be posed as to whether the instruments – the technical base – produce specific ideological effects and whether these effects are themselves determined by the dominant ideology'[15]); approaches which raise questions of meaning and ideology and functioning, of sociality and subjectivity, immediately and thus which cannot espouse the realisation-then-exploitation chronology that runs deep in thinking about the fully technological systems of communication,

with its traces even in Brecht or Raymond Williams (the idea of radio or of radio and television as technologies developed 'without content'[16]).

Hence the necessity to engage not a history of the technology of cinema, but a history of the cinema-machine that can include its developments, adaptations, transformations, realignments, the practices it derives, holding together the instrumental and the symbolic, the technological and the ideological, the current ambiguity of the term *apparatus*. Hence the necessity also to conceive that that history is a political understanding, to imagine that it can be grasped critically from aspects of contemporary. avant-garde film practice, for example, or that it might be radically envisaged and recast by the questions posed by women to the machine in place.

Cinema, therefore. It is usually said that the creation of commercial cinema hinged on the conjunction of at least three areas of technical understanding and development: photography, persistence of vision, and projection; on their own terms, those areas can be given a long and uneven history of investigation and realisation (which, of course, is still continuing, shifting; understanding of persistence of vision has been much transformed and the scientific status of the concept itself rendered increasingly dubious, and its contribution to the explanation of the illusion of movement in cinema greatly diminished). The introduction of the hold of the commercial in the conjunction of the technical areas is evidently crucial. Resting on an industrialisable technological base, cinema, different to theatre, offers the possibility of an industry of spectacle. And spectacle is then evidently crucial with its introduction of the hold of meaning and vision and representation into, as a fact of, the industry itself. The series is not a chronology but a constant interlock: projection, for instance, which is at once 'early' (projecting devices were experimented in the mid seventeenth century, Kircher's famous magic lantern) and 'late' (intensive work on projectors between 1893–6, from the phantascope to the biograph), cannot but engage at one and the same time, and determiningly, commerce and spectacle and the relation of the two (the possiblity of a new theatre–novel–image industry, the possibility of a new theatre of the subject, representing, positioning, fixing: a veritable *speculation*).

The history of cinema can be easily written along the lines of the

commercial or the technological or some simple combination of the two. Thus, for example, technological frameworks are seen as the major factors in the creation of cinema, with gelatine emulsions and continuous roll film as the decisive innovations which prompt technicians to depart from a previous and limiting framework of operation, the public success of the kinetoscope coming to give 'the final impetus to the technological development of commercial cinematography'.[17] Thus again, for example, the subsequent development of cinema is seen in terms of the stages of its financial control: competitive small business, conflicts between trusts for overall control, control by banking finance.[18] The lines can be shifted together – sound is the key to the establishment of the banks' control – and balanced out – 'although technological innovation and the exclusive possession of certain technological knowledge proved significant for the pattern of development of the motion picture industry, innovations in marketing and corporate structure were at least equally important in shaping the pattern'.[19] Invention and business strategy become central focuses, with the former varied in its sources and situations: many important inventions or realisations come from outside cinema (sound systems, Technicolor), research switches from individuals or groups close to the nineteenth century mechanics of cinema (interest in the science, the phenomena of vision, photography, etc.) to highly financed research laboratories working in new areas such as electronics to develop patents for the sponsoring companies (firms such as Western Electric or General Electric which set up the first industrial laboratory of this kind in the US[20]).

Histories along those lines leave another line which is, in fact, that of the most common histories, histories of the movies, written in terms of films rather than cinema, concerned with style, aesthetic innovation, 'the progress of film as an art form'. Evidently, here and there, that line will be involved in accommodations, propositions of the technological: 'Because film is a technological art, its production confronts both mechanical and aesthetic problems.'[21] The quotation shows the aesthetic line, its separation from the technological, and the return of the latter as an additional factor to be borne in mind, occasionally acknowledged. A slightly different version can be seen in the following: 'As the movie cannot exist apart from its apparatus, a satisfactory definition of the medium's artistic nature depends on a full recognition of its technological base.'[22] But what this full recognition would mean (and whether, indeed, the problem

is to be posed in this way at all), the relations and determinations, remains difficult, the effective history unwritten.

'It is technical advances which underlie stylistic innovations like hand-held techniques, depth of field photography, zooming, craning, and shooting by available light at night.'[23] The assertion has its obviousness – zooming requires the development of a single lens of variable focal length – and has the impasse of that obviousness, its impermeability to the further question then as to the determinations of the technical advances (as also to the criteria for the term 'advances' itself). Arriflex cameras were available in Hollywood in the late 1940s, but there was no particular turn to hand-held sequences in response to the technical advance (nor in France at the same period in response to the Eclair Cameflex). With the emphasis given by such an assertion, technology becomes very much an autonomous instance, its explanations internal to itself in an ongoing movement of advance and modification consequent on advance: problems of loss of quality in post-synchronisation mean that location scenes in the early thirties are shot with direct sound, microphones in use are omni-directional and pick-up of background noise a difficulty, hence the introduction of slow-speed, fine-grained Eastman background negative in 1933 which allows the possibility of good standard back projection again and thus the shift back to studio shooting for exterior scenes and so on.

A different inflection within the same problematic is provided by the kind of work most clearly represented by the various writings of Barry Salt. Salt retains the technological base, which he describes in detail across the decades of cinema's history, but gives it an autonomy which limits its effects of determination: it is at once neither greatly determining – 'the constraints of film technology on film forms are far less than is currently supposed, though not negligible' – nor much determined – 'as for ideology, its connection with film technology is practically zero'.[24] The basic thesis is that of 'the dominance of aesthetic considerations over technical possibilities as far as the form of films is concerned';[25] technology, a pressure not a constraint, continually responds to the determination of aesthetic demands. Thus, for example, the trend towards longer shot lengths in the 1940s requires increased camera manoeuvrability and it is as a result of this requirement that the crab dolly is produced (Houston crab dolly 1946, Selznick crab dolly 1948). At the same time, technology is itself effective, as, for example, in the same area of shot length: various hindrances to assembling a film in

the early thirties are relieved by developments such as the sound moviola and rubber numbering which allow shot length to decrease. Salt continues his discussion of this: 'Having reached this point about 1934–5, new technical developments began to have some effect on film photography, and at the end of the thirties a new trend towards longer takes was just starting to emerge independently of any technological pressures; a trend that was to flourish in the forties.'[26] The movement of the argument there is indicative: new technical developments have effects, a new stylistic trend begins: the determination is technical *or* aesthetic, the latter the general rule and the lacuna in this kind of history, a point beyond which there is no further explanation or the explanation only of a more or less crude psychology (the decisions of director-artists, what the audience demands, etc.).

Within the terms of this conception of 'the technological' and 'the aesthetic' there will always be an endless series of adducible elements to carry the different inflections: demonstrating the aesthetic over the technological (Carl Mayer's notions of dramatic movement in his work with Murnau in 1923–4 leading to improvements in camera support technology), the technological over the aesthetic (the effect of Cinemascope on the film image – 'shallow focus, very wide angles, no definition'[27]), and including all the time moments of puzzle, of neither one nor the other, of inexplicable mystery (the lateness of the development of the optical printer).

In relation to the histories and arguments just described, there is a need to make certain immediate clarifications. *Technology* is generally taken as the systematic application of scientific or other organised knowledge to practical tasks; the knowledges and the devices they allow become the particular applied technology that is cinema. Within cinema, *techniques* are the procedures involving elements of the technology in specific ways, processes in the production and presentation of films. The terminology is wavering, confusing, since not all of the techniques involved in the production – presentation of films are dependent on technological processes for their operation; as an extreme example, techniques of acting play a part in the production of many films without necessarily being dependent on the technology of cinema; a less extreme example might be said to be the jump cut, a technique which does not depend on a technological process in the manner

that, say, a zoom shot depends on a certain type of lens.[28] The example of the jump cut, however, is unconvincing – jump cuts are after all bound up with the technology of cinema apart from which, unlike techniques of acting, they could have no possible realisation – and thereby at the same time indicative of the distinction to be followed in discussion between cinema and film. What Barry Salt is concerned with, for example, are film forms, the various techniques – standard or individual – of films, with cinema effectively left out of the account *because* it is a technology, the technology for the production of films which as such is outside of any ideological determinations or effects and can only be described technologically, in terms of its own history of invention, advance, improvement, modification. Within cinema, as it were, the question of the relation between technological determinants (the inventions, advances, improvements, modifications) and techniques (the standard or individual practices) in which technology is exploited is a question at the level of films: the determination of the forms of films by technical elements or/and the determination of the technical elements by the aesthetic requirements of film forms, 'technique' being the term that shifts between the one and the other. Technology itself is then always found and finally confirmed as an autonomous instance, with ideology involved – should the argument envisage it – in the creation and maintenance of the various techniques, even if (just because) – again should the argument even pose the problem – technology is also acknowledged as bound up with the determinations of economic forces guiding its development in this or that direction. Effectively, a kind of base/super-structure model is deployed in which technology provides a base for techniques which are the point of the relations of ideology.

The question of films, of film forms, is important, and, moreover, as yet relatively unacknowledged in this context: what, for example, would be a textual analysis informed by reflection on technology/technique (where the answer, of course, could not lie in the simple adoption in the analysis of technical terms, odd references to depth of field or whatever)? At the same time, however, a further question can be, has been, posed (with consequences in return for the question of film forms): that of the applied technology cinema, the machine, of the apparatus, in fact, with reference to which large areas in themselves, and not merely a particular technique, become crucial focuses for discussion, camera, colour, sound, and so on; the question of the *limits* of cinema, historical and ideological, and the

effects of the technology *there*: the apparatus as instruments, mechanisms, devices, *and* of the subject – as that history too.

NOTES

1. See the reproduction of an early Lumière programme in Georges Sadoul, *Histoire générale du cinéma* (revised edition) vol. I (Paris: Denoel, 1973), p. 290.

2. 'Le signifiant imaginaire', *Communications* no. 23 (1975), pp. 3–55 (quotations p. 6); reprinted in Christian Metz, *Le Signifiant imaginaire* (Paris: Union Générale d'Editions, 1977), pp. 7–120 (quotations pp. 13–15); translation 'The imaginary signifier', *Screen* vol. 16 no. 2 (Summer 1975), pp. 14–76 (quotations p. 19).

3. Introductory remarks to 'Métaphore/Métonymie', in *Le Signifiant imaginaire*, pp. 179–80.

4. Christian Metz, *Langage et cinéma* (Paris: Larousse, 1971), p. 11; translation *Language and Cinema* (The Hague and Paris: Mouton, 1974), p. 17.

5. Ibid., pp. 170–87 (trans. pp. 225–48).

6. Ibid., p. 144 (cf. p. 177) [trans. p. 191 (cf. p. 236)].

7. Cf. Jean-Louis Baudry, 'Le dispositif', *Communications* no. 23 (1975), pp. 56–72; reprinted in J.-L. Baudry, *L'Effet cinéma* (Paris: Albatros, 1978), pp. 27–49; translation 'The apparatus', *Camera Obscura* no. 1 (Fall 1976), pp. 104–26.

8. Christian Metz, *Essais sur la signification au cinéma* vol. II (Paris: Klincksieck, 1972), p. 192.

9. An emphasis equally valid in science, the science to which discussions of technology constantly refer as to an indisputable area of the observable, the factual, the real: 'observational reports, experimental results, "factual" statements, either *contain* theoretical assumptions or *assert* them by the manner in which they are used' (Paul Feyerabend, *Against Method* (London: New Left Books, 1975), p. 31).

10. Raymond Williams, *Television: Technology and Cultural Form* (London: Fontana, 1974), pp. 13–14.

11. 'Any technical practice is defined by its objectives: such specified effects to be produced in such an object, in such a situation. The means depend on the objectives. Any technical practice utilizes amongst these means knowledges which intervene as procedures: either knowledges borrowed from outside, from existing sciences, or "knowledges" produced by the technical practice itself to accomplish its end. In every case, the relationship between technique and knowledge is an *external* relationship, without reflection, radically different from the reflected internal relationship existing between a science and its knowledges.' (Louis Althusser, *Pour Marx* (Paris: Maspero, 1965), p. 172, n. 9; translation *For Marx* (London: New Left Books, 1969), p. 171, n. 7.).

12. Gene Youngblood, *Expanded Cinema* (New York: Dutton, 1970), p. 419.

13. V. F. Perkins, *Film as Film* (Harmondsworth: Penguin, 1972), p. 40.

14. Jean-Louis Comolli, 'Technique et idéologie' (II), *Cahiers du cinéma* no. 230 (July 1971), p. 57.

15. Jean-Louis Baudry, 'Cinéma: effets idéologiques produits par l'appareil de

base', *Cinéthique* no. 7/8 (1970), p. 3; *L'Effet cinéma*, p. 15; translation 'Ideological effects of the basic cinematographic apparatus', *Film Quarterly* vol. XXVIII no. 2 (Winter 1974/75), p. 41.

16. B. Brecht, *Gesammelte Werke* vol. XVIII (Frankfurt am Main: Suhrkamp, 1967), p. 127; Williams, op. cit., p. 25. Cinema, of course, was not developed in the abstract; 'the reproduction of life itself' was not a subsequent discovery by Lumière; the description of what cinema would be, from the Lumière *'sujets actuels'* to animation, in Ducos du Hauron's ambitious 1864 patent for an 'apparatus designed to reproduce photographically a given scene with all the transformations to which it is subject over a given period of time' is not some freak – and neither is it the indication of cinema as an eternal dream of humankind: the technological and the ideological move together as the very possibility of the development of the former as cinema; the pre-imaginary of cinema has its historical content from the problems of social definition and representation in the nineteenth century, the pressures for 'machines of the visible', and is itself a force in that development of cinema.

17. Reese V. Jenkins, *Images and Enterprise: Technology and the American Photographic Industry 1839–1925* (Baltimore: Johns Hopkins, 1975), pp. 274–5.

18. H. Mercillon, *Cinéma et monopoles: le cinéma aux Etats-Unis* (Paris: A. Colin, 1953), p. 7.

19. Jenkins, op. cit., p. 298.

20. Cf. Douglas Gomery, 'Failure and success: Vocafilm and RCA innovate sound', *Film Reader* no. 2 (1977), p. 215.

21. John L. Fell, *Film: An Introduction* (New York: Praeger, 1975), p. 127.

22. Perkins, op. cit., p. 40.

23. Liz-Anne Bawden (ed.), *The Oxford Companion to Film* (London, New York, Toronto: Oxford University Press, 1976), p. 106 (article 'Camera').

24. Barry Salt, letter in *Screen* vol. 17 no. 1 (Spring 1976), p. 123.

25. Barry Salt, 'Film style and technology in the forties', *Film Quarterly* vol. XXXI no. 1 (Fall 1977), p. 46.

26. Barry Salt, 'Film style and technology in the thirties', *Film Quarterly* vol. XXX no. 1 (Fall 1976), p. 32.

27. Lee Garmes A. S. C., interviewed in Charles Higham, *Hollywood Cameramen* (London: Thames & Hudson, 1970), p. 54.

28. The jump-cut example is taken from a paper entitled 'Colour and cinema: problems in the writing of history' prepared for the conference by Edward Branigan and subsequently published in *Film Reader* no. 4 (1979).

2. Cinema and Technology: A Historical Overview

Peter Wollen

I would like to give an overview, necessarily schematic, of the history of technological change and innovation in the cinema, together with a few theoretical comments, bringing out the implications of the reduced empirical material. My paper is intended as introductory and the main stress I want to make is on the heterogeneity of the economic and cultural determinants of change and the way in which innovations in one area may help to produce conservatism and even 'retreat' in another – history not simply with 'differential' times, but even with 'reverse' times. In dealing with the heterogeneity of film technology, I want to stress the presence of three distinct phases — recording, processing, and projecting or exhibiting[1]—and the way in which developments in one may cause repercussions in the others. In general, I believe too much attention is usually paid to the recording stage at the expense of the laboratory and the theatre – a serious distortion because exhibition, rather than production, is economically dominant in the film industry, at least as far as the timing and impact of technological changes are concerned.

I am aware that, despite this, my own approach is probably too traditional in bias, if only because what data are available has been determined by the bias of previous researchers. The history of the technique of editing, for instance, is rather neglected. I happened recently to see again Vertov's *Man With A Movie Camera* with its shots of Svilova editing with a pair of scissors and was reminded then of the changes which have taken place in editing equipment. Even an apparently extraneous and trivial invention like Scotch tape has had an enormous impact on editing technique.[2] It is difficult to escape entirely from those myths of film history which themselves

concentrate on only the recording phase and which narrate this history in terms of four legendary moments. The first moment is that of Lumière and the first Lumière programme (often condensed into the train entering the station at La Ciotat). The second moment is the arrival of sound and its instance is *The Jazz Singer*. Then there is colour (strictly speaking, three-colour Technicolor) with the Disney cartoons and *Becky Sharp*. Fourthly, there is the moment of wide screen and 3-D (*The Robe, This is Cinerama*). This series, of course, suggests possible extensions in the future, in line with Bazin's celebrated myth of total duplication of reality.

In fact, I think, the crucial changes in the recording process have involved not the camera itself, as the Lumière legend suggests, but changes in film stock. The camera itself is a very simple piece of mechanical equipment. As Hollis Frampton once pointed out, it represents the culmination of the Age of Machines and was superseded almost as soon as it was invented. Lumière's own inspiration was the sewing machine, itself a typical piece of nineteenth-century machinery. Lumière regarded the invention of the film camera as a simple task in comparison with the invention of the Autochrome colour photography process which he also introduced. The camera is not an extremely elaborate piece of equipment even by nineteenth-century standards. Most of the devices necessary were the product of tinkering by skilled enthusiasts—the Maltese cross, the Latham loop, all the things which occupy chapters in books and really acquired significance through patents litigation. Most changes in camera efficiency are involved with the optical rather than the mechanical system (better light transmission through the lens; the post-war explosion of the zoom; improvements in focusing systems), with miniaturisation and portability and with by-products of other innovations (sound-proofing, for instance). In one cinematographer's words, 'of course, the new camera is easier to use, with many labour-saving gadgets, but the final result looks the same.'

The real breakthroughs have been in the technology of film stock, in chemistry rather than mechanics. The precondition for the invention of cinema was the invention of celluloid (first used as a substitute for ivory in the manufacture of billiard balls and for primitive false teeth) which provided a strong but flexible base for the emulsion. Later the history of film stock is one of steadily improving speed/grain ratios, faster and more sensitive emulsions without adverse graininess. There is an important paradox here.

Improved stocks have made film-making much more accessible, allowing films to be made in lower and lower levels of available light and giving the possibility of 8mm and 16mm film-making on a wide scale. Yet at the same time a good deal of the pressure for improved emulsions came because the development of sound and colour made filming much more difficult – colour demanded more light, and sound too made lighting much more cumbersome (hence, the well-known lag in deep-focus cinematography between the silent period and *Citizen Kane*). The innovations which restricted access to film-making, which demanded enormous capital investment and caused real set-backs, have attracted attention, while the steady development of stock – chemical rather than optical or electronic – has never been comprehensively chronicled.

I would like to dwell a little on the adverse effects of the introduction of sound. It was with sound that the truly modern technology of electronics first made a real impact on the cinema. In fact the breakthrough in sound technology is associated much more with the third of the phases that I described at the start than with the first, more with projection than with recording. The problems were twofold. First, image and sound had to be synchronised. Second, sound had to be amplified to fill a large theatre (Edison had shown sound films but only in a peepshow with a primitive listening-tube: in fact, it was his wish to incorporate sound, without any means of amplification, which led him towards the peepshow rather than theatrical projection). The two crucial discoveries were the audion tube which made possible advances in loudspeaker and public address technology that could eventually feed into the cinema and, of course, the photoelectric cell (leading in time to television as well) which made possible an optical sound-track that could be picked up, with absolutely precise synchronisation, by a component within the projector, rather than demanding, as previous systems did, synchronisation between the projector and a separate sound system.[3]

The introduction of sound set off a series of effects. A technical advance on one front brought retreats on others: one step forward, two steps backwards. In the first place, the economic effects must be mentioned. (The introduction of sound, also, of course, had economic determinants: principally, saving in labour costs through the elimination of orchestras and between-the-screenings entertainers). The conversion costs were enormous and led to a vastly increased role for banks in the industry in alliance with the giant

electronics firms which controlled the relevant patents.[4] (Fox, who tried to challenge the patents, was driven to bankruptcy and gaol). In comparison with the twenties, the thirties was a period in which very little independent or experimental film-making took place. In Hollywood, the power of the producer was enormously enhanced.

Technically, sound, while it introduced new possibilities (scarcely realised), also introduced new obstacles and a chain of bizarre secondary problems and solutions. The carbon lights hummed and the hum came through on the sound-track. The tungsten lights which replaced them were at the red end of the spectrum and so the old orthochromatic film, which was blind to red, had to go, to be replaced by panchromatic stock (like so much else, a spin-off from military technology – it had been originally developed for reconnaissance fog photography). This change brought changes in make-up; the fortunes of Max Factor date from this period.[5] Studios replaced locations; multiple camera set-ups were introduced; the craft of script-writing was transformed. Most important of all, the laboratory was completely reorganised. The need for sound-image synchronisation meant that every aspect of timing had to be standardised.[6] On the set, the camera was no longer hand-cranked. New equipment was introduced: for example the sensitometer and densitometer. Every aspect of the laboratory was automated and there were standardised development and printing procedures. In this way, the laboratory became completely divorced from the work of the director and cinematographer; it became an automated, industrial process with its own standard operating procedures. Anyone who has made a film will be familiar with the opacity of the laboratory, something which dates from this period.

It was not until after World War II that new developments in sound technology were universalised, this permitting the immediate set-backs to be overcome.[7] The crucial breakthrough was the advent of magnetic tape, invented in Germany and, like reflex focusing, hand-held camera and monopack colour stock, part of the booty of victory. Tape made sound recording much easier, and cheaper; it transformed dubbing and mixing and, with the subsequent development of the Nagra and crystal-synchronisation, led to much easier location filming and the whole *cinéma-vérité* movement, with subsequent new definitions of 'realism' in film. It is worth noting, perhaps, that the main limitations on sound currently come at the projection stage; poor speakers and poor acoustics make

working to the full potentiality of modern recording and mixing technology pointless.

The history of the development of colour is similar to that of sound: a breakthrough which proved to be a set-back. There were attempts to introduce colour from the very beginning – with hand-tinting, toning and various experimental systems, including two-colour technicolor – but the successful invention was that of three-colour Technicolor in the early thirties by Herbert Kalmus.[8] The success of Technicolor derived from Kalmus's realisation that he had to devise a system which not only recorded colour but would also be acceptable to exhibitors. Once again the projection stage proved to be the determining factor. At the production end Technicolor produced new obstacles. The beam-splitter camera was extremely bulky and could only be leased together with an approved Technicolor cinematographer. Colour consultants came on the set, led by Natalie Kalmus, and keyed colour to eye and lip tones; filters and unconventional effects were barred until Eastman Color arrived and Huston broke free with *Moulin Rouge* in the fifties.[9] Technicolor required more light which meant a lower effective film speed. Film memoirs are full of complaints by cinematographers about the limitations Technicolor imposed.

As with sound, the next step came after the war with the appropriation by the victorious allies of Agfacolor, fruit of superior German dye technology, developed within the I. G. Farben group. Russian and American armies raced to get to the Agfa works and, though the Russians won (hence Sovcolor), the destruction of patents and diffusion of new technical information led to the appearance of Eastman Color with *The Robe* in 1953.[10] (The new colour process was linked to Cinemascope: Technicolor beam-splitter cameras could not be fitted with scope lenses).[11] Eastman's problems were essentially matching Technicolor's speed, and then improving on it, without losing colour correction. Every new dye introduced as a corrective would tend to slow the film down. There was also a strong economic incentive, of course, in improving film speed, namely to reduce lighting costs.[12] Again, the strength of Eastman Color lay in its greater accessibility, though there was a time-lag of 20 years or more.

Colour, like sound, also demanded standardisation in the laboratory. Elaborate controls were developed and matching and grading colour became crucial parts of the laboratory's work. It is still extremely difficult and expensive to get really detailed control

over complex colour effects. The opacity and autonomy of the laboratory was further accentuated. It might be added that one of the attractions of colour video, which uses electronic rather than chemical technology for colour, is that there is no laboratory involved. In video the three phases of articulation are much more closely connected and, of course, are not separated in time in the same way that they are in film. It is only a matter of time before electronic technology gains the ascendancy in image as well as sound.

Both sound and colour had to meet the requirements of the exhibitor. Projection has been the most conservative side of film technology. Exhibitors, for instance, defeated 3-D— an attempt by Polaroid to challenge Eastman's supremacy in the film stock market. Cinerama (derived from aerial gunnery simulation) never succeeded except in a few big city theatres.[13] Cinemascope (another military spin-off—emanating from tank gun sighting periscopes) was able to make headway because it involved minimal adaptation of the projector, under the economic pressure of competition from TV (and also to eliminate 3-D).[14] Exhibitors have consistently resisted conversion costs.

The economic strength of the exhibitors has always rested on the real estate value of the theatres. Production companies, in contrast, have been subject to recurrent crises, bankruptcies and take-overs throughout their history. They have simply not been able to afford research and development projects, except for a limited involvement in special effects, ironing out secondary technical problems and adapting technology developed elsewhere. Almost all the major technical innovations have been introduced by outsiders with the support of economic interests wishing to break into the industry. Dupont and 3M have tried to enter through magnetic tape and polyester film bases; Polaroid was fought off over stereoscopic film. New challengers will come from video and presumably laser technology. Moreover, the interests of the major technology-producing companies are not limited to Hollywood, which is only a small part of their market. The general industrial and also domestic markets are much more significant and here there are no entrenched exhibitors to contend with. It is here that, on the one hand, expensive laser and fibre optics 'cinema' and, on the other, cheap 8mm synch sound and video disc 'cinema' will first make headway.

At this point I would like to shift focus from Hollywood to experimental and avant-garde forms of film-making. This area, of

course, has been crucially dependent on the improved quality and accessibility of 16mm and, to some extent, 8mm film-making: faster stock, portable equipment, miniaturisation and so on. Up until the 1950s histories of avant-garde film list almost every experimental film made; there were so few. Clearly this was because of the difficulty and prohibitive cost of making films independently. Since then, however, there has been an enormous explosion in the number made following the introduction of the Eclair camera and the Nagra tape recorder (first used in 1960 in Rouch and Morin's *Chronique d'un été*), together with increased subsidies, either through state or para-state arts funding bodies or through the educational system. The entire new field of independent film has begun to appear between home movies and the industry.

In addition to owing its possibility to these technical advances, avant-garde film has had other technological implications. First, of course, there has been the mis-use of existing technology, its use to transgress the norms implicit in it. On the whole, this has not involved very advanced technology: Flicker films counteract the use of the shutter, and so on. A variety of mis-use is hyperbolic use—thus the hyperbolic use of the zoom lens (as in *Wavelength*), or the optical printer or the projector or the geared head (as in *Riddles of the Sphinx*). Then there is an area in which technological innovations have actually taken place—Chris Welsby's landscape films or Michael Snow's *La Région Centrale* for which ingenious contraptions were devised for the camera to permit realisation of a project which would otherwise have been technically impossible.[15] In all these areas, I think, there is an ambivalence between contravening legitimate codes and practices (a negative act) and exploring possibilities deliberately overlooked within the industry, or tightly contextualised (in contrast, a positive act).

Finally, a few theoretical, or pre-theoretical, remarks. I would like first to stress that the technology of cinema is not a unified whole, but is extremely heterogeneous. It covers developments in the fields of mechanics, optics, chemistry and electronics. It covers the Latham loop, Scotch tape, the densitometer, the zoom lens, magnetic tape, and so on and on (the list is long). In the past theorists have tended to stress and even essentialise one or other area of technology at the expense of the others. Cinema is seen in terms of the camera and the recording process or reproduction and the printing process or projection and the physical place of the spectator (Bazin, Benjamin, Baudry). In this way the heterogeneity of the

cinema is reduced to one subset of determinations in a reductionist manner. In effect a myth of the cinema (Bazin's own term) is thereby created, which serves to efface the reality of production.

Within the avant-garde too (or perhaps I should say within the theory of the avant-garde) there has been a parallel tendency to create an ontology, seeing means not as secreting a teleology, but as ends in themselves, as essences. This new ontology can easily be disguised as a materialism, since it seems to foreground means of production rather than 'images'. Yet implicit within it is an assumption that the equipment used for making films is an essential bedrock rather than itself the product of a variety of historical determinations, at the interface where the economies of capital and libido interlock. The forms of matter taken by the technical apparatus of film are determined by the forms taken by the material vicissitudes of labour and instinct, within history (or rather, as history).

At the same time, however, it is within the avant-garde that we find resistance to the perpetual anthropomorphisation of technology in the cinema. It is instructive to re-read Vertov's rhapsodies on the camera-eye. Technological developments outside the cinema have already produced microphotography, X-ray photography, infra-red and thermal photography, magnetic photography and many varieties of photography which Vertov never saw. Yet these have had almost no impact on the cinema. The eye of the camera is still assimilated to the human eye, an eye whose imaginary is constructed around a range of differences within a basic unity, rather than a search for a fundamentally different form of vision. The problem is not one of representation as such, so much as the dominant and cohesive mode of representation. It is here that a specious unity exists, rather than within the technology itself, and it is here, by understanding the different and heterogeneous determinations at work and struggling to release them from the interlock in which they are bound, that we can conceive and construct a new cinema, not necessarily with a new technology, but certainly with a new place of and for technology.

NOTES

1. It is worth noting that the light source is different at each stage: sunlight or artificial lights during filming, printer light and then projector light.

2. Dai Vaughan has graphically described the impact of Scotch tape on editing in 'The Space Between Shots', *Screen* vol. 15 no. 1 (Spring 1974).

3. *The Jazz Singer* was sound-on-disc. Without the optical track sound would probably have been restricted to leading inner-city theatres (as stereophonic sound is today).

4. The relevant patents were controlled by ATT and RCA who struck a deal at the expense of Fox who tried to use the German Tri-Ergon patents. The whole story is reminiscent of earlier bitter battles over the Edison-inspired Patents Trust. Later Technicolor and Eastman worked out a patent-pooling arrangement until Eastman were ready to launch their own colour system.

5. Red, which had come out black on orthochromatic stock, now came out nearly white, with a particular effect on hair and lip hues. Contour make-up became a key development later on in the thirties.

6. Hand-cranking disappeared and editing, previously done by eye and hand, was standardised by the introduction of the moviola.

7. Carbon arcs came back in after the electrolytic capacitator was introduced. The blimped Mitchell BNCs were sold to Goldwyn in 1934/35. In time these innovations fed into *Citizen Kane*, an anomalous film, which took the possibilities of sound as far as was possible before magnetic tape. Disney's *Fantasia* was similarly pioneering, but a failure: only six theatres used the stereo version.

8. Early colour devices included filtered projection light, multiple projectors, 'pointilliste' emulsions, etc. Two-colour Technicolor was used throughout some films in the twenties, though mainly restricted to set pieces and finales.

9. Natalie Kalmus's favourite picture was *The Red Shoes*.

10. *The Robe* was important because it introduced Eastman color, Cinemascope and tape-based stereophonic sound together.

11. The same was true of 3-D which had used Trucolor or Anscocolor.

12. Actually, labour costs associated with lighting were probably more important than the lighting costs themselves.

13. Like Technicolor, Cinerama was backed by Whitney (cf. *Gone With The Wind*) and by Reeves Sound Studio which hoped to break into the field of cinema through stereo. Early Cinerama attempts were shown at the New York World's Fair—fairs and exhibitions have often been privileged places for introducing new technology only rarely taken up industrially.

14. During the 1914–18 war. Autant-Lara made a Scope film in the 1920s, when the system was called Hypergonar. Fox bought the patents to fight the twin threats of TV and 3-D.

15. Snow's camera is also itself exhibited as a sculpture.

Discussion

Christian Metz I should like to insist on certain points in Peter Wollen's very interesting historical survey. There is one important difference between the technology of the spoken language and that of the cinema. The technology of the spoken language involves only the use of the human body, of certain of its parts (tongue, teeth, etc.), while the technology of the cinema involves the use of a physical apparatus, a set of machines. This difference, which is a very simple and obvious difference, has profound consequences, two of which I want to stress. The first is that the spoken language is the only real mass medium; in the cinema, the plain act of the enunciation is expensive, is expensive even in kinds of non-professional avant-garde film; the very fact of enunciation costs money – some at least, most often a lot. If cinema is to become a real mass medium, it will be necessarily with important economic changes within society. The second consequence that stems from the difference is a crucial theoretical question: to what extent does the physical apparatus of cinema reproduce, for historical, ideological reasons, the imaginary and symbolic patterns of the human body (I am thinking of things like identification, the mirror phase, scopic drive, and so on)?

Inez Hedges I have a similar question to address to Peter Wollen. Among the long list of transformations which cinema technology has undergone, can you classify the different types of change in a way that would be coherent with the kind of analysis Comolli makes of the relationship between spectator and cinematic event as a contract, specifically a 'disposition of representation'? It seemed to me, as you were enumerating the various technological changes, that some of these could be considered to be breaks of the contract, would involve a new contract between spectator and cinematic event, whereas others might just be refinements of an existing contract. One begins to think in such terms as 'realism', which I realise can be dangerous; but is there not some way that we could start to talk about which innovations were merely refinements and

which of them actually caused new developments or relationships between spectator and event?

Peter Wollen I think there are two main directions in which the technology of the cinema has developed. One is well known to everybody and has to be seen in terms of a contract which is based on representation, the imaginary, illusionism, depending on how you want to put it. For this, the catastrophic event was, I suppose, the coming of sound, because the introduction of the sound-track does clearly change that contract: it makes much more difficult the myth of cinema as a visual art, brings with it a whole new set of possibilities with regard to verbal language, and so on. That was the crucial event and the process of normalisation after the coming of sound is very important. The second direction underlying this kind of history of perfection or change or enlargement of the possibilities of representation is a consistent historical development of faster and faster, narrower and narrower gauge film stocks, which relates very much to what Christian Metz was saying about the fact of enunciation in cinema as expensive. This second direction of technological development has made cinematic enunciation cheaper and simpler, more open to people, and is crucial for thinking of cinema as a mass medium. There are home movies as well as Hollywood or avant-garde film and the home movie is a category which should not be forgotten.

The other thing I wanted to focus attention on was the lab. We so often forget, for example, that when a colour film is seen projected, the colour is not in the Bazinian sense a direct indexical registration of colour in the natural world; it is dye, what you see is dyed, obviously it is an iconic approximation; there is, in fact, no direct indexical link between the colour of the natural world and the colour of the projected colour film – a whole technology of dyeing has intervened. In a sense, the lab is the area which allows potentially the greatest breaks with representation, illusionism or whatever; as you can see in the way in which lab technology shows up in special effects (a very specialised and controlled area within habitual cinema) and as you can also see in avant-garde films in which things that would ordinarily be the prerogative of the lab are attacked as part of an attack on representation. What you see is an image and that is the power of cinema, but it is also its power for you not to think about what you do not see, which is as much the sound-track and the lab as anything else.

Aimee Rankin Could you differentiate between the notion of technological advancement in terms of the cinema and in terms of film? It seems to me that there is often a large difference between technological advancement in film – microphotography, say, used for medical and other purposes – and that which is appropriated by the actual cinema. My impression was that your paper tended to emphasise this appropriated technological advancement and it would be interesting to know if there are areas where there have been technological advances not taken over by the cinema, something which may be due to certain conventions of narrative form.

Wollen In the programmes of the London Film Society in the 1920s, the major place for the showing of experimental and independent and Soviet films at the time, there were always scientific films, in which one could see things like microphotography, slow motion photography, time lapse photography. It is in scientific film that you see the technological developments and possibilities which have simply never been absorbed into the institution of cinema at all, for reasons that relate to anthropomorphism, the constant equation of camera with human eye. Someone like Vertov, with his whole idea that the camera eye is different from and superior to the human eye, allowing a discourse quite other than that of the normal human imaginary, is obviously reliant on things which happened in scientific film – that is what fascinated him and it is what has largely been suppressed.

3. The Industrial Context of Film Technology: Standardisation and Patents

Jeanne Thomas Allen

Bazin's essay 'The Myth of Total Cinema'[1] and evolutionary surveys of the early history of cinema technology[2] stress the development of the cinematic apparatus as a logically progressive response to a centuries-long drive to replicate reality, a drive which gained momentum in the nineteenth century. From this perspective film technology advances in the direction of an ideal cinema which ever more fully represents the world of sensory experience. Bazin characterises film as a neutral technology, a passive recording mechanism which evolves towards self-effacement by quintessentially matching human perception and experience. Outlines such as those of C. W. Ceram in *Archeology of the Cinema* or Martin Quigley in *Magic Shadows* start with a less idealistic premise but also present the development of film technology as a single line of refinement with each modification as the stimulus for the next.

'The myth of total cinema' appears as an autonomous force controlling the development of cinema above and outside the social context from which the technology emerges. Evolutionary theories of film technology describe innovation as a purely formal change operating within a narrow world of predecessors. The view of technological invention as a gradual series of modifications has been fostered as an antidote to the 'star' orientation of much of the history of invention.[3] Nevertheless, this portrayal of collective effort does not consider social processes or how they inform discovery. The gradualist or evolutionary view of the development of technology,

like a necklace of successive individual beads, still isolates the innovation itself from the social conditions which may account for observation and recognition[4] and links it with a predecessor which, by hindsight, appears to be no more than a preliminary step.

These two modes of explanation — the one idealist, the other more mechanistic — are not at odds so much with each other as they are separated by a considerable field of interaction at the societal level. Bazin's contention that the drive to replicate reality has been the dominant impulse weaving sporadic efforts into the final synthesis of film really subsumes, rather than accounts for, the points of transition which evolutionary outlines describe. Between the Western 'dream' of illusionistic art and the individual tinkerer providing a new twist to one of the toys in film's archeology stands a transformation in economic and social relations so profound it has been regarded as a revolution.

Beyond the assertion that the cinema is indeed the product of an industrial revolution, discussions of cinematic invention do not stress the significance of the transition from manual to mechanical power. Bazin's chief concern with photography as the inspiration for 'the myth of total cinema' is with its ability to correct the defects of the eye, to efface the interpreting hand and to record the imprint of reality. The significance of mechanical reproduction for Bazin is limited to the culturally attributed quality of objectivity. As for film technology evolutionists, the industrial revolution is a gradual progression from the Renaissance onwards and is restricted to the activity of the lone tinkerer rather than examined in the workshop or the marketplace.

David Noble has recently described this tendency to view modern technology 'as though it had a life of its own, an internal dynamic which feeds upon the society that has unleashed it' in his study of the electrical and chemical industries in America.[5] Noble says there seems to be an element of truth in the myth of human creation assuming an independent existence, but, he argues, this metaphorical representation (of our problem in coordinating technological innovation with human welfare) should not be construed as, or confused with, a historical method. Technology cannot be viewed formalistically; it is the product of a complex social process. In the instances he chooses to examine, technology is an integral part of the socio-economic relations between corporate-style, science-based industry and an academic and governmental institutional base which both serves and is serviced by such industry. His study might

be pursued into a study of the American film industry—for example, the resemblance between the technological strategy of the Edison Manufacturing Company between 1907 and 1915 as the leader of the American film industry and that pursued by General Electric and Westinghouse a decade earlier.[6] The Edison laboratories at Menlo Park, New Jersey, mark an important transitional stage in the direction of the corporate-owned research laboratory.[7] Edison's group of researchers were first of all a group constituted as a kind of a factory of invention and motivated by what some biographers refer to as Edison's democratic ideal of practical science or science in the service of mankind[8] and what others have seen as Edison's entrepreneurial and profit-oriented conception of invention as a response to marketing feasibility (systematic invention).[9]

Similarly Jean-Louis Comolli argues that the spark necessary for the 'completion' of previously sporadic cinematic invention was marketability:

> But the real reason for this delay is not just the inevitable (according to Bazin) gap between the 'dream' and its 're-alisation'. Rather it is that, on the one hand, while the 'scientific' conditions for the production of the definitive camera apparatus had been brought together more than half a century before its final completion, the scientists themselves scarcely bothered with resolving the technico-practical difficulties of its manufacture because they had very little interest in that manufacture; and that, on the other hand, it is from the moment that the production of the camera was inscribed in a social demand and an economic reality that things started to go very quickly and efforts were multiplied.[10]

The factory of invention, the linking of technology with the goals of business, was the necessary final stage of the evolutionary process and the one in which social forces became most evident. But I would suggest that the economic and social processes which Noble and Comolli describe as surfacing most emphatically in the 1890s were evident and formative in the process of technological discovery much earlier in the nineteenth century, when industrialisation was gaining momentum.

Industrialisation pervades the technology of cinema through the principle of standardisation. Film developed in a century marked

by the standardisation of products and the standardisation of the machinery necessary to manufacture them. Standardisation is primarily the outcome of the interchangeability of parts made possible by the development of precision tools to replicate identical component parts. This mode of production, with continuous-assembly manufacture and the division of labour common to the factory system, resulted in new economies of scale in mass production, lowering the per unit cost of production and reducing the costs of repair and/or replacement.

What Europeans come to label 'the American System' developed in the United States within the fire-arms industry and as a response to the demands of government contracts for armaments. Such firms as the Colt Armory under the management of Elisha Root, Robbins and Lawrence, or North, Starr and Waters used milling tools to achieve an accuracy of within 1/32 of an inch for their component parts. By 1851 the vernier caliper enabled accuracy of 1/1000 of an inch. The methods of producing interchangeable parts spread in the period from the 1830s to the 1850s to other industries such as clocks and watches, sewing machines and agricultural implements and became the cornerstone of the factory system which spread through New England. The centre from which this diffusion radiated was the machine tool industry that Nathan Rosenberg has explored in suggesting a theory of convergence in mechanical invention as machine tool shops re-geared themselves to solve mechanical problems shared by other industries, for example bicycle to automobile,[11] textiles to locomotives.[12]

The machine tool industry served as a common context for manufacturing much as an Edison-style research laboratory would serve as the common ground of numerous electrical based industries. The machine tool industry that developed between 1840 and the 1880s when it became independent of any particular manufacturing interest was the fulcrum of industrial standardisation.[13]

Emerging from this era, film technology bore the earmarks of the movement towards industrial standardisation in several dimensions: the equipment necessary to produce and exhibit film is a manufactured assembly of interchangeable parts; film itself relates to this equipment as one of those parts both as a physical artifact (film gauge and number of sprocket holes) and to some degree as an entertainment commodity (which industry leaders presumed was a standardised, largely undifferentiated product); and finally, the

film product itself, through the processes of photography, achieves an immensely precise level of standardisation in its ability to be duplicated.

The overlapping chronological development of industrial stan-dardisation and photography may not be purely coincidental. The methods of engraving and lithography enabled producers to turn out first a limited number of prints (approximately 6000 through copper engraving) and then an unlimited number with the use of lithographic stones. The result was greater diffusion of visual images at a reduced cost. And we may note, here, that Niepce's perfection of the photographic plate was preceded by his researches on lithographic processes and ways of copying engravings by a chemical process. Mechanical production of visual images ac-complished in the sphere of mass culture what was also occurring elsewhere in the economy. Photography, mechanical reproduction and industrial standardisation are related through the realisation of a mass market for less expensive and seemingly infinitely replicable products. Later the process of producing lithographs and celluloid would be transformed by 'the American System' of interchangeable parts and continuous assembly, which proved that visual culture could be industrialised.[14]

The dimensions of standardisation in the film industry find perhaps their closest precedent in the mass production techniques of George Eastman in supplying film for the amateur photographic market. From the time commercial photography began in 1839 until the late 1870s, photography was the domain of professionals and only a few avid amateurs, due to the complexity of its technical processes. But when roll film or negative paper film manufactured on a continuous basis did not effect a conversion among pro-fessionals from glass plate to film, Eastman found a new and larger constituency for his mass produced film.

Having developed the resources for both supplying negative paper film on a large scale and employing mechanised printing techniques for prints and enlargements, Eastman developed a camera which would be simple to operate, and, hence, marketable to thousands of non-professionals; the latter, moreover, would both need the negative paper film and demand that the exposed film be developed, fixed and printed into finished positive images. What had been visible for hundreds of amateur photographers in the United States and Europe became an invisible process conducted in industrial laboratories for the thousands and then millions of Kodak

consumers. 'You press the button; we do the rest' became Eastman's watchword and a prominent advertising appeal. By combining strategies of mass production techniques and the purchase of patents to control the entire process from beginning to end, Eastman had brought 'the American System' to the photographic industry and created a mass market in amateur photography.[15]

C. Francis Jenkins, who patented the Phantascope or first American projector with Thomas Armat, wrote in 1920 that 'the process which will succeed is that which fits standard machines without change',[16] an observation which the Motion Picture Patents Company took to heart in making the patents of each member available to all. It was a hard-learned lesson for John Murdock, who sought to enter the film market from vaudeville through a series of innovations which were neither interchangeable with existing products nor mass produced widely enough to gain hegemony[17]. The necessity of interchangeable parts to service a mass market was evident in the field of amateur film-making equipment as well. Lack of standardisation among various amateur designs prevented their widespread diffusion. An array of film gauges and variance in the number of perforations prevented interchangeability among different cameras until 1923. Learning from the marketing experiences of amateur still photography, Eastman promoted the first complete amateur film system backed by manufacturing resources and an advertising expertise which surpassed Edison's unsuccessful attempts in 1912. Recognised almost immediately as the dominant producer of such equipment, Eastman established 16mm as the definitive gauge for non-professional film-making. A standardised sub-system of commercial cinema grew up alongside, manifesting the same demands of the marketplace.[18]

The degree to which film technology is indebted to other related manufacturing technologies remains to be explored, but a couple of examples may help to argue for further research. Intermittent motion was achieved through the use of a geneva gear, 'a gear found in many watches to prevent winding the spring too tight'.[19] W. K. L. Dickson explains the transition from cylinder to rolls of film rather elliptically as follows: 'I caught sight of his (Edison's) perforated paper automatic telegraph.'[20] Other historians, however, argue that Marey's photographic gun provided Edison with the suggestion.[21] Marey's gun itself offers an interesting point of comparison, used as it was to study the movement of animals, with

the machine or gattling gun[22] which John Ellis tells us first appeared commercially in the United States in 1861, although patents describing a rapid-fire automatic gun go back to Europe in the early eighteenth century.[23]

With regard to the standardisation of film products for marketing efficiency, several recent suggestions by film students have implied a spilling over of the standardisation principle from the physical characteristics of film (gauges, sprocket holes, emulsions, etc.) into film content. The surprisingly early development of guidelines for the writing of continuity scripts as they appeared in *Moving Picture World*,[24] and the use of such scripts to control production argue that standardisation made its way into film as a means of managing a production team if not as a structural element of narrative.[25] It may also be argued that standardisation as a principle of production and marketing coincided with or facilitated the drive to create an illusion of reality which requires standardised presentation in order to induce absorption into the illusion rather than have one's attention called to the illusion-creating process. The assumption of Motion Picture Patents Company businessmen that films could be regarded as undifferentiated one-reelers, interchangeable in exhibition and public reception, proved incorrect. But at least one film student has suggested that the trend from 'actualities' or short documentaries to brief humorous sketches, during film's vaudeville-sponsorship period, was less a response to loss of audience interest for the 'actualities' than an attempt to minimise product differentiation (hence audience response) and maximise product supply through studio-controlled production.[26]

The implications of this pervasive standardisation are discussed elsewhere in terms of the process of production as well as consumption. What can only be suggested here is that standardisation needs to be explored as a dominant principle firmly grounded in the socio-economic context of nineteenth-century industrialisation out of which film technology emerges.

A second closely related factor, worthy of examination in a study of the technology of the cinema, is the role of patents in directing and utilising innovation. In his study of American manufacturing methods of the nineteenth century, Paul Strassmann[27] discusses the tension between the promise of invention as a means of lowering the cost of production, thereby affording a competitive edge, and the cost of accommodating the industrial process to a change in machinery. Large-scale metal machines in the textiles industry, for

example, led to conservatism in the wish to keep machines uniform
and avoid scrapping. As early as 1835 the founding of new textile
machinery works by inventors became so expensive and difficult
that inventors had to persuade existing machine shops to adopt their
ideas rather than founding their own works.[28]

Other aspects of innovation in the film industry must be added to
this picture of an attempted balance between modification and
standardisation; for instance, the ability of patented inventions to
provide a patent monopoly serving both as a barrier of entry to
competitors and a means of collecting income through royalties.
Film manufacturers were quick to realise that the outright sale of
equipment would sizably diminish potential revenues in com-
parison with rental or licensing. Patent infringement suits, then,
were the legal weapon for the right to collect royalties, an example
which had been set in textiles. The light high-speed spindle, the
most important innovation between 1835 and 1880, cost the Whitin
Machine Works $2.8m in royalties. The company which owned the
patent, Draper, built up such a formidable patent pool that any
machine shop interested in promoting innovations along certain
lines had to cut the Draper Company in.[29]

Inventors in film technology, from their own account, appear to
be well aware of the functioning of such patent law in the creation of
a legal monopoly.[30] Their direction of invention is twofold: to refine
an earlier mechanism by expanding its marketing effectiveness and
to avoid the patent prerogatives of previous inventors. Edison's
work even before film, for Western Union, exemplifies his principle
of subordinating invention to commercial objectives. Western
Union had rejected the letters of patent for $100,000 that might
have given them a monopoly of the world's future telephone
industry. Such a move would have required heavy investment and
scrapping of present equipment. As Justice Louis Brandeis noted,
the large companies characteristically rejected electric light, the
telephone, and later radio. With the benefit of hindsight, however,
Western Union retained Edison at $500 per month to develop a
telephone mechanism that would circumvent Bell's patents.[31]

Similarly, innovation as a means of circumventing a patent
monopoly is suggested by W. K. L. Dickson's development of the
Biographic camera after he had been dismissed by Edison who,
ironically, anticipated just such a development.[32] C. Francis
Jenkins' 'Phantascope' offered a modification of the Edison kineto-
scope using Edison parts but adding a shutter sufficient to merit the

issuing of a separate patent.[33] The development of an acetate-cellulose film by Eastman Kodak arose in the context of nego-tiations with the MPPC and was viewed as an increased asset in raising the barriers of entry for non-MPPC members not privy to special contractual arrangements with Eastman as a supplier.[34]

David Noble documents the process in the late nineteenth century and early twentieth century of bringing scientific research and innovation under the auspices and control of corporate objectives. Formerly a means of protection for the *inventor*, who was granted a patent monopoly for 17 years, patents became a way of protecting the *companies* which employed inventors[35] (Edison's research laboratory and his relation to Dickson) or simply pur-chased and utilised the patents (Edison's purchase of the Armat–Jenkins patent for projection). The result is that innovation is stimulated and controlled by what will benefit the economic and competitive position of the company. The Edison/MPPC phase in the industrial development of film marks a transitional step from the entrepreneurial competition of the early years to the consolidation and conservatism of the MPPC. Like General Electric and Westinghouse, who by 1896 had more than 300 patent suits pending, the principal competitors in the film industry resolved their patents war in order to avoid infringement suits and costly royalties. But the degree to which cinematic invention may have depended upon (the establishment of) corporate control, as Noble suggests, remains to be explored.

In conclusion, I have suggested that i) the principle of standardis-ation which emerged out of American industrialisation in the early nineteenth century was a formative principle of invention in film's early development; and ii) technological development in the cinema should be examined in the light of several interrelated factors: among them are the cultural and socio-economic drives to maintain standardisation, to improve the possibilities of market competition, and to perfect the illusion of ideal representation.

NOTES

1. André Bazin, 'Le mythe du cinéma total', *Qu'est-ce que le cinéma?* vol. 1 (Paris: Cerf, 1958), pp. 21–6; translation 'The myth of total cinema', *What is Cinema?* vol. 1 (Berkeley: University of California Press, 1967).

2. C. W. Ceram (K. W. Marek), *Archeology of the Cinema* (New York: Harcourt, Brace and World, 1965).

3. S. C. Gilfillan, *The Sociology of Invention* (Chicago: Follett, 1935) and Abbott Payson Usher, *A History of Mechanical Inventions* (New York: McGraw-Hill, 1929) are among the better known and most frequently referred to.

4. Usher, op. cit., p. 64.

5. David F. Noble, *America by Design* (New York: Knopf, 1977), p. xviii.

6. Harold C. Passer, *The Electrical Manufacturers 1875–1900* (Cambridge, Mass.: Harvard University Press, 1953), p. 396.

7. Matthew Josephson, *Edison* (New York: McGraw-Hill, 1959), pp. 136–7.

8. Ibid., p. 138; see also Philip Alger, *The Human Side of Engineering* (Schenectady: Mohawk Development Service, 1972).

9. Noble, op. cit., p. 8.

10. Jean-Louis Comolli, 'Technique et idéologie' (I), *Cahiers du cinéma* no. 229, June 1971, p. 15.

11. Nathan Rosenberg, *Perspectives on Technology* (London: Cambridge University Press, 1976), p. 27.

12. Herbert G. Gutman, 'The reality of the rags-to-riches myth', in *Work, Culture, and Society in Industrializing America* (New York: Knopf, 1976), pp. 216–17ff.

13. Rosenberg, op. cit., p. 12.

14. Jeanne Allen, 'American lithography: industrialisation of visual mass culture', paper presented at the Center for Twentieth Century Studies, University of Wisconsin–Milwaukee conference on 'Technology and culture', November 1976.

15. Reese V. Jenkins, 'Technology and the market: George Eastman and the origins of mass amateur photography', *Technology and Culture* vol. 16 no. 1 (January 1975), pp. 1–19.

16. Raymond Fielding (ed.), *A Technological History of Motion Pictures and Television* (Berkeley: University of California Press, 1967), p. 12.

17. Jim Wiet, 'Theatre, vaudeville and film: a symbiotic relation turned aggressive', unpublished seminar paper, University of Wisconsin–Madison, Spring 1978.

18. Patty Zimmerman, 'Amateur motion picture apparatus 1897–1923: a history of the conception of the masses as producers', unpublished seminar paper, University of Wisconsin–Madison, Spring 1978.

19. Fielding, op. cit., p. 4.

20. Ibid., p. 10.

21. Reese V. Jenkins, *Images and Enterprise: Technology and the American Photographic Industry 1839 to 1925* (Baltimore: Johns Hopkins, 1976), p. 267.

22. I first heard this idea suggested by Ben Brewster during a conversation in Madison, April 1977.

23. John Ellis, *The Social History of the Machine Gun* (London: Croom Helm and New York: Pantheon, 1975), pp. 13, 25.

24. Everett McNeil, 'Outline of how to write a photoplay', *The Moving Picture World* vol. 9 no. 1 (July 15, 1911), p. 27.

25. Janet Staiger, 'Dividing labour for production control', unpublished seminar paper, University of Wisconsin–Madison, 1977.

26. Robert C. Allen, 'Vaudeville and film 1895–1915: a study in media interaction' (Ph.D. dissertation, University of Iowa, 1977).

27. Paul W. Strassmann, *Risk and Technological Innovation: American Manufacturing Methods During the Nineteenth Century* (Ithaca: Cornell UP, 1959), pp. 7–19.
28. Ibid., p. 103.
29. Ibid., p. 112.
30. Fielding, op. cit., pp. 15, 21.
31. Josephson, op. cit., p. 134.
32. Fielding, op. cit., p. 15.
33. Ibid., p. 17.
34. Jenkins, *Images and Enterprise*, pp. 287–8.
35. Noble, op. cit., p. 85.

Discussion

Jean-Louis Comolli A few remarks with regard to this question of the mass-production of objects, the manufacture of objects in series.

First, it can be noted that one of the earliest examples of the manufacture of objects in series is that of the printing of books, the example of the printing-press. There one has something that relates very interestingly to film – to the whole fact of the printing of copies.

The second remark is that it is at the moment when the mechanical eye of the camera, of the lens, can in some sort come to take the place of the human eye, decentring it, that the manufacture of objects can come equally to be done by delegation. There is a double delegation: the eye can see by delegation of the camera lens and, in the same way, man's hand can manufacture objects by delegation of the machine.

Finally, the third and last remark, this double delegation has a contradictory effect: on the one hand, it leads to a devalorisation or decentring of man's place in the process of his relation to things and the world; on the other, there exists at the same time for the subject a feeling of power through being thus able to assure its hold on reality precisely by machinery and beyond the machine, by science.

4. Towards an Economic History of the Cinema: The Coming of Sound to Hollywood

Douglas Gomery

In this paper I will focus on a major problem I find in histories of the cinema, formulate an alternative, and then develop the method I use, labelled 'industrial management', as far as I believe it can go.[1] My goal will be to provoke discussion and analysis of the relationship between economics and ideology in constructing a 'materialist history of the cinema'. I will focus on the coming of sound to Hollywood.

Like many others, Jean-Louis Comolli attacks 'idealist' histories of the cinema. In his essays 'Technique and ideology' he provides at least three objections: (i) such histories ignore 'economics as a major determining factor'; (ii) they seek a progression toward 'perfect forms'; and (iii) they try to reduce history to a series of firsts.[2] I agree. Yet in constructing his arguments about the economic determinants of the coming of sound to the American cinema, Comolli seems to have relied on those idealist histories he abhors. He thus continues to overemphasise the role of *The Jazz Singer* and concentrates on narrative feature films to provide his evidence.

Briefly, Comolli claims that Warner Bros used two feature films, *Don Juan* and *The Jazz Singer*, to open decisively the market for sound films. Only Fox receives credit for issuing 'some sound shorts'; he never mentions Hollywood's other major product of the period, newsreels.[3] From this evidence Comolli then sums up his argument concerning the economic factors of Hollywood's change to sound:

38

The technical apparatus of the talkies must be immediately productive in order to be profitable. It is costly: because there are markets to conquer under the fire of competition; because at the time that sound was developed, cinema was already a capitalist industry and there can be no question after fifteen years of profit of not making any more during a period of adaptation, leaving the industry the leisure to experiment with diverse formulas as had been the case in the early years of cinema. All the enormous apparatus of Broadway . . . furnished Hollywood with a material which was immediately consumable, diffusable, tested, and inexhaustible.[4]

Comolli has provided an important beginning. However, in order to obtain the materialist history of the coming of sound Comolli seeks, I think we should move away from 'firsts' like *The Jazz Singer* and examine all forms of Hollywood products. In terms of my method, I argue that shorts and newsreels were more important than features during Hollywood's transition to sound; such a re-focus, I further argue, asks us to examine the *process* of change—at least in economic terms.

I

In 1925, the American film industry was organised thus:

I. Three large monopolists: Famous-Players
 Loew's (MGM)
 First National
II. Six potential monopolists: Universal
 Fox
 Producers Distributing
 Corporation (PDC)
 Film Booking Office (FBO)
 Warner Bros
 United Artists
III. Forty-five small, 'independent' firms

This structure existed in terms of assets, sales and profits. Moreover the 'Big Three' were moving to eliminate all competition by increasing distribution to almost all the countries in the world and by purchasing first-run theatres in major United States, Canadian and European cities. Thus it remained for the six potential

monopolists either to challenge the 'Big Three', or cooperate and accept marginal profits like the independents, or possibly go out of business. By 1930 most of the independents were out of business, while Universal, United Artists, and Columbia were cooperating and making low profits. RCA took over PDC and FBO. Only Fox and Warner Bros were able to break into the monopoly groups; Warners even took over First National. Both Warners and Fox achieved status within the monopolists' group by expanding on all fronts: production, distribution and exhibition. I have written elsewhere of how such expansion took place.[5] Here I will examine how these two firms used sound shorts and sound newsreels as part of the policy to become monopolists.

Warners' initial strategy for sound was to record vaudeville and musical acts and distribute them at low prices to first-run theatres. 'Vitaphoned' shorts would simply replace the live entertainment which in 1925 was a vital part of the accepted strategy of performance for first-run theatres. First-run 'shows' opened with a musical overture, usually five minutes long. Live entertainment, lasting 20 to 25 minutes, followed. A newsreel, a short-subject film and the feature film filled the rest of the two-hour period. Indeed exhibitors would shorten the feature film, not the live entertainment, if a 'show' threatened to spill over the prescribed two-hour period. Large orchestras accompanied the newsreel, shorts, and feature films. Warner Bros figured sound films could eliminate the need for an orchestra and present the most famous live talent on film – all at a great saving for the exhibitors. Moreover, Warners would sign the labour – that is to say, the vaudeville acts and musicians – to exclusive contracts, capture all the monopoly profit, raise its overall profit rate, re-invest in production, distribution, and exhibition, and so challenge the 'Big Three'.[6]

Warners signed with Western Electric in June 1925, and immediately set up a separate subsidiary, The Vitaphone Corporation, to produce and sell sound shorts, and thus not to disrupt the continuity of other Warners' operations. By the end of 1925 Vitaphone had negotiated exclusive contracts with a large number of the major musical and vaudeville stars in the United States. The New York Philharmonic would provide the 'incidental' music.

In the first Vitaphone show in August 1926, Vitaphone recordings replaced the typical overture, live entertainment and short. There were seven 'numbers' in that first 'prelude'. In the opening

short Will Hays congratulated Warners for its pioneering effort. Hays bowed at the end, anticipating applause. Next, the New York Philharmonic played the overture; again, conductor Henry Hadley bowed at the end. Six musical 'acts' followed. Five originated in the concert stage; only vaudevillian Roy Smeck broke the serious tone. Marion Talley of the Metropolitan Opera opened the programme, followed by Smeck, violinists Misha Elman and Efrem Zimbalist, tenor Giovanni Martinelli, and finally soprano Anna Case, backed by the Metropolitan Opera Chorus. Martinelli's aria from *I Pagliacci* was the hit of the evening; he received a two-minute ovation. Warners' strategy of getting the most popular stars began conservatively; critics praised this technology which could bring fine classical music to larger audiences. For Warners the shorts cost on average only $12,000 to produce and generated universal praise as great 'recordings'. Few critics commented on the 'Vitaphoned' music which accompanied the feature, *Don Juan*; here the recorded orchestra simply replaced a live one.[7]

Following this initial success Western Electric pressured Warners to move quickly and place Vitaphone shows all over the United States, for this would enable Western Electric to sell the maximum amount of equipment. But Warners resisted; it wanted to sell movies, not sound equipment. Warners pursued a slower strategy in which Vitaphone would play only in a selected number of the large cities in the United States. The rented theatre need not be the largest, but should be a first-run house with costs which would permit Vitaphone to present its shorts *continuously* before the public for at least an entire season. Then, following that publicity, Vitaphone would gradually place shows in smaller, surrounding cities. By this time Vitaphone could have increased production so that any theatre could have a continuous flow of the 'Vitaphoned' entertainment. Using this method Vitaphone could construct the necessary production facilities and build up a staff experienced in making sound films. In October 1926 Harry Warner, president of Warner Bros, warned his counterpart at Western Electric:

> When it is all said and done, the public are not going to the theatre to see the instrument — they are going to see and hear the performance and you have to satisfy them. Whether you charge them ten cents or ten dollars, if the show does not satisfy, it is an assured failure. The public will only judge the Vitaphone by the performance which you give them with the Vitaphone.[8]

During the 1926–27 season Vitaphone pursued its 'shorts' policy. Soon after the *Don Juan* show, it replaced concert attractions with vaudeville stars. In an October 1926 show, two months after the *Don Juan* show première, Vitaphone presented an orchestra and vaudeville artists whom (according to *Variety* estimates) only the four largest motion picture theatres could have afforded to present live. The programme opened with an overture; *Variety* estimated the New York Philharmonic would cost $6000 per week. The Four Aristocrats were next at the cost of $1000 per week. Then came four of the most important vaudeville stars of their day; their total estimated cost was a minimum of $15,000 per week, probably closer to $25,000.[9] The first was George Jessel who did a short monologue and one song. Elsie Janis followed with four short songs, the last of which critic Mordaunt Hall of *The New York Times* found so convincing that 'one forgot all about the Vitaphone in listening to the distinct words of the songs . . . it was just as if Miss Janis were on the stage'.[10] Janis commanded $3000 per week. Eugene and Willie Howard followed with their comic vaudeville sketch. The top 'headliner' was Al Jolson who sang three songs, 'The Red Red Robin', 'April Showers' and 'Rock-a-Bye Your Baby', standing before a set of a Southern plantation. *Variety* predicted a bright future for an invention that could place so much high-priced vaudeville talent 'on one stage' at one time.[11]

Gradually Vitaphone signed exclusive contracts with nearly every available vaudeville star. It consciously followed the model provided by the Victor Phonograph Company. It wanted to make the Vitaphone trademark as famous as Red Seal was in its field. Consequently, Vitaphone spent a great deal on advertising. By February 1927, it had 50 vaudeville subjects on disc and was recording five shorts per week. Vitaphone hired an experienced vaudeville booker from Keith–Albee to sell the 'acts'. *Variety* began to review these shorts on 23 March 1927, and like all facets of the industry, treated the shorts as 'canned' vaudeville.[12] The acts ranged from comics to singers, to bands, even to recitations—the complete spectrum of 1920s vaudeville. In April 1927 Vitaphone signed the last major holdout, comics Weber and Fields. Yet from the beginning Jolson made the greatest number of shorts, and at the top wage—$5000 per short.[13]

For the next movie season Warners decided to create features with Vitaphoned sequences, and narrative shorts. For features Warners simply implanted musical numbers within the narrative of

a silent feature film. *The Jazz Singer* was the first. For shorts, according to the trade papers of the time, Warners produced narratives with 'advanced' camerawork and elaborate costumes and décor. On 4 December 1927 *Variety* praised a ten-minute narrative comedy, *My Wife's Gone Away*. This film was an adaptation of a vaudeville skit — a playlet; it contained no titles. Later in December Warners released *Soloman's Children*, a 20-minute drama. *Variety* found this film to be exceptional. During the winter and spring of 1927 and 1928 Warners produced and released an increasing number of part-talkie features and narrative shorts — all as unit shows. Simultaneously it built more sound studios, and trained more directors, engineers and other needed labour.[14]

During the spring of 1928 Warners' shorts strategy began to pay off. One package, including sound shorts and the sound version of *The Jazz Singer*, began to break box office records. In April the shorts production staff made a 'long' gangster playlet, *The Lights of New York*, which was released in July by Warners as its first all-sound narrative feature. Here I will stop. The rest of the history can be summed up as follows: Warners quickly moved to full-time production of all-sound features and shorts, reaped immense short-run profits from its temporary advantage in sound films, invested the money into new production facilities, distribution outlets and first-run theatres, and by 1929 was the most profitable American film company and a member of the industry's dominant monopoly. Warner Bros strategy of the gradual introduction of sound shorts was the key process by which it innovated sound.

II

Warners began earlier than its rivals, but soon its success spurred imitation. With about a year's lag, Fox at first simply copied Vitaphone's strategy. On 24 February 1927 Fox held its first demonstration and presented 'Movietoned' (Fox's trade name) recordings of a banjo act, a comic and three songs by vaudeville star, Raquel Mueller. Reporters for trade papers were not impressed; all found Warners' shorts far superior. Fox then abandoned this strategy and decided to develop an alternative, sound newsreels. Fox would hold a temporary advantage: Warners had no newsreel division. Moreover sound newsreels would provide Fox with a cheap method by which to develop needed production staff and facilities without disrupting normal operations. Fox Movietone

News would simply release sound and silent versions of all newsreels.

Fox premiered sound newsreels on 30 April 1927 at New York's Roxy theatre; the subject was the marching cadets of West Point. Lasting only four minutes, this sound newsreel drew an enthusiastic response from both the press and the public. On 20 May 1927, Charles Lindbergh left for Paris; that evening Fox Movietone News released a 'sound' newsreel of the take-off to New York's Roxy theatre. The capacity audience gave the newsreel a standing ovation. In June Movietone News recorded Lindbergh's reception in Washington. Both Mordaunt Hall of the *New York Times* and an unnamed *Variety* critic reported that this newsreel carried an otherwise weak Roxy show. During the summer, Movietone newsreel cameramen began to gather footage round the world. They recorded aviators, harmonica contests, Admiral Byrd, Al Smith and Benito Mussolini — the last in both Italian and English. Newspaper columnists and other commentators praised the educational value and noted the wide appeal of these newsreels. In the fall of 1927 Fox made sound newsreels the standard at all Fox-owned theatres. That October it set a regular release rate of one 'issue' per week. By the end of the year Fox Movietone News had a permanent staff of cameramen stationed throughout the world.

Following the favourable response, Fox slowly began production of vaudeville shorts and scored features, and pursued its sound newsreels more actively and aggressively. During the summer of 1928 Fox Movietone News increased its 'issues' to two per week, with 27 Movietone units covering the world. By September, it demanded and got long-term contracts from all exhibitors desiring Movietone News. Most chains signed up; only Paramount and Loew's had the resources to resist. Thus by the beginning of the 1928–29 movie season, Fox was reaping monopoly profits from sound films, re-investing this money and expanding in production, distribution, and exhibition, and thus becoming the fifth member of Hollywood's dominant monopoly. The gradual introduction of shorts — here newsreels — was the process by which Fox also proceeded, as an industrial concern, to innovate the new product — sound movies.[15]

III

In sum I have argued through an economic model that Warner Bros and Fox used shorts and newsreels to innovate sound. Success with

this and other strategies helped these medium-sized firms become monopolists. Gone, I hope, is the undue emphasis on *The Jazz Singer* and other firsts. The coming of sound was a much more complex process than simply filming Broadway plays, as previous histories have led us to believe. Vaudeville provided the subject matter; activities during 1925–28, usually regarded as 'pre-history', were most crucial.

Yet this is about as far as this economic model can go. I think my conclusions stand, given the assumptions and logic of the model I use. But are the assumptions Comolli and I use so different that my economic analysis really does not alter his major conclusions about technology, ideology and the coming of sound? Part of the problem is that until recently we could see only a handful of these shorts and newsreels, principally at archives. Thus trade papers had to serve as the next best source of information. Today the situation is little better for the Warners' shorts: most of them exist only in negative form — without sound discs — at the Library of Congress, a few — re-recorded later, sound-on-film — are at the George Eastman House and at the Wisconsin Center for Theater Research in Madison, Wisconsin. But the Fox newsreels are, or at least should be, all available now.

NOTES

1. See Edward Branigan, 'Colour and Cinema: Problems in the Writing of History', presented at the International Film Conference IV, The Cinematic Apparatus: Technology as Historical and Ideological Form, February, 1978, Milwaukee and to be printed in *Film Reader 4* (1979). It should be noted that Branigan outlines the 'industrial management' method as part of an argument by which to demonstrate the superiority of Comolli's approach and consequently, I think, presents a biased summary. My method originates from concepts of industrial organisation economics, best outlined in Frederick M. Scherer, *Industrial Market Structure and Economic Performance* (Chicago: Rand McNally & Co., 1970). Alfred D. Chandler employs this method in his history of US business, *The Visible Hand* (Cambridge, Mass.: Harvard University Press, 1977).

2. Jean-Louis Comolli, 'Technique et idéologie', six parts in *Cahiers du cinéma*, no. 229 (June 1971), pp. 4–21; no. 230 (July 1971), pp. 51–7; no. 231 (August–September 1971), pp. 42–9; no. 233 (November 1971), pp. 39–45; no. 234–5 (December 1971/January 1972), pp. 94–100; no. 241 (September–October 1972), pp. 20–4.

3. Comolli, no. 235, op. cit., pp. 99–100.

4. Comolli, no. 241, op. cit., p. 20.
5. J. Douglas Gomery, 'The Coming of Sound to the American Cinema: A History of the Transformation of an Industry' (Ph.D. Dissertation, University of Wisconsin–Madison, 1975), pp. 110–367.
6. Ben M. Hall, *The Best Remaining Seats* (New York: C. N. Potter, 1961), p. 208; Lewis W. Townsend and William W. Hennessy, 'Some novel projected motion picture presentations', *Society of Motion Picture Engineers Transactions*, XII (1928), p. 349; Maurice D. Kann (ed.), *The Film Daily Yearbook* (New York: Film Daily, 1927), p. 509; Eric T. Clarke, 'An exhibitor's problems in 1925', *Transactions of the Society of Motion Picture Engineers*, January 1926, pp. 36–55; *Variety*, 10 March 1926, p. 35; *Variety*, 1 April 1926, p. 36.
7. Will H. Hays, *See and Hear*ǀ (Hollywood: Motion Picture Producers and Distributors Association, 1929), pp. 48–9; *Moving Picture World*, 14 August 1926, p. 1; *Variety*, 11 August 1926, p. 10; *New York Times*, 8 August 1926, II, p. 6; *Moving Picture World*, 14 August 1926, p. 1; Koplan (Scharaf et al., Interveners) v. Warner Bros Pictures, Inc. et al., 19 F. Supp. 173 (1937), Record, pp. 1128–9; *Variety*, 11 August 1926, p. 5; *Variety*, 11 August 1926, p. 9.
8. General Talking Pictures Corporation et al. v. American Telephone and Telegraph Co. et al., 18 F. Supp. 650 (1937), Abel Cary Thomas deposition, exhibits, pp. 58–62; Gomery Ph.D., pp. 145.
9. *Moving Picture World*, 4 September 1926, p. 20; *Moving Picture World*, 18 September 1926, p. 174; *Variety*, 21 July 1926, p. 4; *Variety*, 8 June 1927, pp. 1, 48.
10. *New York Times*, 8 October 1926, p. 23.
11. *Variety*, 13 October 1926, pp. 1, 25; *Moving Picture World*, 18 September 1926, p. 174; *Moving Picture World*, 25 September 1926, p. 211; *Moving Picture World*, 9 September 1926, p. 340; *New York Times*, 8 October 1926, p. 23; *Moving Picture World*, 16 October 1926, p. 1.
12. *Variety*, 20 October 1926, p. 64; *Variety*, 30 March 1927, p. 12; *Variety*, 9 February 1927, p. 21; *Variety*, 23 March 1927, p. 14; *Variety*, 6 April 1927, p. 34; Electrical Research Products, Inc. v. Vitaphone Corporation, 171 A. 738 (1934), Plea, Exhibit D, p. 335.
13. *Variety*, 23 March 1927, p. 15; *Variety*, 6 April 1927, p. 31; *Moving Picture World*, 23 April 1927, p. 736; *Variety*, 27 April 1927, p. 27; *Moving Picture World*, 2 May 1927, p. 1; *Variety*, 13 April 1927, p. 30.
14. *Variety*, 7 December 1927, p. 36; *Variety*, 23 November 1927, p. 8; *Variety*, 21 December 1927, p. 11.
15. See Douglas Gomery, 'Problems in film history: how Fox innovated sound', *Quarterly Review of Film Studies*, vol. 1 no. 3 (August 1976), pp. 322–4 for a summary of Fox's activities.

5. Ideology and the Practice of Sound Editing and Mixing

Mary Ann Doane

The practices of sound editing and mixing to be considered here are those developed within the Hollywood studio system. 'System', should be understood in a rigorous sense as necessitating a certain amount of standardisation (with respect to techniques and machinery) and a relatively strict division of labour. Nevertheless, these practices have become 'normalised' to a large extent outside of that system — they have had enormous impact on the film-making industries of other countries, for instance, and on independent film-making activities as well. My assumption is that not only techniques of sound-track construction but the language of technicians and the discourses on technique are symptomatic of particular ideological aims.

It has become a cliché to note that the sound-track has received much less theoretical attention and analysis than the image. Yet the cliché is not without truth value and isolates, but leaves unexplained, a fact. This lack of attention indicates the efficacy of a particular ideological operation which is masked, to some extent, by the emphasis placed on the 'ideology of the visible'. While it is true that, as the expression would have it, one goes to 'see' a film and not to hear it, the expression itself consists of an affirmation of the identity (i.e. wholeness, unity) of the film and a consequent denial of its material heterogeneity. Sound is something which is added to the image, but nevertheless subordinate to it — it acts, paradoxically, as a 'silent' support. The effacement of work which characterises bourgeois ideology is highly successful with respect to the sound-track. The invisibility of the practices of sound editing and mixing is

47

ensured by the seemingly 'natural' laws of construction which the sound-track obeys.

The disregard of the sound-track on the level of theory, however, does not have its counterpart on the level of practice. Hollywood has recognised the extent to which the 'supplement', that is to say sound, can infiltrate and transform that which is supplemented. In an industry whose major standard, in terms of production value, might be summarised as 'the less perceivable a technique, the more successful it is', the invisibility of the work on sound is a measure of the strength of the sound-track. The publicity accorded to the activity of shooting a film is far more extensive than that given the 'backstage' processes involved in building a track.

A concentration on the ideological determinants of sound editing practices does not necessarily entail a denial of the significance of the 'ideology of the visible' stressed by Comolli and others. In a culture within which the phrase 'to see' means to understand, the epistemological powers of the subject are clearly given as a function of the centrality of the eye. Michel Marie has illuminated the degree to which the eye is posited as the ground of all knowledge in a discussion of the hierarchy of the senses established by Western civilization. Marie maintains that hearing is not as privileged as sight within that hierarchy — it is sight which becomes 'the royal road to the apprehension of the external world'.[1]

Nevertheless, bourgeois ideology cannot be reduced to a monolithic ideology of the visible. Behind the historical use of the cinema lies a complex of determinations whose very multiplicity guarantees the subtlety and pervasive nature of the ideology. While the notion that the eye is central places the subject in a certain position of knowing, the verb 'to know' does not exhaust the function of the subject in bourgeois ideology. Or rather, the concept of knowledge is split from the beginning. This split is supported by the establishment and maintenance of ideological oppositions between the intelligible and the sensible, intellect and emotion, fact and value, reason and intuition. Roland Barthes explains that:

> bourgeois ideology is of the scientistic or the intuitive kind, it records facts or perceives values, but refuses explanations; the order of the world can be seen as sufficient or ineffable, it is never seen as significant.[2]

The ineffable, intangible quality of sound — its lack of the concrete-

ness which is conducive to an ideology of empiricism — requires that it be placed on the side of the emotional or the intuitive. If the ideology of the visible demands that the spectator understand the image as a truthful representation of reality, the ideology of the audible demands that there exist simultaneously a different truth and another order of reality for the subject to grasp.

The frequency with which the words 'mood' or 'atmosphere' appear in the discourse of sound technicians testifies to the significance of this other truth. Most apparent is the use of music tracks and sound effects tracks to establish a particular 'mood'. In *The Technique of the Film Cutting Room*, Ernest Walter describes this practice:

> Music is used to create an atmosphere which would otherwise be impossible. . . . Just as the sound editor assembles his sound effects to create an almost musical effect in some sequences, so the music composer creates the instrumental background, to become at times an additional sound effect in itself. Often, it is an augmented effect blending with a dialogue scene so that one is almost unaware of its musical presence yet, adding so much to the value of the scene.[3]

The 'value' alluded to remains unexplained. On this question the writer must be mute, inarticulate — precisely because the concept is inaccessible to language, to analysis or to intellectual understanding. Sound is the bearer of a meaning which is communicable and valid but unanalysable. Its realm is that of mystery — but mystery sanctioned by an ideology which acknowledges that all knowledge is not subsumed by the ideology of the visible, allows a leakage, an excess which is contained and constrained by that other pole of the opposition which splits knowledge and emotion, intuition, feeling. However, one cannot deny the remarkable powers of sensuality and mystery attributed to the image as well as the sound-track or the use of dialogue to guarantee intelligibility. The image and the sound-track are both subject to an ideological overdetermination. Nevertheless, what sound adds to the cinema is not so much the intelligibility as the presence of speech — banishing its absence in the mode of writing, in the intertitles which separate a character's speech from his or her image. The techniques applied in the construction of a sound-track do not partake of the neutrality of a 'pure science'. But neither do they function simply to reinforce a

unitary ideology of the visible. While sound is introduced, in part, to buttress this ideology, it also risks a potential ideological crisis. The risk lies in the exposure of the contradiction implicit in the ideological polarisation of knowledge. Because sound and image are used as guarantors of two radically different modes of knowing (emotion and intellection), their combination entails the possibility of exposing an ideological fissure — a fissure which points to the irreconcilability of two truths of bourgeois ideology. Practices of sound editing and mixing are designed to mask this contradiction through the specification of allowable relationships between sound and image. Thus, in the sound technician's discourse synchronisation and totality are fetishised and the inseparability of sound and image is posited as a goal. The 'joy of mixing', according to one sound editor, lies in watching the emergence of 'something organic'.[4] Editor Helen Van Dongen acknowledges the existence of similar goals in her own work:

> Picture and track, to a certain degree, have a composition of their own but when combined they form a new entity. Thus the track becomes not only an harmonious complement but an integral inseparable part of the picture as well. Picture and track are so closely fused together that each one functions through the other. There is no separation of *I see* in the image and *I hear* on the track. Instead, there is the *I feel, I experience*, through the grand-total of picture and track combined.[5]

It is no accident that in the language of technicians, sound is 'married' to the image.

Symptomatic of this repression of the material heterogeneity of the sound film are the practices which ensure effacement of the work involved in the construction of the sound-track. Cuts in the track are potential indicators of that work. In the editing of optical tracks, it was discovered that the overlapped lines of a splice caused a sharp noise in playback. The technique of 'blooping' was developed to conceal what could only act as an irritating reminder that syntagmatic relationships are not 'found' or 'natural' but manufactured. Blooping is the process of painting or punching an opaque triangle or diamond-shaped area over a splice and results in a fast fade-in, fade-out effect. In the editing of magnetic film, it is paralleled by the practice of cutting on a diagonal. The ideological objective of these techniques doubles that of continuity editing —

the effect desired is that of smoothing over a potential break, of guaranteeing flow. Abrupt cuts on music or sound effects are avoided in favour of the homogenising effects of the fade or dissolve. Obviously repetitive sounds in loops are labelled 'irritating'.[6] Since the absence of sound would signal a break in an otherwise continuous flow, it has become a major taboo of sound-track construction. When there are no sound effects, music or dialogue, there must be, at the very least, room tone or environmental sound. Ernest Walter's prescriptions for sound in the screening of rough cuts indicate the extent to which the values of continuity and fullness govern techniques:

> It can be very disturbing to all concerned [in the screening of rough cuts] when the sound-track of sequences incorporating mute shots suddenly goes dead on the cut. It is better to incorporate even a temporary sound effect to cover these shots so that the normal flow of sound is uninterrupted.[7]

'Normality' is established as a continuous flow, and the absence of sound, in the language of the sound technicians, is its 'death'. When a sound-track goes 'dead on the cut', the transgression is one of a theological nature. 'Death' and 'life' are consistently metaphors associated with sound. A room or stage with low reverberation potential is 'dead' and in post-synchronisation, reverberation must be added to give 'life' to the recording. Sound itself is often described as adding life to the picture. And the life which sound gives is presented as one of natural and uncodified flow.

This illusion of an uncodified flow is also supported by the practice of staggering cuts. Only in exceptional cases are sound and image cut at exactly the same point. The continuation of the same sound over a cut on the image track diverts attention from that cut. Similarly, the process of mixing is characterised by 'a work of unification, homogenization, of a softening and polishing of all the "roughnesses" of the soundtrack'.[8] All of these techniques are motivated by a desire to sever the film from its source, to hide the work of the production. They promote a sense of the effortlessness and ease of capturing the natural.

What is concealed is the highly specialised and fragmented process, the very bulk and expense of the machinery essential to the production of a sound-track which meets industry standards. Direct sound, the sound which is recorded during shooting, consists only of

dialogue and some sound effects. Most of the sound effects and the music are recorded later and this necessitates the establishment of specialised departments within the studio structure. Dialogue which is not recorded on location or which is marred by background noise is post-synchronised. The stratification, the continual sub-division which the sound track undergoes, is aligned with the aim of sustaining a rigid hierarchy of sounds. Because the microphone itself, whether omni-directional or uni-directional, is not sufficiently selective, because it does not guarantee that the ideological values accorded to sounds and their relationships will be observed in the recording, the expensive mixing apparatus which will enforce that hierarchisation is standardised. Dialogue is given primary consideration and its level generally determines the levels of sound effects and music. Dialogue is the only sound which remains with the image throughout the production — it is edited together with the image and it is in this editing that synchronisation receives its *imprimatur* as a neutral technique through the sanction of the moviola, the synchroniser, the flatbed. Sound effects and music are subservient to dialogue and it is, above all, the intelligibility of the dialogue which is at stake, together with its nuances of tone. The hierarchy observed in mixing reinforces, in Comolli's terms, the identification of 'discourse and destiny' in Hollywood fictions and the concept of the 'individual as master of speech'.[9] The notion that sound dissolves or fades applied to dialogue are 'unnatural', expressed in a 1931 article on re-recording,[10] indicates a desire to preserve the status of speech as an individual property right — subject only to a manipulation which is not discernable.

The need for intelligibility and the practice of using speech as a support for the individual are both constituted by an ideological demand. Yet, it is an ideological demand which has the potential to provoke a fundamental rent in the ideology of the visible. This potential finds expression in the arguments concerning sound perspective which appear with regularity in the technical journals of the early 1930s. If sound is used simply to confirm the ideology of the visible, to reassert the notion that the world *is* the same as it looks, it necessarily encroaches upon that speech which *belongs* to the individual, defines and expresses his or her individuality, and distinguishes the individual from the world. In the arguments over sound perspective, 'realism' (as an effect of the ideology of the visible) is viewed as conflicting with intelligibility. If the demands of sound perspective are respected (that is, close-up sound 'matches'

close-up picture, long-shot sound 'matches' long shot picture), at a certain apparent camera – subject distance intelligibility of dialogue is lost. The problem is similar to that of the relationship between dialogue and background sounds or sound effects. For instance, in a shot involving a couple conversing, in a large crowd, the mimetic power of the crowd noise is generally reduced in favour of the intelligibility of the dialogue. The compromises made in favour of intelligibility indicate an ideological shift within the rationale of 'realism'. The Hollywood sound film operates within an oscillation between two poles of realism: that of the psychological (or the interior) and that of the visible (or the exterior). (While it is true that interior states are often depicted through *mise-en-scène* as well as facial expression, this representation is less 'direct' than that of speech—it must operate a displacement. And it is precisely the presence-to-itself of speech which is valorised). The truth of the individual, of the *interior* realm of the individual (a truth which is most readily spoken and heard), is the truth validated by the coming of sound. It is the 'talkie' which appears in 1927 and not the sound film.

The fact that sound perspective poses a significant problem in the early 1930s, however, requires further explanation. If the individual within the film is defined by his or her words, this does not automatically guarantee a position for that other individual — the spectator. Renaissance perspective and monocular vision organise the image which positions the spectator as the eye of the camera. But that position is undermined and placed in doubt if the apparent microphone placement differs from that of the camera and fails to rearticulate the position. In the first years of sound film production, a number of microphones were spread around the set and their signals mixed during shooting in a monitor room to attain consistent quality and intelligibility of speech. In 1930 a writer complains that this technique results in dialogue scenes in which

> quality and volume remain constant while the cutter jumps from across the room to a big close-up. At such times one becomes conscious that he is witnessing a talking picture, this condition indicating that the illusion has been partially destroyed at that point.[11]

The effect of spatial depth conveyed by the image is destroyed, and it is this illusion of a certain perspective and a certain spectator

position which is broken by the early sound films.

The astonishment at hearing actors speak and the captivation of the experience of the synchronisation of word and image conceal for a time the fragmentation of a position, the splitting of the senses which characterises the spectator's reception of the spectacle. In a 1930 article entitled 'The Illusion of Sound and Picture', John Cass describes the body of the spectator posited by the early sound film:

> When a number of microphones are used, the resultant blend of sound may not be said to represent any given point of audition, but is the sound which would be heard by a man with five or six very long ears, said ears extending in various directions.[12]

This confusion of the body is the consequence of another confusion on the level of the different media. The realm of sound recording is initially that of the radio industry, the phone industry, and of electricians. For the film technician and the director of the early thirties sound is the mysterious province of a group of specialists. A writer in the *Journal of the Society of Motion Picture Engineers*, Joe Coffman, places the blame for complex microphone systems and the resultant lack of sound perspective on the intrusion of the radio industry:

> In some ways it is unfortunate that the radio industry supplied most of the sound experts to the film industry. In radio broadcasting it usually is desirable to present all sounds as coming from approximately the same plane — that of the microphone. And so levels are raised and lowered to bring all sounds out at approximately the same volume, the microphone being placed as near as possible to the source of sound. But in talking picture presentations, it is very desirable to achieve space effects, and dramatic variation of volume level.[13]

The crucial difference between radio and film is posited as the image — the image which anchors the sound in a given space. Coffman makes a suggestion which is very close to that given in current handbooks of film-making: use one microphone, position it, set the levels, and do not readjust them during the recording. In 1930 Western Electric moving-coil microphones and RCA velocity microphones were made available to the industry, simplifying microphone boom construction.[14] The action on the set was more

easily followed and the maintenance of sound perspective ensured. The presentation of all sounds as being emitted from one plane could not be sustained. For the drama played out on the Hollywood screen must be parallelled by the drama played out over the body of the spectator — a body positioned as unified and non-fragmented.

The visual illusion of position is matched by an aural illusion of position. The ideology of matching is an obsession which pervades the practice of sound-track construction and demands a certain authenticity of the technique. A 1930 article on dubbing assures audiences that dubbing is not faking, because no matter how many times the sound is reproduced it remains 'the actual voice of the person speaking in the picture'.[15] The standard of authenticity is most intensively applied with the voice, and different standards restrict the uses of non-motivated music and sound effects. Their validity is guaranteed by dramatic logic. Karel Reisz describes a scene from *Odd Man Out* in which the footsteps of men robbing a mill become louder as they get nearer their objective — despite the fact that they are further from the camera than in preceding shots. Reisz cites this scene as an example of the deviations from natural sound perspective which 'are justifiable when the primary aim is to achieve a dramatic effect'; the rhythmic beat of the mill 'makes the sequence appear intolerably long-drawn-out, almost as if we were experiencing it through the mind of a member of the gang'.[16] Music as well is used to match the 'mood' or action of a particular scene. When the principle of mimesis is not strictly observed on the level of the represented world (for instance, in the case of non-motivated music or sound effects which are non-analogical), that principle is carried over to the level of matching different material strata of signification. Sound and image, 'married' together, propose a drama of the individual, of psychological realism. 'Knowledge' of the interior life of the individual can be grounded more readily on the fullness and spontaneity of his or her speech doubled by the rhetorical strategies of music and sound effects (as well as *mise-en-scène*). The rhetoric of sound is the result of a technique whose ideological aim is to conceal the tremendous amount of work necessary to convey an effect of spontaneity and naturalness. What is repressed in this operation is the sound which would signal the existence of the apparatus. For it is the opposition of sound (audible vibrations of air which have a communication purpose) to noise (the random sounds of the machinery — these lack meaning) which has determined so many technical developments in sound recording.

The techniques of sound editing and mixing make sound the bearer of a meaning — and it is a meaning which is not subsumed by the ideology of the visible. The ideological truth of the sound-track covers that excess which escapes the eye. For the ear is precisely that organ which opens onto the interior reality of the individual — not exactly un-seeable, but unknowable within the guarantee of the purely visible.

NOTES

1. Michel Marie, 'Son', in Jean Collet et al., *Lectures du film* (Paris: Albatros, 1975), p. 206.
2. Roland Barthes, *Mythologies* (London: Cape, and New York: Hill and Wang, 1972), p. 142.
3. Ernest Walter, *The Technique of the Film Cutting Room* (New York: Focal Press, 1973), p. 212.
4. Walter Murch in an interview by Larry Sturhahn, 'The art of the sound editor: an interview with Walter Murch', *Filmmakers Newsletter* vol. VIII no. 2 (December 1974), p. 25.
5. Helen Van Dongen, quoted in Karel Reisz, *The Technique of Film Editing* (London and New York: Focal Press, 1964), p. 155.
6. Walter, op. cit., p. 208.
7. Ibid., p. 128.
8. Marie, op.cit., p. 203.
9. Jean-Louis Comolli, 'Technique et idéologie' (6), *Cahiers du cinéma* no. 241 (September–October 1972), p. 22.
10. Carl Dreher, 'Recording, re-recording, and editing of sound', *Journal of the Society of Motion Picture Engineers* vol. XVI no. 6 (June 1931), p. 763.
11. John L. Cass, 'The illusion of sound and picture', *Journal of the Society of Motion Picture Engineers* vol. XIV no. 3 (March 1930), p. 325.
12. Ibid.
13. Joe W. Coffman, 'Art and science in sound film production', *Journal of the Society of Motion Picture Engineers* vol. XIV no. 2 (February 1930), pp. 173–4.
14. James R. Cameron, *Sound Motion Pictures* (Coral Gables: Cameron Publishing Company, 1959), p. 365.
15. George Lewin, 'Dubbing and its relation to sound picture production', *Journal of the Society of Motion Picture Engineers* vol. XVI no. 1 (January 1931), p. 48.
16. Reisz, op. cit., p. 266.

Discussion

Jean-Louis Comolli I should like to make a point in connection with the paper by Mary Ann Doane, a point that concerns the intelligibility of dialogue in the dominant system of cinema. Why is it that the intelligibility of dialogue is so important a technical problem, demanding so much care and attention on the part of the sound engineer? It is not simply in order that the dialogue be clearly understood by the spectator, it is also, more interestingly, for reasons relating to the co-presence of the characters and the spectator. In fact, the intelligibility of the dialogue allows these words and voices to be heard as though one were there with them; there is a direct interpellation of the spectator who is set on the stage on which the dialogue takes place. What is interesting is the way in which this completely abolishes both the technical mediations that are what precisely render possible this kind of dialogue *in absentia*, which is the typical dialogue of representation, and, equally, the real space-time of any communication, a communication always being simultaneously mediated and disturbed by space-time – as I speak to you, for example, my voice is involved in a certain effort to reach you, there is a work of the body against the resistance of the matter of space, air, and so on. All this is abolished in the dominant system of Hollywood representation so as to give the impression of a co-presence, a coexistence of the spectator and the characters on the screen. Thus it is not only sound, the sound-track, that is in question here; it is also, conjointly, the very system of filming, the choice of angles, the order and editing of shots; and, very precisely, the system of shot/reverse shot which functions to bring the spectator into the scene, making him or her the third person in the dialogue.

Peter Wollen I want to try to bring together some comments on Douglas Gomery's paper with some on Mary Ann Doane's in relation to what has just been said, moving from the classic sense of 'economy' to its other sense in discussion of the position of spectator.

Addressing Gomery then, I should like to defend the importance

of *The Jazz Singer* which, I think, has rightly become the legendary moment in the history of the coming of sound. You picked out two things which are crucial as far as the economics are concerned. First, Western Electric wanted to sell equipment. To understand the economic history of the film industry, one always has to go outside the film companies themselves to the people who are selling equipment and the aim of Western Electric was clearly to sell their equipment to every cinema. Second, the aim was precisely to sell to the exhibitors, every cinema, not only to the producers, Warners; the major incentive to the exhibitors being that sound would replace orchestras and live entertainment, the cost of re-equipping the cinemas offset by the large saving on the costs of hiring musicians and artists. However, it is clear that it was only a certain type of cinema, major inner-city cinemas, which had a whole orchestra and expensive live entertainment; in the smaller cinemas the saving in labour costs, hiring live entertainment, would be much less. Therefore, if sound was to spread throughout the whole cinema system, it was the main attraction which had to be replaced, the feature film itself. Hence the importance of *The Jazz Singer*. . . . The important thing was the decision to go over to the feature fiction film with sound, something which involves huge conversion costs for the producers, questions of a new balance of profits. . . .

Douglas Gomery Two points of disagreement. The first concerns the importance of the inner-city cinemas. In the United States and most of Western Europe, the first-run system was the cornerstone of the monopoly that Hollywood achieved. First-run cinemas generated 65 to 70 per cent of the revenues; we may be talking about only 2000 out of 18,000 cinemas but we are also talking about 70 per cent of the gross revenue, which is what I assume Hollywood considered. The second point concerns the way in which you make the feature film the main attraction, which is one of the things I tried to demystify in my paper. In fact, the feature film was not the main attraction; most of the first-run cinemas were very dependent on the stage show in the 1920s and would cut the length of the feature film rather than the entertainment; the feature film was important but not the most important.

Wollen But from the point of view of Western Electric, who wanted to sell the equipment, the box office is not the major factor, that being the number of cinemas.

Gomery I agree that the studio conversion cost was not the central issue. The central issue was the conversion of cinemas. However, the cinemas converted first were the first-run cinemas – contracts sold to Paramount who owned a thousand cinemas, most of which first-run, then to the Loew's cinemas, and so on – because these were the large contracts that Western Electric could obtain from the very distributors and producers who also owned the cinemas.

Wollen My argument is not that Western Electric did not want to sell to first-run theatres first, which are obviously the place where they would make their breakthrough, but that they would clearly have an aim of selling to all theatres, both in order to maximise profits and to get there ahead of competitors. To reach all the theatres needs more than being able to replace the labour costs involved in the orchestra and the live entertainment; it involves being able to produce sound feature films, though I agree partly with what you say when you stress that the feature film was not the main attraction: in fact, it is the coming of sound which turns the feature film conclusively into the main attraction.

The question I want to move towards is that as to why the feature film is turned into the main attraction, giving, as they would have seen it, an 'improved product', making it worthwhile to go through the various re-conversion and write-off costs. What was it that made of the sound feature film the improved product? I want to give something of an answer in terms of realism and representation, which brings us round to the discussion initiated by Mary Ann Doane. When sound came in, there was a kind of trade-off: some things available with silent film went—location shooting, for instance, which is in itself a kind of guarantee of realism; other things now became possible, such as dialogue, which is only another kind of guarantee of realism. Thus there is a displacement in which some sources of pleasure are lost and other sources of pleasure are gained. The point made about co-presence is very important but the question is not just one of realism and representation, it is also one of the presence of the spectator. The transition to sound has to be seen in terms of the way in which the role or place of the spectator changes, changes from being a spectator watching the action to being in the role of 'invisible guest'. The position of the spectator as 'invisible guest' seems to be something which comes with dialogue and that effect of co-presence, and this should lead us to re-think what we mean by the imaginary. On the whole, the imaginary is

discussed in terms of the visual; but if we go back to Lacan and the mirror phase, the scene in front of the mirror is not a silent scene, is a scene in which there are the words of the mother and the crowing of the child. I think that it is very important to realise that sound can relate to the imaginary; we can perhaps consider more complexly the concept of the imaginary once we get away from fixation of the imaginary purely on the visible.

6. The Post-War Struggle for Colour

Dudley Andrew

Current 'technology and ideology' studies have warned us about depending on 'invention' as an explanation either of a process or of its use in the history of cinema.[1] Instead we have begun looking at the interplay of macroeconomics, the economics of the film industry, the ideology which forms that industry and informs its products and the effects of this ideology and this economy on the investments of i) industry, ii) research areas and iii) spectator desire.

The purpose of this more complicated approach is to avoid any sort of simple empiricism which stops its investigation at the surface phenomenon (that is to say, the invention itself or its first aesthetic use) as well as to avoid the idealism which sees in the history of technology and of the aesthetics of cinema an unwritten design progressively worked out over time. A materialist analysis wants at once to go behind these events to their place in larger systems and to make those systems responsive to an actual 'material' history which can never be thought of as 'precast'. While the terms of analysis and the systems they belong to are reasonably constant, the unfolding of history itself cannot be thought of as constant without falling into 'vulgar Marxism'.

Recent undertakings of the technology/ideology/film history sort have in practice, however, often adopted a kind of idealism of their own, in that the relation between the factors in any given instance is too often treated as 'pre-known'. An invention and its early use is invariably shown to result from a given ideological pressure fostering, and fostered by, an economic practice.[2] While this simple scenario may hold true in a general sense, the complications arising in actual situations greatly reduce its explanatory power.

One of the complicating factors most difficult to incorporate in

historical analysis is the ideological discourse associated with the given event. Things are simpler when the historian need deal only with the technological issues of an invention, the seemingly autonomous realm of economics, and the styles and genres of films coming into production in relation to the invention. But not all developments and eras are so mute. What happens when the brute issues of technology, economics and film praxis interact with a contemporaneous discourse about the ideological implications of change? Can this effect the change? Discourse is surely a social *fact*, but should we also treat it as an historical *factor*?

The struggle for colour in post-war France took place within just such a self-conscious discourse. It was an era of international suspicion, one in which no historical development was treated as 'natural' or 'inevitable'. Did the discussion of the ideological implications of technology have any effect on the situation at all? It is my view that (in this example and in most others) the routine analysis of technology, economics and style must be supplemented by a consideration of the stated hopes and fears of those affected by the change. It is all too easy for today's historian to define ideology as completely hidden, thereby discounting all but the mechanical interplay of forces in history. I hope to show that the ideological aspect of technological change is not a recent discovery and that the development of colour in France occurred within, and was possibly altered by, the meditations of a culture upon its fate.

Although discussions of colour technology in cinema go back to the nineteenth century and although histories of that technology can devote scores of pages to processes and inventions during the silent age,[3] colour is normally considered to be a development of the thirties. Three-colour Technicolor became commercially viable around 1935, just after every national cinema had converted to sound. It is as though cinema needed continued technological upheaval for its economic, if not its aesthetic health.

Any standard analysis of the economics of this technological shift runs quickly into a historical blockade, namely World War II. In the specifically continental context, one might have expected to witness the same struggle between the Germans and Americans that had occurred over the dissemination of sound apparatus in the first years of the thirties. Indeed both Technicolor and Agfacolor launched propaganda campaigns as preparation for European control.[4] But such industrial conflict was soon overwhelmed by the

military hostilities of 1939–45. While inventors continued to perfect colour methods during this period, encouraged and funded by the military in connection with its demand for improved reconnaissance film systems, industrial competition for an international marketplace ceased and even domestic competition relaxed.

When 'normal international commerce' recommenced in 1945, the French thought that they would now have to deal with an already perfected technology. To some extent this was reassuring, for they would not be at the mercy of inventors and short-term economic battles, two factors which had made the coming of sound to France particularly traumatic. Indeed there was an assumption that the natural colour sense and good taste of the French would permit them to choose one or another foreign process and put it to uses never before imagined;[5] the apparent choices available at the time were Technicolor and Agfacolor.[6]

Aside from its leading position in colour since the twenties, Technicolor had behind it the enormous prestige of the USA. Agfacolor, on the other hand, was a process without even a viable industrial, let alone national, support. And so it would seem that the French solution ought have been to encourage Technicolor to establish itself in Paris and then to outdo the Americans with their own technology. But this simple solution neglects the broader framework of the political climate of the time as well as the physical limits of Technicolor growth.

Despite their image as saviours of Western civilisation, the Americans were feared and distrusted by many elements of the French populace. In the world of cinema both right and left-wing factions had reason to speak up against the extent of the American presence in Europe. The left-wing naturally was hoping for a Russian solution or a French solution based on Russian ties. They felt France to be an occupied country and loathed the economic net US industry was able to weave in every sector of French life, notably in their second largest industry, the cinema.[7] The right-wing was comprised of two segments, capitalists and nationalists. The nationalists were, of course, opposed to every kind of intervention; the capitalists opposed those interventions which were disadvantageous to them.

One need only mention the number of American films poised off the Normandy beaches in 1945 to account for the general and uniformly hostile French reaction. Since the 1941 embargo, 1800 movies had been made in Hollywood, all awaiting a chance to

compete for however many francs the French could or would spend on entertainment.⁸ The French industry expected to be saved by a strong quota system such as the one which protected them before the war when their home industry reached an economic and artistic peak from 1937–9. But in 1946 the film industry was betrayed. In the reorientation of macroeconomic policy which followed the war the French government found it necessary to allow a large amount of US investment to enter the country. They then planned to block a percentage of profits from leaving, thereby increasing the overall amount of capital available in France and, hopefully, the chances for growth and for the employment of the two million men returning from Germany.

The actual agreement in the motion picture sector, known as the Blum – Byrnes accord, forced all theatre owners to exhibit French products four of every thirteen weeks, the other nine weeks being designated as a free competition period. As might be expected the Americans won this competition hands down and without much regret. The French industry, the Americans insisted, had had the benefit during the war of no foreign competition. It was generally felt that many new French directors and other professionals had been drafted into the movie business because the war created such a vacuum of talent. Therefore, reasoned the Americans, the losses suffered by the French in free competition after the war were not only fair recompense but would in fact purify their industry of all but the worthy talents.

The pomposity of this attitude angered Frenchmen at all levels. Only about 50 films per year were needed to fill the 16 weeks reserved for the French product, whereas their studios, once modernised, could handle over 200. But there was little question of modernised studios being developed in such a depressed production situation. And most important for our consideration, there was little or no hope for an indigeneous French colour film industry. It simply cost too much and the only group capable of financing such a subindustry, the distributors, seemed content to buy foreign colour films and exhibit them in France as almost novelty items. Hence French production languished in semi-depression until 1949.

Given this context, few Frenchmen welcomed Technicolor as a solution to their problems. Technicolor not only meant the importation of a US-patented process, but also of extensive aesthetic controls. Not only would Americans be deciding which French films could be shot in colour, but they would insist on their own camera

operators and their own 'colour consultant' to help regularise the product. Technicolor, in other words, saw itself not as a process but as a product, and the company took pains that the product should maintain a distinct and distinguished look.[9] No French art director wanted to submit to colour specifications dictated by American technicians.

But what were the alternatives? A national process would have pleased everyone and some people held out hopes for just this. The French had long been engaged in colour film research. Aside from a Technicolor derivative called Chimicolor which used a beam-splitting camera, the most important processes were additive ones, Rouxcolor and Thomsoncolor. Indeed these two processes were responsible for the very first French colour features, Tati's *Jour de Fête* and Pagnol's *La Belle Meunière* (both 1948).

Thomsoncolor was a lenticular process involving the addition of a beaded coat of embossed prism particles on the base of the film. During the thirties, lenticular processes vied with subtractive processes and much research was carried out in both fields in America as well as in Europe. But Americans soon abandoned the lenticular option and left the field open to French inventors who made progress during the war. In 1945 they received British financial backing and moved toward a finished product. An embellished use of black and white film, the lenticular process was cheap and therefore considered ideal for European films which were always budgeted well below Hollywood's pictures. *Jour de Fête* came in for $36,000 total, astonishing American producers. It was generally felt that a film had a maximum earning power of $100,000 in France but that the mere fact of colour virtually doubled that maximum. *Jour de Fête* was therefore carefully watched.[10] Unhappily Thomsoncolor failed as the embossed lenticles separated from the base. Fortunately Tati had take the precaution of shooting the film simultaneously in black and white, and the film is shown today without colour. Lenticular processes, based as they are on minute 'double focusing', inevitably encounter difficulties in colour resolution, particularly as the lenticles wear down over time. More important, there was simply no acceptable way of making standard colour prints from the additive originals.

The Roux process received even more public attention but was no more successful. Since 1931 Armand Roux had tried to perfect a colour system based on the filtration of black and white images. His method was to attach a master module to the camera consisting of

four mini-lenses filtering for red, blue, green and yellow respectively. Each 35mm frame was actually a composite of four 16mm black and white images. When the same module was attached to the projector, the image would be reconstituted in colour.[11]

The US Government had attempted to exploit a similar process during the war for aerial photography. Known as Thomascolor it achieved neither enough technical perfection (it used only three colour filters) nor enough private support to rival laboratory processes. But Armand Roux managed to take some magnificent demonstration footage with his four-filter module and, backed by an enormous advertising campaign, made France forget its poor start with *Jour de Fête*. When Pagnol saw Roux's demonstration he completely re-shot *La Belle Meunière* with the new lens attached to his camera. This film was given tremendous promotion once again because it demonstrated the economy of the French colour systems. The average Technicolor film in 1948 cost nearly $800,000 whereas a Rouxcolor film could be produced for the cost of any black and white film.

Roux originally planned to rent his lenses to theatres but subsequently began to sell them at about $500 each. Late in 1948 it appeared to him that he had cornered the national market and could hope to export his process.[12] But Rouxcolor's momentary success was never deeply rooted. It was the result, first, of a cinema industry on the rebound which was seeking for ways to enhance the look of its product and, second, of a colour vacuum in Paris at the time. Even at its best the filtration and reconstitution of images made on black and white film suffered from two irremediable problems. The first was a red fringe on the top and bottom of the projected image. The second was the loss of definition attending any 16mm image blown up in a large theatre, for the Roux process necessarily worked with one quarter of the normal photographic image area. While such a system may be suitable for industrial film or today for television, in 1949 colour films were destined for the largest theatres and the 16mm format was painfully inadequate, at least as a final solution.

The final solution would certainly involve subtractive systems and the French, after four years of occupation and relatively little prior research, had to depend on foreign laboratory processes for this. In 1945 this meant Technicolor or an Agfa-type film.

The most complicated and expensive of subtractive processes,

Technicolor virtually blackmailed its way into dominance in the thirties. Able to guarantee brilliance, latitude and consistency, the company forced all commercial colour films to come to it. None could afford reviews commenting on the poverty of its colour. Technicolor's well-known method involved the company's participation and supervision at every stage of the filmmaking process. Technicolor's own operators and colour specialists would help film the production with the patented beam-splitting camera, an enormous machine which prismatically redirected the blue and red light 90° to a second roll of film running opposite the roll recording the green. The second roll was actually a double layer roll; the first layer recorded blue and filtered all but red light, while the second layer accepted red light only. Technicolor alone could process these three master rolls, for they were not only protected by patent but also by the expensive and complicated process itself. The rolls became colour matrices which were then submitted to the famous imbibition method of dyeing pure, complementary colours on a virgin colour stock, guided by information permanently etched on the three black and white records. Perfect control as well as perfect consistency in the laboratory were thus possible, for the colour records were all in black and white and technicians could adjust the various colours for brightness, hue and saturation until all requirements were satisfied.

In 1945 Agfa's potential was not well understood. Some incredible footage had been found in Germany but no one knew much about its refined process. It was clearly cheaper and more convenient than Technicolor. Early in its history it was typed as a 'socialist' method since the Soviets and Czechs seemed to be the most likely exploiters of Agfa.[13] But to most French writers these economic and political considerations were secondary to an aesthetic comparison between Technicolor and Agfacolor based on the few prints that reached Paris in 1945 and 1946.

Opinions soon developed. Agfacolor was generally thought of as an outdoor film able in full sunlight to produce the most 'natural' of colours because of its sensitivity to pastel tints.[14] Technicolor, though needing a great deal of light to pour through its beamsplitting prism, was considered ideal for studio use. The ability to manipulate colour balances in processing made studio shooting safe. Even more important, though, was the general look imposed by the matchless saturation of Technicolor, a saturation so pure that the density of its colours tended to form flat blocks of colour and produce

a kind of black masking around each object. The separation of objects via colour gave at once either a cardboard or a remarkably 3-D look which could best be exploited in studio lighting conditions. Agfacolor by contrast rendered a more modulated look by mixing its hues more gracefully and separating them softly. Many considered this to be a defect and Agfa was reproached for its lack of a 'firm black', for its 'muted edges', and for its generally 'paler light values'.[15] But even Technicolor was aware that its advantage in the 'strength' of its colour must be kept in check or else it would risk having that colour assume an animated cartoon tone.[16] And even American critics were surprised at Agfa's 'sharp natural' look in medium and long shots, together with its easy response to shifting lighting conditions.

The French could readily decipher an ideological message in this list of opposing attributes. Technicolor had (and promoted) a Hollywood notion of colour: purer than reality, needing strong artificial light, aggressive, almost whorish. Agfa was more supple, more responsive to natural light, paler, nearly receding from the audience. It coloured the film and invited the audience to enter the image and round off its 'muted edges'. It would obviously be the process for documentary work or for fiction hoping to give a documentary feel.

It might seem that most French critics would favour Agfa. Not only was it the more natural process, it was by far the cheaper one and it required no special camera. But even left-wing critics in this period were fascinated by the richness of Technicolor, even while they professed to abhor Hollywood's gaudiness.

Agfa, it was noted, ran into problems with consistency. Shifts in brightness and balance could be detected from reel to reel. It was also somewhat misty throughout.[17] While Technicolor tempted producers to overdo their colour, the French felt that they could overdo 'with taste'. They pointed to Olivier's *Henry V* where gaudiness was turned into a virtue, where colour separation was used thematically and where the brightness and saturation of Technicolor made the scenes seem lit from within as if they were indeed pages of illuminated manuscripts.[18] They could also note that the night scenes before the battle came off spectacularly well; while these shots were not precisely natural, they gave the feeling of Rembrandt or Pieter de Hooch colouring, thus contrasting with the illuminated miniature sections of the film in colour as well as in architecture and theme. Together these aspects gave Olivier the

opportunity to take a public and cultural (illuminated) play and shift it suddenly into a brooding and nearly existential meditation (Rembrandt darkness). The key scene marking the transition between these aesthetic postures – and one of the most beautiful of the film – shows the weakened British troops trudging in the sunset away from the camera and toward a battle they can no longer avoid. This shot was taken against the objections of Natalie Kalmus, the Technicolor consultant on the film and wife (actually former wife) of the inventor of the process.[19]

The French felt that if the British could employ artistically this crass but fantastic American process, how much better could they themselves use it, with their tradition of colour in painting and decorating. Even among the extreme Left, the notion of French tradition and good taste was always asserted as against American opportunism and brutish might. In this way the French hoped to employ Technicolor to enhance their 'cinema of quality' in opposition to America's 'cinema of quantity', where quantity referred both to the mass production of US films and to the power of size and money in the creation of any given American movie.[20]

While critics meditated on the aesthetic and ideological dimensions of Agfacolor and Technicolor, both processes were very actively involved in economic developments which had very little to do with aesthetics.

Technicolor's problems were those of abundance. They had helped subtractive processes defeat additive ones in the early days of competition. They had out-distanced other subtractive processes in the mid-thirties by moving, with the help of their beam-splitting camera, from a two to a three-colour process. By 1939 they had set up laboratories in New Jersey, Hollywood and London. So great was their prestige and so successful were their features that 1948 found them with an incredible work backlog. That year they managed to process 46 American and 10 British films. Many more were in various stages of the process. The imbibition process is slow under any circumstances, but the overload of 1948 made for nine-month work estimates on any film lucky enough to be scheduled, and by this date there were contracts for colour printing being written two to three years in advance of projected delivery time.[21]

Obviously a vacuum existed in the colour film market. Technicolor was proving unable to accommodate American demands and, as a result, the company had no real intentions of expanding into continental Europe. Eight new companies were

trying to fill the market in 1948 but only one could give Technicolor serious pause: Ansco, a company basing itself on the Agfa process.

At the close of the war Technicolor was able to dominate the market largely because Agfa fell with the third Reich. Agfa's international affiliates, including the General Aneline and Film Co. of Santa Monica, were desperately trying to update their processes to take advantage of the great strides the Germans had made during the war. Each was hampered by a different problem. The Soviets captured the German technology, dismantling it for reconstruction in the USSR; but they had done little prior research in the area of colour and contented themselves at first merely with employing captured Agfa stock, as in *Ivan the Terrible* Part 2. It was several years before they could boast of having their own system. Agfa affiliates in Western Europe, especially the Gaevert Co. in Belgium, did not have enough ready capital in 1945 to exploit the advantage in research they enjoyed. And even this research advantage was not informed by the most recent German advances which were hidden from all. If anyone had a chance to compete in the colour market using the Agfa system, it was Ansco. Ansco was lodged safely in California, backed by strong capital, and, supported by the Pentagon, it had been fully active during the war. But Ansco was hampered by its incomplete possession of the Agfa formula. The firm, a pre-war subsidiary of Agfa of Germany and official US holder of all early Agfa patents, had been seized by the US Government in 1941 for security reasons. The film division, which was bought up by the General Aneline Corporation, tried to perfect a multi-layered colour stock on the strength of its German secrets. This was not overly successful, and by 1945 Ansco recognised that its hopes lay in discovering recent German techniques.[22]

In 1945 a Federal inquiry commission under Nathan D. Golden was sent to Germany to interrogate those Agfa scientists who were being held under the custody of the American army. Two Ansco scientists were permitted to accompany this expedition. The findings of the commission were made public in the famous Fiat Report 721.[23] This in no way bothered Ansco, for as heirs to the pre-1940 Agfa patents, they were fairly secure from fears that competitors would exploit this knowledge. The modernised Agfa process, as described in the Fiat Report, was so heavily dependent on the earlier, patented techniques that no company but Ansco could possibly use them in America.

Nevertheless it was two years before Anscocolor, a multi-layered reversal stock in which each layer would absorb its proper colour and filter the light before it penetrated to the next layer, was ready. Processing Ansco involved nothing other than activating the dye-couplers already present in the film. This made it far quicker to develop than Technicolor. The German wartime inventions included a sturdy but very thin base on which could be attached three layers plus two separation filters. Given this, Anscocolor could be employed in conventional cameras and under much lower light levels than Technicolor where, to begin with, the light was split to expose two strips of film.

Ansco's first commercial film, *Climbing the Matterhorn*, was made for Monogram Pictures in 1948.[24] The ability to take advantage of outdoor light and colour conditions was well displayed, winning Ansco an immediate contract with MGM. With a secure part of the expanding US market, Ansco set up a laboratory in Paris in 1949 hoping to claim the market vacated by the failing additive processes. But by this time Agfa's other child, the Belgian Gaevert Co., had perfected its Gevacolor and it too moved confidently into Paris. Gevacolor and Anscocolor were comparable economically and aesthetically; Ansco was perhaps a bit sharper, but Geva was available in negative as well as reversal. It would not be until 1955 that Ansco would introduce its negative Anscochrome, and by this time, Ansco's earliest patents having run out, Gaevert would be establishing itself in America in hopes of undercutting Ansco as the cheapest of the commercially viable professional colour films.[25]

Meanwhile, however, a momentous change had occurred in the colour world. Technicolor abandoned its cumbersome camera, and entered into a pact with the Eastman Kodak Company. From 1953 on, Technicolor would process only Eastman Color negative stock using its peerless imbibition process. Nearly the last to enter the field, Kodak by 1950 had come up with a multi-layered negative stock combining Agfa's economy and flexibility with Technicolor's consistency and brilliance. Kodak's innovation was to eliminate the colourless dye couplers from the emulsion itself and introduce the dyes only in the laboratory. Its original negative stock therefore was essentially three layers of black and white film on a single base mutually self-filtering and recording information about the red, blue and green light entering the lens. In processing, this information was converted into dyes for printing. This could be done conventionally or with the richer, slower imbibition method.

As devastating as Eastman Color was to its American rivals, its effect in Europe was not strongly felt until 1955. Until then nearly all French colour films used Gevacolor. But oddly enough colour film accounted for barely two per cent of commercial French production and those few 'tinters' (as *Variety* called them) were primarily studio made, despite Geva's (Afga's) supposed outdoor advantage. French producers wanted to combat Hollywood spectacles with 'quality' subjects, and some even thought of colour as a genre. M. Remauge, producer for Pathé films, had declared in 1947 'The French don't go in for musicals or colour films. They prefer dramas with intellectual ideas to carry them along.' Thus, despite the multitude of predictions that the French art directors and cameramen would instil the American invention with some aesthetic worth, it was only the coming of the pre-New Wave directors like Vadim, Marcel Camus, and René Clément who began to move France into colour in the late fifties. By this time, with the death of the three strip camera, the first era of highly contrived colour had passed and a more casual look was finally breaking down the rigid academic 'quality' style of French films. The great aesthetic, ideological and economic predictions made in 1945 about colour in Europe failed to materialise because of small but determining factors such as the Technicolor overload, the inability to make satisfactory, durable prints from additive processes, the delay caused by the war in putting all of the Agfa formulae together in a company large enough to exploit this product. These factors when seen in the light of a highly unstable industry such as that of French cinema (based as it is on literally hundreds of tiny production companies) kept colour from becoming much of a factor in European production until well into the fifties.

That delicate industry, the second largest of an equally weak and unstable government, was prey to the illusions created by 'interested discourse'. Industrial spokesmen as well as left-wing critics constructed a vast fictional context for this invention (seeing, for example, Technicolor and Agfa waging a cold war battle in the midst of Paris) but these were fictions with the power to alter decisions made by industry and government and contribute to the outcome of the situation as a whole. I hope to have demonstrated something of the action of the contemporary discourse about the ideological implication of technological development even if the terms of that action, the deployment of such a discourse, has not been fully specified. Do we have a model of history capable of

accounting for the power of fictions as well as of facts? More specifically, can we account for the interplay of fact and fiction which weaves the fabric of every development in human history?

The lesson to be drawn from the case of colour in France is that the 'hiddenness' of ideological workings may be recognised even by a people playing out their situation. Not only did most French see the implicit political struggle underneath the overt technological one, some of them even pointed to the ideological effects of the colour processes themselves (comparing garish Technicolor to a Hollywood view of the world).

While France did indeed avoid an American takeover in colour, adopting the Belgian Geva system after the failure of its two most promising indigenous methods, this should not be seen as the victory of vision and intelligence over crass American money. Technicolor was working beyond the point of surfeit and was unable to move into France. Still, it undoubtedly wanted to hold the French market open for an eventual takeover and, strangely enough, it was aided in this desire by the very visionary forces which hated America. For, contradictory as it may appear, the 'radical' strategy of the French film industry in its attempt to stay free of American domination was the pursuit of its cinema of 'quality', an aesthetic which would unquestionably have preferred the formal and saturated look of Technicolor to the more casual and documentary look of Agfa processes. Indeed, one reason for the failure of the French processes was that they were never supported by the real money in the industry, the money which put its stock in 'quality' films. Both Pagnol and Tati were always considered outsiders.

Thus we are faced with contradictory impulses at both the economic and discursive levels (a desire for, and loathing of, American technology). These contradictions, instead of producing activity, in fact paralysed the development of colour until 1953 when rumours about another invention coming from America – colour television – suddenly sparked French producers into putting out the extra money for colour films. If one takes the entire leisure-time context into consideration, one might say that colour played a crucial role early in American film because of factors like television and the competition fostered by the anti-trust laws (the 1948 Paramount case). The French situation did not fully deteriorate until 1956 when cinema admissions began dropping enormously due to the impact of television and other leisure time alternatives. The advances made in colour after this date would, from this

perspective, be due neither to the general availability of ever-cheaper colour film nor to the shifting of a film aesthetic in the direction of the New Wave, but rather to pressures outside the film world in the overall area of leisure-time industry. But the technology and economics of television and its effect on the international film industry are another topic for investigation. Nevertheless, if I have shown anything in this paper, it is that such an investigation must not proceed patronisingly and mechanically from a safe position some 30 years after the fact. We must include in our paradigm the real input of the contemporary discourse and debate. While the expressions of those affected by a change clearly do not determine that change in any direct sense, neither are they totally illusory. Decisions, delays and exploitation undoubtedly respond to such discursive pressure. In this way technology and ideology are linked more intricately than even our recent discussions of the subject have indicated.

NOTES

1. Jean-Louis Comolli, 'Technique et idéologie', *Cahiers du cinéma*, Nos. 229–32, 233–5 and 241.
2. James Spellerberg, 'Technology and Ideology in the Cinema', *Quarterly Review of Film Studies* vol. II, no. 3 (August 1977), esp. p. 295.
3. See especially Adrian Cornwell-Clyde, *Colour Cinematography* (London: Chapman and Hall, 1951).
4. See, for example, the 11-page brochure Agfa distributed in Italy, *Il Film Colori secondo il procedimento Agfacolor* (Milan: A Lucini, n.d.).
5. Christian Berard in *Le Film Français*, 13 July 1945.
6. Roland Dailly, 'La palette de la caméra', *L'Ecran Français*, No. 172, 12 October 1948.
7. *L'Ecran Français* attacked US influence in nearly every issue. At first it did so in the name of trade unions. See editorials of 6 February, 29 May and 5 June 1946. Later it lashed out in the name of producers as well, see 2 December 1947.
8. *New York Times*, 16 June 1946.
9. See especially John Huntley, *British Technicolor Films* (London: Skelton Robinson, 1949).
10. Los Angeles *Daily Mirror*, 28 August 1948.
11. 'Revolution in Color', *Time*, 7 June 1948.
12. Dailly, op. cit.
13. Ibid.
14. Dailly (Ibid.) wants to question what he claims has become an aesthetic commonplace by arguing that Agfacolor has excellent indoor possibilities.

15. Margaret Markham, 'Focus on Color', *Film News*, 12:21, January 1953.
16. Natalie Kalmus, herself called for restraint at the end of her essay 'Color Consciousness', *Journal of SMPTE*, vol. XXV, no. 2, August 1935.
17. 'German Color Secret on Way to US and Britain', *Motion Picture Herald*, 23 March 1946.
18. Dailly, op. cit.
19. C. Clayton Hutton, *The Making of Henry V* (London: Ernest Day, 1945).
20. The term 'quality' was actually an official designation, coming into legal usage in the famous government report of 1937 *Où va le cinéma français?* conducted by M. Renaitour. The first issue of *Le Film Français* after World War II was devoted to a definition of this term which dominated critical discourse all the way to Truffaut's vituperative attack on it in 'Une certaine tendance du cinéma français', *Cahiers du cinéma*, January 1954.
21. Darr Smith in *New York Daily News*, 6 July 1948.
22. *Motion Picture Herald*, 23 March 1946.
23. Government Report no. 15476 of 30 January 1946 (Fiat Report, No. 721).
24. James Limbacher, *Four Aspects of the Film* (New York: Brussel and Brussel, 1969), p. 55.
25. The history of the various colour processes and stocks is most thoroughly documented in Roderick Ryan, *A Study of the Technology of Color Motion Picture Processes Developed in the Unites States* (Ph.D. dissertation: University of Southern California, 1967).

7. Motion Perception in Motion Pictures

Joseph and Barbara Anderson

Historians and theorists of the motion picture who have felt obliged to provide some explanation of how the illusion of motion on the screen is perceived have, almost without exception, relied upon a phenomenon they have termed 'persistence of vision'. The notion is ubiquitous in film literature. Credit for its discovery may be attributed to different sources, and the details of the process vary slightly from one account to the next, but 'persistence of vision' in one form or another is invariably proffered as the basis of filmic illusion.

A representative definition of the term reads as follows:

> Movement in film is an optical illusion. Present-day cameras record movement at twenty-four frames per second. That is, in each second, twenty-four separate still pictures are photographed. When the film is shown in a projector at the same speed, these still photographs are 'mixed' instantaneously by the human eye, giving the illusion of movement, a phenomenon called 'the persistence of vision'.[1]

While such perfunctory explications are common, more imaginative descriptions have been offered on occasion:

> The movie camera is essentially a machine for taking pictures intermittently, the separate, spaced-out pictures afterwards being fused together in the observer's brain. Persistence of Vision, a sort of mental hangover, prolongs the image of what the eye is seeing. In this way, a rapid succession of slightly different still pictures deceives it into thinking that it has seen real continuity of

movement. If the eye were entirely sober, there would be no movies.[2]

Even the two major classical theorists of film, Sergei Eisenstein and André Bazin, accepted and perpetuated the concept. Eisenstein wrote that in cinema 'the idea (or sensation) of movement arises from the process of superimposing on the retained impression of the object's first position, a newly visible further position of the object'[3], and Bazin marvelled at how long it took for the motion picture to come into being, 'since all the prerequisites had been assembled, and the persistence of the image on the retina had been known for a long time'[4]. As recently as 1971, film theorist Jean-Louis Comolli asserted that 'persistence of vision is, after all, what specifically distinguishes the cinema from photography'[5].

Persistence of vision is, of course, an inadequate explanation for the illusion of motion in the cinema. The proposed fusion or blending of images or frames could produce only the superimposition of successive views; the result would be a static collage of superimposed still pictures, not an illusion of motion. The apparent inadequacy of the explanation, however, coupled with its recurrence in film literature, arouses one's curiosity about the origins of the notion, the means by which it has been perpetuated, and the possibility of a more satisfactory explanation of motion perception in the cinema.

Film historian Terry Ramsaye attributed the discovery of persistence of vision to the English-Swiss physician Peter Mark Roget and reported that Roget presented his finding before the Royal Society in a paper entitled, 'Persistence of Vision with regard to Moving Objects'[6]. Arthur Knight, 30 years after Ramsaye, provided the identical citation and recounted the spread of Roget's theory throughout Europe. He listed a number of parlour toys that served to establish the 'basic truth of Roget's contention that through some peculiarity of the eye an image is retained for a fraction of a second longer than it actually appears', and went on to assure us that 'upon this peculiarity rests the fortune of the entire motion-picture industry'[7].

In the annals of the Royal Society of London there is no record of a paper with the title cited by Ramsaye and Knight. They were apparently referring to a paper presented by Roget on 9 December 1824, entitled 'Explanation of an optical deception in the appearance of the spokes of a wheel when seen through vertical

apertures'[8]. In this paper Roget reports that if one views a revolving wheel through a series of vertical slits, 'the spokes of the wheel, instead of appearing straight, as they would naturally do if no bars intervened, seem to have a considerable degree of curvature'[9]. While the lateral movement of the wheel was seen, its rotation appeared to cease, the curved spokes seeming to be frozen in one unchanging position. Roget explained that the spokes of the wheel, passing behind the grating, 'leave in the eye the trace of a continuous curved line, and the spokes appear to be curved'. He likened the phenomenon to the

> illusion that occurs when a bright object is wheeled rapidly round in a circle, giving rise to the appearance of a line of light throughout the whole circumference: namely, that an impression made by a pencil of rays on the retina, if sufficiently vivid, will remain for a certain time after the cause has ceased.[10]

It is unlikely that any psychologist today would attempt to explain either of these illusions solely in terms of retinal processing. Regardless of the relative accuracy of Roget's conclusions, however, the point to be made is that it is on the basis of this explanation that many film scholars have accounted for the perception of successive frames of a motion picture as a continuously moving image. (Roget, of course, can hardly be held responsible for their misuse of his work. The illusion he describes is not an illusion of motion, nor does he claim that it is. Roget has described a case in which a series of moving points results in the perception of a static image, while in cinema a series of static images results in the illusion of motion).[11]

In French writings on the cinema Roget often takes second place to the Belgian physicist Joseph Plateau, who is credited with having discovered the principle of persistence of vision.[12] Unlike Roget, Plateau was concerned with illusions of motion, and his explanations of the persistence of the retinal image are intended as explanations of stroboscopic motion. In 1830 Plateau constructed an instrument he called a 'phenakistiscope' (meaning 'eye deceiver') by means of which successive, slightly differing pictures on a revolving disc, when viewed through a vertical slit, produce an illusion of continuous motion. The principle underlying the illusion, he claims, is simple:

> Si plusieurs objets différant entre eux graduellement de forme et de position se montrent successivement devant l'oeil pendant des intervalles très courts et suffisamment rapprochés, les impressions

qu'ils produisent sur la rétine se lieront entre elles sans se confondre, et l'on croira voir un seul objet changeant graduellement de forme et de position.[13] (If several objects, progressively different in form and position, are presented to the eye for very short intervals and sufficiently close together, the impressions they make upon the retina will join together without being confused, and one will believe one is seeing a single object gradually changing form and position.)

On the basis of this finding Georges Sadoul, French film historian, credits Plateau with having set forth the principle of modern cinema (more precisely, the law upon which film projection or viewing is based) as early as 1833.[14]

A closer examination of Plateau's work, not only that specifically on the phenakistiscope, but that stretching over a long career devoted in large part to the study of physiological optics, reveals two other visual phenomena that become intertwined with retinal after-images in the treatment of 'persistence of vision' in subsequent treatises on the motion picture: light or colour mixture (often called simply 'fusion') and flicker fusion.

It was Plateau who, in 1835, formulated what was to become known as the Talbot–Plateau law, or simply Talbot's law of fusion (after H. F. Talbot, who established it for use in making photometric matches in 1834): that the effect of a brightness or colour, briefly presented, is proportional to the intensity and to the time of presentation.[15] C. S. Sherrington specifically related the phenomenon of flicker fusion to Talbot's law: 'I cannot myself believe satisfactory', he wrote, 'any explanation of "flicker" that does not recognise the as it seems to me fundamental intimacy of connection between it and Talbot's law.'[16] In so doing he contributed to a generalised notion of 'fusion' that was applied to the illusion of motion by a host of psychologists working in that period.

William Stern, in 1894, put forth one of the first general theories of movement perception that was based upon a kind of retinal fusion. Stern formulated three principles of motion perception, one of which he regarded as 'the essential condition of the perception of movement when the eyes are held stationary', that is, a positive after-image from the first flash of a two-flash display is assumed to be still present when the second flash occurs. The continued existence of the positive after-image, he claimed, makes possible the perception of continuous movement.[17]

Karl Marbe, four years later, outlined his theory of motion perception, which is also based upon a fusion of after-images. Marbe reduced the phenomenon of stroboscopic movement to the fusion (*Verschmelzung*) of successive periodic retinal excitations.[18] Unlike Stern, Marbe referred to Talbot's law of fusion, offering the observation that there is a certain minimal rate of succession of discrete stimuli, below which movement will not be seen, just as there is a minimal rate of intermittent stimulation below which light will not fuse.

In 1900 Ernst Durr made a similar attempt to explain the phenomenon of apparent movement in peripheral terms. Like Marbe, he posited the fusion of after-images and made the connection with Talbot's law, but Durr added to Marbe's doctrine a 'dependence upon shifts in fixation', that is, on eye movement. According to Durr both retinal fusion of after-images and eye movements are essential conditions for the perception of movement. When the glance follows the successively appearing stimuli, good movement is perceived.

Walter S. Neff offers a cogent criticism of Marbe's work, which applies equally well to Durr's discussion of after-images:

It is clear that Marbe confuses the stimuli presented with the object perceived. He would have us believe that the appearance of a continuum arising with discretely presented stimuli is dependent upon a sensory fusion of the images upon the retina. Now, to identify the appearance of a continuum with fusion is to give the term fusion an entirely novel meaning. In typical cases, as with rotating disks, we speak of fusion only when the colors, perceived as distinct when the disk is stationary, blend into an homogeneous surface upon rotation. The matter is quite different with stroboscopically presented objects. Under stroboscopic conditions, the report is in terms of an object appearing at one place in the field, moving over to another place, and disappearing in this final position. We find no observation which is couched in terms of an homogeneous light surface. Marbe has been misled by an incidental similarity in two totally different experimental situations.[19]

Neff's comment points to the generalised and imprecise use of the term 'fusion' in these theories that has rendered equally problematic the recurrent explanations of 'persistence of vision' in film litera-

ture. After 1900, in the literature of psychology, movement is treated almost without exception as principally a central phenomenon. Durr represents the last attempt to explain motion perception solely in peripheral terms. Yet the ghost of 'fusion' is not so easily laid to rest.

In 1912 Max Wertheimer published his 'Experimental Studies on the Seeing of Motion', the classic work on apparent motion that is cited as the founding work of Gestalt psychology. Through a series of experiments utilising variations of the traditional two-element display, Wertheimer isolated what he considered three primary stages of stroboscopic motion: (i) beta movement (the object at A seen as moving across the intervening space to position B), (ii) partial movement (each object seen moving a short distance) and (iii) phi movement (objectless or 'pure' motion). In another series of experiments, through haploscopic presentations of elements A and B, and presentations in which the inter-stimulus interval was too great to admit of any fusion of after-images, Wertheimer convincingly refuted the 'trace' or after-image theory, which, as he put it, 'deduces the phenomenon of motion from the event of the excitation in the stimulated points of the retina.'[20] His conclusions were clear: 'it is not sufficient to draw upon pure peripheral processes in relation to a single eye: we must have recourse to processes which "lie behind the retina".'[21] Having established this point, and having rejected the 'trace theory' along with other theories of motion perception, Wertheimer proceeded to outline his own 'physiological hypothesis' (*Kurzschluss* – often called the 'short-circuit theory' of motion perception):

> It is a question of certain central processes, physiological 'transverse functions' of a special kind, which serve as the physiological correlate of the phi-phenomenon. According to recent neurophysiological investigations it must be assumed as probable that the excitation of a central point 'a' sets up a physiological disturbance in a definite circle around it. If two points 'a' and 'b' are thus excited, there would result a similar circular disturbance in both cases; this circle is then predisposed for excitation processes. If the point 'a' is stimulated, and within some specific short time, the neighboring point 'b', then there would occur a kind of psychological short-circuit from 'a' to 'b'.[22]

When he proposed that brain events were isomorphic with the

perception induced by successive exposures, the element of fusion entered Wertheimer's theory: 'With successive exposures, the resulting Phi process will, under the best conditions, continually join [the successive items] together, giving rise to a single, continuous total event.'[23]

Wolfgang Köhler, recognising that Wertheimer's physiological hypothesis had accounted for only the rare, objectless phi movement, set about to demonstrate that Gestalt theory could account as well for the more commonly experienced beta or optimal movement. In the process, Köhler added to the short-circuit suggested by Wertheimer a chemical transformation in the brain field. Harry Helson, in his essay 'Psychology of Gestalt' provides a succinct description of the approach:

> Köhler asserts that the stimuli 'a' and 'b' set up currents in the optic sector with different voltages. A and B fuse into one *beneath* the psychophysical level, so that the conscious process arises as a unitary structure. . . . We may call this a theory of 'subpsychophysical absorption' to account for the various stages of movement and fusion. The part, successive, and simultaneous stages are easily accounted for in the following manner: if A and B do not fuse, then part movement of each is seen; if A and B appear too closely together, both are seen at rest.[24]

In supporting and expanding upon Wertheimer's physiological theory, Köhler made more explicit the role played by fusion in the Gestalt notion of psychophysical isomorphism as applied to motion perception.

Meanwhile, Kurt Koffka and a student, Cermak, had been investigating whether or not stroboscopic movement and the phenomenon of fusion (meaning light mixture) fell under the same conditions. Like Wertheimer and Köhler, they knowingly proceeded from G. E. Müller's psychophysical axiom: 'An equivalence, similarity, or difference in the character of the sensations corresponds to an equivalence, similarity or difference in the character of the psychophysical process, and vice-versa. Indeed, a larger or smaller similarity of sensations corresponds to a larger or smaller similarity in the psychophysical process, and vice-versa.'[25] A series of experiments in which 'comparisons, both phenomenal and objective, [were] made between movement (Wertheimer's three "states"), flicker, and fusion', resulted in the formulation of eight

'parallel laws', which were held to apply to both fusion and apparent motion.[26] Their reasoning proceeded along these lines: the phenomena of light-fusion and perceived movement have been shown to obey the same laws; it may therefore be concluded (on the basis of Müller's axiom) that the two phenomena are governed by the same psychophysical processes. Cermak and Koffka assumed that light-mixture or fusion is a limiting case of stroboscopic movement, in which the spatial (but not the temporal) interval between successive stimuli is reduced to zero.

Theories such as these which emphasise a central fusion process were reflected in early film literature. Frederick A. Talbot in *Moving Pictures: How They Are Made and Worked* offered the most fully elaborated account of this variation of the 'persistence of vision' theme. The cinematographer, according to Talbot, takes advantage of a 'deficiency' of the human eye: 'This wonderful organ of ours has a defect which is known as "visual persistence".'[27] Talbot provided one of the most colorful explanations of this so-called defect:

> The eye is in itself a wonderful camera. . . . The picture is photographed in the eye and transmitted from that point to the brain. . . . When it reaches the brain, a length of time is required to bring about its construction, for the brain is something like the photographic plate, and the picture requires developing. In this respect the brain is somewhat sluggish, for when it has formulated the picture imprinted on the eye, it will retain that picture even after the reality has disappeared from sight.[28]

According to Talbot, then, each two contiguous images blend or fuse together in the brain, allowing for the perception of smooth, continuous movement. This view is further confirmed by his comparison of the brain with a contemporary apparatus for slide projection, known as a 'dissolving lantern', by means of which 'one view is dissolved into another'.[29]

Yet another early film theory, though not espousing a strictly fusional theory of perceived movement, shows the direct influence of Wertheimer's short-circuit theory and other current hypotheses of movement perception: that of Harvard psychologist Hugo Munsterberg, as outlined in his 1916 work, *The Photoplay: A Psychological Study*. Munsterberg was aware of the notion of 'persistence of vision' and its shortcomings:

[The routine explanation of the appearance of motion was] that every picture of a particular position left in the eye an after-image until the next picture with the slightly changed position of the jumping animal or of the marching men was in sight, and the after-image of this again lasted until the third came. The after-images were responsible for the fact that no interruptions were noticeable, while the movement itself resulted simply from the passing of one position into another. . . . This seems very simple. Yet it was slowly discovered that the explanation is far too simple and that it does not in the least do justice to the true experiences.[30]

As an alternative explanation Munsterberg proposed a central 'filling-in' or impletion process. In the traditional two-element display, he would argue, the two stimuli are perceived at different locations at different times, and the observer's mind fills in the gap—movement is 'not seen from without, but is superadded, by the action of the mind.'[31]

Munsterberg recognised that his hypothesis was not in and of itself an explanation of motion perception, and he proposed to 'settle the nature of that higher central process' through systematic experimentation in his laboratory. Unfortunately, both Munsterberg's book on film (or the 'photoplay' as it was then called) and his proposal that we try to understand perceived motion in the cinema through experimental research, have been all but ignored by film scholars for the last 50 years. The so-called psychological analyses of film have been facile psychoanalyses of movie characters and film directors, or, more recently, complex psychoanalyses of 'filmic texts'. Psychology has been virtually eclipsed by psychiatry in film study.

Our understanding of the illusion of movement in the cinema has consequently progressed little since 1916. Film theorists and historians recite the litany of 'persistence of vision' and proceed with their work. Little research has been done specifically with motion pictures, even in psychology (until very recently [32]). Irvin Rock has aptly summarised the situation:

Everyone, it would seem, knows that moving pictures are made by projecting a series of stationary frames on a screen in rapid succession. Yet few people seem to be curious about the basis of this effect, and those who are seem to be satisfied with an incorrect

explanation. . . . The fact of the matter is that we do not know why movement is perceived.[33]

Fortunately, psychologists have not been as averse to experimental research as have film scholars and, in recent years, have increased our understanding of stroboscopic motion outside of the filmic context. They have addressed themselves to such questions as 'Are apparent motion and real motion mediated by the same mechanism?'; 'What attributes of an object—colour, brightness, form—are necessary to carry the perception of motion?'; 'What is the role, if any, played by visual masking in the perception of stroboscopic motion?'; and 'What is the relationship between the processing of form and the processing of motion?'

Each of these inquiries, pursued in an effort to understand better motion perception *per se*, is directly relevant to the perception of the motion picture. There is, after all, no motion on the screen. There is nothing but a succession of still images. The motion in motion pictures is the result of a transformation made by our visual system. An understanding of this transformation would be a first step in gaining an understanding of the complex set of transformations performed by the perceptual system when confronted with cinematic images.

In work done in the early sixties, Paul Kolers noted several ways in which apparent motion and real motion differ, and on this basis argued against any explanation of motion perception that maintained that real and apparent motion are mediated by the same mechanism. More recently, however, he has somewhat amended his earlier view. In 1971 Kolers and Pomerantz used a computer generated display to test the effect of spatial intermittency on the illusion of motion:

The face of a cathode-ray tube (CRT) is made from a fine matrix of spots of phosphor that glow when they are excited by electrons. The CRT face used for the experiment contained more than 1024 spots in the horizontal dimension. A computer program controlled a 5 cm high beam of electrons as it moved across the screen from column to column of spots; it also controlled the duration for which the beam rested on each column and the dark interval between the extinction of the beam on one column and its excitation of the next. The width of the surface was about 13 cm. The number of columns illuminated in that width varied as powers of two. . . . Viewing distance was one meter.[34]

When two lines appeared on the screen, good illusory motion was seen with proper timing (this is the usual binary display – the limiting case for apparent motion). When 4, 8 or 16 lines appeared on the screen, smooth continuous motion was never attained. However, with 32 or 64 or more lines, smooth continuous motion was perceived. Thus, if smooth continuity of motion was rated as a function of number of lines presented, the result would be a U-shaped curve. Kolers concluded: 'It seems there is no necessary continuity of processing between spatially separated and spatially contiguous flashes; the ways the visual system constructs the two perceptions of motion seem to be quite different.'[35]

This new addition to Kolers' work on stroboscopic motion leaves open the possibility that multi-element or closely spaced displays are mediated by the same mechanisms as real motion, while more widely spaced binary displays (the usual two-flash displays used to demonstrate apparent motion) involve a different type of processing.

Work done in rather different contexts by other psychologists also supports this notion. Biederman-Thorson, Thorson and Lange, for instance, presented subjects with two dots so closely spaced as to be perceived as a single dot when flashed simultaneously. When those same dots were flashed sequentially, motion was clearly perceived. Like Kolers, these experimenters concluded that perception of motion accompanying very small dot separation (which they term the 'fine-grain illusion') may involve a different level of processing than apparent motion induced by more widely spaced stimuli. Moreover, they specifically suggested that the fine-grain illusion may share a common base with the perception of real motion.[36]

Oliver Braddick, working with random-dot patterns arrived at a similar conclusion. He demonstrated that motion was perceived between two random-dot patterns only when the dots were displaced about a quarter of a degree of visual angle or less. (This was the same spatial limit suggested by Kolers and Pomerantz for the perception of stroboscopic motion with multi-element displays).[37]

If this is the case, if closely spaced or multi-element displays are mediated by the same mechanisms as real motion, consider the implications for film. The motion picture, a series of rapidly presented (closely spaced) images, falls into the category of multi-element displays or the fine-grain illusion. This would suggest that the mechanisms that mediate the perception of motion in cinema

are not those which mediate the perception of the usual two-flash demonstration of apparent motion, but those which are operative in perceiving real motion. One of the clearest implications of this research for film theory is the support it provides for certain aspects of a 'realist' approach to the cinema. It provides a perceptual basis, for instance, for Christian Metz's assertion that motion in the cinema is not a re-presentation, but a presentation, not the re-experience but the experience of motion.[38] The figures on the screen are insubstantial phantoms easily distinguished from corporeal reality. The experience of motion in the cinema, however, cannot be distinguished from the experience of real motion.

In addition to investigating the mechanisms mediating real and apparent motion, perceptual psychologists have asked about the attributes of an object that seem to be necessary to carry the perception of motion. Both Rattleff and S. M. Anstis demonstrated the priority given by the visual system to brightness over such attributes as form or colour in the perception of apparent motion. Anstis concluded:

> The visual system perceives phi movement between individual points of corresponding brightness in successive frames, and phi movement is determined on a local point-for-point basis, mediated by brightness; not on a global basis, mediated by form.[39]

These findings suggest two things that are not immediately obvious: first, that form and motion are separable phenomena, and, second, that brightness rather than form is the primary carrier of motion. This necessitates thinking not in terms of seeing form in motion but rather of first perceiving motion and then postulating what it is that is moving. We will return to the separation of form and motion and the significance of that research for the study of film, but first we should consider the importance of brightness and its role in both motion and motion picture perception.

In investigating the relationship between brightness and motion perception, one is forced to consider the phenomenon of visual masking. Masking is said to occur when two visual presentations are made sequentially and one renders the other invisible. In his work with random-dot patterns Braddick found that displaced regions appeared in motion, oscillating laterally, when the random-dot patterns were presented alternately. He also discovered that the perceived motion was eliminated if a uniform bright field were

exposed during the interval between the two patterns. It was expected that a patterned mask would be significantly more effective than a blank field, since in experiments where the visibility of a form is degraded or abolished by a masking stimulus, a contour-rich pattern is generally a much more effective mask than a uniform field of light. However, results indicated that a patterned mask whose blank areas matched the luminance of the uniform field was not a significantly more effective mask. This would seem to indicate that not form or contour masking, but rather a type of motion masking is at work in this case. Braddick indeed uses the term 'motion masking'.[40]

Such 'motion masking' was noted by film theorist Frederick A. Talbot as early as 1913. He reported the following effect of a white field intervening between two frames of a motion picture:

A positive film was prepared, but between each successive image a wide white line was inscribed. This film was then passed through the projector, and the pictures were thrown upon the screen at the speed generally accepted as being necessary to convey the effect of natural movement; but animation could not be produced at all, however rapidly the pictures were projected. The reason was simple. Immediately after a picture disappeared from the screen the white flash occurred, and notwithstanding its instantaneous character it was sufficient to wipe out the image of the picture, which without the white line would have lingered in the brain. Even when the pictures were run through the projector at thirty per second, no impression of rhythmic motion was obtained; they appeared in the form of still-life pictures with spasmodic jumps from one to the other. They failed to blend or dissolve in the brain, notwithstanding that the white flash in some cases was only about one ten thousandth part of a second in duration.[41]

Talbot went on to describe the case in which a black space rather than a white one intervenes. Motion became apparent as soon as the speed attained 16 frames per second. The explanation for such a masking effect is, of course, not as simple as Talbot suggests. Only recently have we begun to investigate systematically this aspect of motion perception.

In the operation of a motion picture camera, each time the camera stops and starts up again, frames of the film are over-

exposed. While a single black frame in a film generally goes unnoticed, even a single one of these so-called flash frames proves very disturbing to the viewer. Perhaps the flash frame is so disturbing because it is not just a one frame interruption of the motion but, like the uniform bright field used by Braddick, it *masks* preceding frames, thus creating a multi-frame interruption of the perceived motion. In most films flash frames are carefully edited out and what is perceived on the screen is smooth, continuous, uninterrupted motion. If visual masking plays a role in the perception of motion in the cinema, therefore, it is most likely not masking of this order.

It is more likely that the type of masking operative in the perception of filmic motion is form or contour suppression. The role played by this type of masking in the perception of stroboscopic motion was investigated by Breitmeyer, Love and Wepman in 1974, and results indicated that detailed contour information is suppressed during stroboscopic motion.[42] Two years later these findings were extended by Breitmeyer, Battaglia and Weber. They asked whether the contour masking noted in the earlier experiment was confined to the first stimulus. Was it, in other words, a *backward* masking effect? The results confirmed the expectation that in stroboscopic motion the second stimulus has a *backward* contour masking effect on the first.

If this type of visual masking is operative in the perception of motion in the cinema, it might well be the mechanism that allows for the perception of smooth, continuous motion. There is, one will recall, no motion on the screen, just a succession of still images. If there were a persistence of these images in the eye of the viewer, figures on the screen would pile up, one on top of the other, resulting in a kind of chronophotographic display. A mechanism such as this backward contour masking would preclude a piling up of images and at the same time account for the fact that at any given time the film viewer is aware of only the currently present position of the figure(s) on the screen (the immediately preceding position(s) having been wiped out in the backward masking process).

Though it *allows* for the perception of smooth continuous motion (in that it prevents a superimposition of still images), contour suppression does not *explain* the perception of motion on the screen. In order to come closer to such an explanation it is necessary to consider the relationship between form processing and motion perception. As Paul Kolers has pointed out, long overdue con-

sideration has recently been given to the distinction between object perception and motion perception. This was, one will recall, one of the implications of Wertheimer's 1912 experiments with apparent motion. For Wertheimer the distinction was demonstrated by the existence of 'pure phi' or objectless motion. It would seem, however, that Wertheimer's own 'physiological hypothesis' in itself did much to blur the distinction. Kolers, for instance, is prompted to ask: 'If the short-circuit was the analog of motion, what happened to the figure? And if the short-circuit was of both figure and motion, what happened to the distinction between them?'[43] De Silva re-introduced the distinction between form and motion perception, referring to vehicles of motion as opposed to motion itself. However, for both Köhler and Osgood, who carried forward Wertheimer's ideas, figure and motion are treated as part of the same process.[44] Until recently little effort had been made to dissociate the two.

In 1971 Kolers and Pomerantz undertook a study of the effects of presenting disparate or identical shapes in a stroboscopic movement display. It was reasoned that if figural processes were important to the perception of the illusion, many fewer judgements of smooth continuous motion would be made with the disparate pairs than with identical pairs of objects. It was found, however, that the figural differences between paired items made very little difference. Observers saw one shape change smoothly and continuously into the other. Kolers concluded:

> Motion can be seen between any two shapes having the proper spatial and temporal characteristics, irrespective of their identity. . . . The classical argument is that the visual system perceives figures in different locations and infers motion to have occurred in order to resolve the disparity of figure location. What I have shown is that, to the contrary, the visual system responds to locations of stimulation and infers or creates changes of figure to resolve that disparity.[45]

Kolers offered a 'two-component model' of motion perception that derives from this distinction between form perception and motion perception. Briefly, he proposed that a visual stimulus may be thought to generate two signals, one called a horizontal or 'H' signal that carries information about the location of the stimulus, and another called a vertical or 'V' signal which goes directly to

deeper parts of the nervous system, carrying information about object identity. Kolers' contention is that the threshold for motion is lower than that for form, and that the former is primary in the perception of stroboscopic movement. (He describes phi movement, for instance, as the percept resulting from having crossed the threshold for motion but not for form).

Anstis also provided support for a distinction between motion and form processing. As noted earlier, Anstis maintained that movement is mediated on a local point-for-point basis by brightness rather than form. Anstis specifically asserted that motion perception can precede pattern recognition. In a further set of experiments Anstis found that all of Julesz's random-dot figures, which produced depth when viewed binocularly, were seen in apparent motion when viewed in monocular alternation. This, too, could be interpreted as evidence that form processing need not precede motion perception, in the same way that Julesz made the argument that form processing is not needed for the perception of depth in his random-dot stereograms.[46]

Recent neurophysiological findings have provided further evidence for the distinction between form and motion perception and have provided a plausible explanation of results obtained in experiments on visual masking and motion. Ulker Keesey found that flicker-detection and pattern-recognition thresholds are independent functions, not only of spatial frequency but of temporal frequency as well. She proposed that the two thresholds represent the activity of two independent types of detectors in the human visual system.[47]

A concise description of the respective roles of the two types of neurophysiologically identified cells was provided by Kulikowski and Tolhurst. Movement-analysers or transient-response cells, when excited, give information about the nature of temporal changes. The role of form-analysers is different. They provide useful information about the shape, size or relative position of a stimulus. They respond to moving stimuli, but if they are excited alone, no movement is perceived.[48]

Other psychophysiological and neurophysiological studies indicate that (i) transient cells have a response latency shorter (by 50–100 milliseconds) than that of sustained channels; (ii) the activity of transient cells inhibits that of sustained channels; and (iii) transient cells have substantially larger receptive fields than do sustained cells.[49] It is on the basis of these findings that Breitmeyer, Love and

Wepman explain contour suppression during stroboscopic motion:

> It is possible that the contour suppression effect is related to the strong activation of low spatial frequency channels and the relatively weak response of the high spatial frequency channels.[50]

Such an explanation of contour suppression recalls Kolers' description of 'pure phi' movement as the percept resulting from having crossed the threshold for motion but not the threshold for form perception. Such findings, moreover, lend support to Kolers' model of motion perception, especially in its emphasis upon motion and form perception as two separate constituents of perceptual experience.

These several insights, gained by psychologists pursuing questions of interest to them, when taken together shed considerable light upon the fundamental question of interest to us—that is, how motion in the motion picture is perceived. One may hypothesise on the basis of such research, for example, that when confronted with a series of rapidly presented, closely spaced images as in film, the eye responds (perhaps by means of 'movement-analysers' or transient-response cells) simply to the locations of stimulation, and that motion (motion alone, not form in motion) is thus experienced. The task then facing the visual system is to assign that motion to some form or figure, to determine what it was that moved. A background masking mechanism, as indicated earlier, might assist in that task by interrupting the processing of previous positions of a figure, thus rendering only one position visible at a time. This would produce the perception of a single (rather than several) objects to which the motion may be assigned. Moreover, if this perception of motion is mediated by the same mechanisms as real motion, as research with closely-spaced, multi-element displays of stroboscopic motion would seem to suggest, we are one step closer to an understanding of not only the perception of motion but also the so-called impression of reality in the cinema.

These speculations about motion perception in cinema must, of course, like all models of perception, be considered a working hypothesis. We have as yet no fully satisfactory explanation of how motion is perceived. It seems clear, however, that the answer does not lie in visual persistence or fusion. The notion of 'persistence of vision' seems to have been appropriated from psychology in the first decade of the century, the period during which cinema came into

being. But while most film scholars accepted 'persistence of vision' as the perceptual basis of the medium and proceeded to theorise about the nature, meaning and functioning of the cinema from that base, perceptual psychologists continued to question the mechanisms involved in motion perception; and they have achieved insights that necessitate the re-thinking of many conclusions reached by film scholars during the past 50 years.

Since most film scholars may feel unprepared to conduct experimental research, they may be tempted simply to acknowledge the inadequacy of the persistence of vision explanation and proceed with their work. The temptation should be resisted, for in any theoretical discussion of the cinema basic assumptions are embedded about how we see form in motion.

Motion perception is, moreover, only one of the areas of visual perception about which naive assumptions have been and continue to be made. Emphasis has been placed upon cinema as a system of signification, the site of various levels of coding. It is essential for a theory of the cinema to take into account the other side of the equation as well—the spectator, whose visual system performs an equally complex series of systematic transformations and evidences multiple levels of coding. Just as film theorists have supplanted naive notions of cinema as a simple copy of the world with an attempt to come to grips with the medium as a system of representation and signification, so too must the naive notions of persistence of vision and of direct perception be replaced with an effort to understand visual perception itself as a transformational and representational process.

NOTES

1. Louis Gianetti, *Understanding Movies*, 2nd edn (Englewood Cliffs, N.J.: Prentice-Hall, 1976), pp. 123–4.
2. Raymond Spottiswoode, *Film and its Techniques* (Berkeley: University of California Press, 1963), p. 47.
3. Sergei M. Eisenstein, *Film Form* (New York: Harcourt, Brace and World, 1949), p. 49.
4. André Bazin, *Qu'est-ce que le cinéma?* vol. 1 (Paris: Cerf, 1958), p. 22; trans *What is Cinema?* vol. 1 (Berkeley: University of California Press, 1967), p. 19.
5. Jean-Louis Comolli, 'Technique et idéologie' (I), *Cahiers du cinéma* no. 229 (June 1971), p. 8.

6. Terry Ramsaye, *A Million and One Nights* (New York: Simon and Schuster, 1926), p. 10.

7. Arthur Knight, *The Liveliest Art* (New York: New American Library, 1957), p. 14.

8. Peter Mark Roget, 'Explanation of an optical deception in the appearance of the spokes of a wheel when seen through vertical apertures', Royal Society of London, Philosophical Transactions, MDCCXXV, pt I (London: Nicol, 1825), pp. 131–40.

9. Ibid., p. 135.

10. Ibid.

11. For a more detailed discussion of Roget's paper and its relation to film theory and history, see Joseph Anderson and Barbara Fisher, 'The myth of persistence of vision', *Journal of the University Film Association* vol. XXX no. 4 (Fall 1978), n.p.

12. See, for example, André Bazin, *Qu'est-ce que le cinéma?* 4 vols. (Paris: Cerf, 1958–62); trans (selection) *What is Cinema?* 2 vols. (Berkeley: University of California Press, 1967 and 1971); Georges Sadoul, *Histoire générale du cinéma* (Paris: Denoel, 1948); and Georges Potonniée, *Les Origines du cinématographe* (Paris: P. Montel, 1928).

13. Joseph A. F. Plateau, as quoted in Georges Sadoul, op. cit., vol. 1, p. 25.

14. Sadoul (Ibid.).

15. Edwin S. Boring, *Sensation and Perception in the History of Experimental Psychology* (New York: Appleton – Century – Crofts, 1942), p. 145.

16. C. S. Sherrington, 'On reciprocal action in the retina as studied by means of some rotating discs', *Journal of Physiology* (London), 21 (1897), p. 42.

17. Walter S. Neff, 'A critical investigation of the visual apprehension of movement', *American Journal of Psychology*, VLVIII, no. 1 (January 1936), p. 4.

18. Ibid., p. 5.

19. Ibid., p. 6.

20. Max Wertheimer, 'Experimental studies on the seeing of motion', as reprinted in Thorne Shipley (ed.) *Classics in Psychology* (New York: Philosophical Library, 1961), pp. 1076–7.

21. Ibid., p. 1084.

22. Ibid., p. 1085.

23. Richard J. Hernstein and E. G. Boring (eds.), *A Source Book in the History of Psychology* (Cambridge, Mass.: Harvard University Press, 1965), p. 261.

24. Harry Helson, 'The psychology of Gestalt', *American Journal of Psychology*, 36 (1925), pp. 517–18.

25. Hernstein and Boring, op. cit., pp. 257–78.

26. Helson, op. cit., pp. 511–12.

27. Frederick A. Talbot, *Moving Pictures: How They Are Made and Worked* (Philadelphia: J. B. Lippincott, and London: William Heinemann, 1912), p. 3.

28. Ibid., p. 4.

29. Ibid., p. 5.

30. Hugo Munsterberg, *The Photoplay: A Psychological Study* (1916); reprinted as *The Film: A Psychological Study* (New York: Dover Publications, 1970), pp. 25–6.

31. Ibid., p. 29.

32. See Julian Hochberg, *Perception*, 2nd edn. (New York: Prentice-Hall, 1978).

33. Irvin Rock, *An Introduction to Perception* (New York: Macmillan Publishing Co., 1975), pp. 193–4.

34. Paul Kolers, *Aspects of Motion Perception*, International Series of Monographs in Experimental Psychology, Vol. 16 (New York: Pergamon Press, 1972), p. 36.

35. Ibid., p. 39.

36. Marguerite Biederman-Thorson, John Thorson and G. David Lange, 'Apparent movement due to closely spaced sequentially flashed dots in the human peripheral field of vision', *Vision Research*, Vol. 11 (1971), p. 897.

37. Oliver Braddick, 'The masking of apparent motion in random dot patterns', *Vision Research* vol. 13 (1973).

38. Christian Metz, *Film Language* (New York and London: Oxford University Press, 1974), pp. 7–9.

39. S. M. Anstis, 'Phi movement as a subtraction process', *Vision Research* vol. 10 (1970), p. 1419; A. Ratleff, 'A study of visual movements determined by form, color or brightness', *Acta Psychol.* vol. 12 no. 64 (1956).

40. Oliver Braddick, 'A short range process in apparent motion', *Vision Research* vol. 14 (1974).

41. Frederick A. Talbot, *Practical Cinematography* (London: Heinemann, 1913), pp. 14–15.

42. Bruno Breitmeyer, Rhonda Love and Barry Wepman, 'Contour suppression during stroboscopic motion and metacontrast', *Vision Research* vol. 14 (1974), p. 1453.

43. Kolers, op. cit., p. 15.

44. H. R. De Silva, 'An analysis of the visual perception of movement', *British Journal of Psychology* vol. 19 (1929); C. E. Osgood, *Method and Theory in Experimental Psychology* (New York: Oxford University Press, 1953); W. Kohler, 'Zur Theorie der strobokopischen Bewegung', *Psychol. Forschung* vol. 3 (1923).

45. Kolers, op. cit., p. 57.

46. Bela Julesz, *Foundations of Cyclopean Perception* (Chicago: University of Chicago Press, 1971).

47. Ulker Tulunay Keesey, 'Flicker and pattern detection: a comparison of thresholds', *Journal of the Optical Society of America* vol. 62 no. 3 (March 1972), pp. 446–8.

48. J. J. Kulikowski and D. J. Tolhurst, 'Psychophysical evidence for sustained and transient detectors in human vision', *Journal of Physiology* no. 232 (1973), pp. 159–60.

49. See Breitmeyer, Battaglia and Weber, 'U-shaped backward contour masking during stroboscopic motion', *Journal of Experimental Psychology: Human Perception and Performance* vol. 2 no. 2 (1976), pp. 170–1.

50. Breitmeyer, Love and Wepman, op. cit., p. 1454.

8. Flicker and Motion in Film

Bill Nichols and Susan J. Lederman

If the cinema differs from still photography in its ability to create the impression of motion, how is this effect achieved? – a simple question to which hoards of film books give a simple answer, 'persistence of vision'.

The catechism runs like this:

> According to the principle of persistence of vision, the eye retains the static image during the period of darkness, so that one image, in effect, is dissolved into the next to provide either a continuous view of a static image, or, more importantly, an illusion of continuous motion.
>
> Lincoln F. Johnson[1]

> The key to the success of this system of recording and projecting a series of still images that give the appearance of continuous movement lies in what Ingmar Bergman calls a certain 'defect' in human sight: persistence of vision. The brain holds an image for a short period of time after it has disappeared, so it is possible to construct a machine that can project a series of still images quickly enough so that they merge psychologically and the illusion of motion is maintained.
>
> James Monaco[2]

We hope to show that these and virtually every other account of the perception of movement in film texts are wrong. The impression of movement is not due to the persistence of vision. The very persistence with which this 'explanation' has been recited says more about the hermetic and impressionistic world of some film schol-

arship than it does about the actual mechanisms involved. Consequently, a secondary goal of this paper is to demonstrate the value of interdisciplinary research between film scholars and scientists in psychology and other disciplines.

To begin with, 'persistence of vision' is itself an imprecise term. We can only guess that film writers are referring to what psychologists call 'positive after-images'.[3] When a person stares at a light, he or she can still see it after the light has been turned off. Positive after-images retain the colour and brightness relations of the original stimulus. Common sense would suggest that the positive after-image is a plausible explanation for motion perception in film since it allows one image-frame ('image-frame' refers to the image perceived when a single frame of film is projected onto a screen; 'film-frame' refers to the actual frame of film itself) to 'bleed' into another, despite the fact that the beam of light projecting the film-frame is itself intermittent. *But this fusion occurs regardless of whether motion is perceived or not.* The appearance of a continuously visible series of images, in other words, is a phenomenon distinct from the appearance of motion.

Can 'persistence of vision' (which we now assume means positive after-images) explain either of these phenomena? Not according to research by psychologists. If this is so, we are then presented with a situation involving two distinct perceptual phenomena —*flicker* and *apparent motion*. We shall examine each in turn, bearing in mind that the perceptual mechanisms supporting these phenomena remain areas of active research in psychology today.

The first phenomenon is known as *visual flicker*. Flicker was a discernible problem in the early days of cinema when the frequency of light flashes was between 16 and 24 frames per second. Psychologists[4] have studied the nature of visual flicker by rotating a sectored disc with a light source directly behind it so that light passes through intermittently during the disc's rotation. This will yield different perceptual experiences at different speeds:

As the frequency of intermittence is increased to about 8 to 10 Hz, the light part of the cycle becomes brighter, and, to some, peculiarly unpleasant with a hypnotic quality. At higher frequencies, the alternation becomes less and less marked until only a faint tremulous appearance remains. Finally (above a certain threshold), the subject reports seeing a perfectly steady light which he is unable to distinguish from a stimulus that is

steadily illuminated and matched in color and brightness to the physically intermittent light.[5]

Fusion only occurs above a certain threshold frequency (called CFF — critical fusion frequency), which is dependent upon variables such as illuminance.[6] The typical relationship between these two variables is shown in Figure 1:

Figure 1 CFF as a function of intensity for several wavelengths

Source: H. R. Schiffman, *Sensation and Perception: An Integrated Approach* (New York and London: Wiley, 1976), reprinted by permission of John Wiley & Sons; the graph is modified from S. Hecht and S. Shlaer, 'Intermittent stimulation by light: The relation between intensity and critical frequency for different parts of the spectrum', *Journal of General Physiology* vol. 19 (1936), pp. 965–77.

CFF increases as the level of illuminance is increased. The relationship obtained suggests two important ideas which are relevant to our discussion of flicker in film.

First, the low rates of projection originally used in motion pictures were likely to have been below fusion threshold. The flicker perceived might thus have been the result of the visual system's ability to differentiate the on–off periods of successive frame presentations. The obvious solution to the problem was to pick a rate which the visual system could *not* resolve; that is to say, a frequency above which fusion occurs.

In the early days of motion pictures, it was discovered that this 24-frames/second rate was not pleasant to watch (due to flicker). By designing the (projector) shutter with two equally spaced

blades, it is possible to project each frame twice, thereby increasing the field to 48 times/second[7]

And where the level of illuminance is relatively high (where we would expect to find, as Figure 1 illustrates, a higher CFF) as in most 16mm projection, three blades can be used. This increases the rate to 72 'flicks' per second, and further ensures a smooth, continuously fused image.

The relationship between CFF and illuminance also makes it clear that 'visual persistence', that is to say positive after-images, *cannot* underlie the experience of fusion in motion pictures. Graham puts it succinctly:

> The early idea that fusion is the result of 'persistence' of vision and that it can be explained in relation to the duration of a positive after-image is obviously untenable. With an increase in the stimulation luminance, although the positive after-image lasts longer, CFF is elevated, that is, the value of 'persistence' based on fusion frequency *decreases*.[8]

Other work also challenges the role of positive after-images in film perception. When a relatively intense stimulus is briefly presented to a person placed in a dark room, as many as seven successive after-images are often observed.[9] This series involves alternating positive and negative after-images, an experience never to our knowledge reported during a film presentation. Furthermore, the first after-image, which is positive, does not occur until some 50 milliseconds after the cessation of the initial stimulus. During an equivalent period of time in the projection of a motion picture, however, not one but three successive image-frames would be presented. For this reason it is very unlikely that after-images contribute to the fusion of successive image presentations in film.

The result of the eye's summing successive image-frames over time is fusion, the elimination of flicker, but not necessarily any impression of movement. Fusion masks the work of the cinematic apparatus, the intermittent mechanism of the projector which blocks the projection of light during the interval when one frame replaces another in the projector gate. Fusion operates even in the projection of a shot of an absolutely stationary scene. It creates the impression of a solid, stable world of successive images *but does not yield the impression of movement.*

It seems safe to conclude that explanatory recourse to the term 'persistence of vision' is incorrect and outdated. It does not explain the absence of flicker from successive image-frames nor, as we will see next, does it explain apparent motion within those frames. Hopefully we have seen the last of film writing that ignores scholarship in other disciplines. This closed-mindedness provides an artificial life-support system, keeping alive concepts which ought to have died long ago.

Let us now turn to the second phenomenon, *apparent motion*. Clearly, apparent motion, 'the perception of movement when the stimulus is not moving physically',[10] rather than the perception of real movement is at work in film.[11] Each frame, a static image, is held absolutely stationary while light passes through it from the projector to the screen. Any impression of movement from one frame to the next must be apparent under these conditions.

Many kinds of apparent movement have been observed; J. O. Robinson's *The Psychology of Visual Illusion* catalogues most of them.[12] Of these the category pertinent to film perception is stroboscopic movement — 'the rapid and successive presentation of stationary stimuli'[13] — first investigated by Max Wertheimer.[14] Wertheimer, a founder of Gestalt psychology, seized upon the phenomenon of apparent movement to argue that the perception of movement was 'as direct an experience as . . . brightness or hue, an experience mediated by its own physiological mechanism rather than by experiences of change in position'.[15] (His point was in contradistinction to older structuralist theories of perception; these theories argued that complex perceptions like movement were the result of a summation of more basic sensations arising from the successive stimulation of points on the retina.[16]

Wertheimer's own experiments involved two short vertical lines separated by a short distance. They were presented sequentially with a brief interval between the two exposures. With very brief intervals, simultaneity was reported; with longer intervals, successiveness. At intermediate values, however, subjects reported different kinds of apparent movement. Since then, other forms of apparent movement have been discovered. A full description of the various forms of apparent motion (sometimes collectively referred to as 'phi phenomenon') is of some interest:

a) With a very short interstimulus interval, the stimuli appeared simultaneously.

b) Over a mid-range of intervals (from 30–200 milliseconds), various forms of apparent movement were reported.

　　1) alpha: apparent expansion and contraction seen when two physically or perceptually different stimuli are presented.

　　2) beta: apparent motion of the stimulus object from point 1 to point 2 (occurred at interval values around 60 milliseconds, but due to the considerable differences in the perception of film, we should not anticipate that the same values will hold true).

　　3) gamma: apparent expansion and contraction of the stimulus as the luminance is increased or decreased.

　　4) delta: apparently reversed motion when the second stimulus is brighter.

　　5) phi: 'pure' or disembodied movement without an attendant stimulus–object.

　　6) bow: apparent movement follows an arc around an obstruction between the lines in the third dimension rather than the shortest route.

c) With longer exposure intervals, the stimuli appeared successively without the appearance of movement.[17]

Of these the one most prevalent in cinema is beta movement (called 'optimal' movement by Wertheimer). The technological apparatus for recording and projecting motion pictures works to produce this phenomenon under a wide range of circumstances.[18]

Although the work of perceptual psychologists makes it very clear that the appearance of smooth, continuous movement in film is dependent upon exceeding the CFF and establishing the conditions necessary for beta movement, there is no experimental work we know of that explores the parameters within which the apparent movement of recognisable visually complex objects like people remains possible in film. Even under restricted experimental conditions such as Wertheimer's, where only two simple stimuli are utilised, there is an appreciable range of limits (some of which have been semi-formalised as Korte's Laws).[19]

These limits, however, pertain to carefully controlled conditions and can be stretched. Continued practice or learning leads to increased reports of beta movement, even under controlled conditions,[20] and 'the more nearly two stimuli presented in sequence connote a familiar moving object, the greater will be the range of

other stimulus variables (such as exposure duration, the interstimulus spatial separation, and the interstimulus temporal separation) giving rise to the perception of good apparent movement'.[21] Even when forms of apparent movement other than beta movement are present and discernible, most film-goers do not perceive them.[22]

Today, scientific research in this area aims primarily at determining the nature of the mechanisms involved in the perception of apparent movement. At this point two hypotheses are under investigation, although they are not mutually exclusive. Both hypotheses are well summarised in a recent paper by Jacob Beck and Albert Steven:

> The results (of the reported experiments) are interpreted to support the hypotheses that the perception of apparent movement involves the excitation of specific neural mechanisms selectively responsive to sequential changes in stimulus position. An alternative hypothesis is that the perception of apparent movement involves an inference based on the separate registrations of the position of that stimulus at an earlier point in time.[23]

This alternative hypothesis is pursued in a study by Sigman and Rock. They suggest that stroboscopic movement perception may be considered

> as the solution on the part of the perceptual system to the problem posed by the alternating appearance and disappearance of the stimulus objects. Under typical conditions there is no information provided which could account for such unexplainable stimulus change, so that movement is the plausible solution.[24]

Sigman and Rock set up conditions in which the alternating appearance and disappearance of two lights could be explained as continuously present lights which were progressively covered and uncovered by an object passing in front of them. Under such conditions, the subjects did not perceive apparent motion. 'These findings are interpreted as supporting the theory that perception results from a process analogous to intelligent problem solving'.[25] Although it remains quite likely that both movement–detection cells and a higher-order process of inference or 'filling in' are

involved, the only qualification about their possible relationship that can be advanced with certainty is that the work of a feature detector 'needs to be consistent with contextual stimulus information which indicates that motion is a plausible explanation of the alternating appearance and disappearance of the stimuli'.[26]

In this paper we have sought to correct a faulty explanation of some basic aspects of the film experience and to demonstrate the value of interdisciplinary collaboration. What remains is to specify how the phenomena described here contribute to the complex system of cinematic signification, especially the ideological function of the basic cinematic apparatus. This question exceeds the bounds of the present paper, but *at least* it can now be addressed with a more accurate account of flicker and motion perception in film in mind.

NOTES

1. L. F. Johnson, *Film, Space, Time* (New York: Holt, Rinehart and Winston, 1973), p. 3.
2. James Monaco, *How to Read a Film* (New York: Oxford University Press, 1977), p. 73.
3. Positive after-images are usually followed, perceptually, by negative after-images. These reverse brightness and colour relations: that is to say, bright becomes dark, colours become their complement (for example red shifts to blue-green). Such a phenomenon is only rarely observed in film: it is clearly not central to the perception of movement. For a treatment of these and other phenomena, see Clarence H. Graham (ed.), *Vision and Visual Perception* (New York and London: John Wiley and Sons, 1965).
4. Graham, op. cit., pp. 69–70. See also Lloyd Kaufman, *Sight and Mind: An Introduction to Visual Perception* (New York: Oxford University Press, 1974), for an explanation of visual flicker utilising linear systems analysis.
5. Leo Ganz, 'Vision', in B. Scharf (ed.), *Experimental Sensory Psychology* (Glenview, Illinois: Scott, Foresman and Co., 1975), p. 240.
6. In dim light the different wavelengths of light have separate thresholds but as illuminance increases the threshold becomes independent of wavelength.
7. Don V. Kloeptel (ed.), *Motion-Picture Projection and Theater Presentation Manual* (New York: Society of Motion Picture and Television Engineers, 1969), p. 28.
8. Graham, op. cit., p. 291.
9. Ibid., pp. 480–1.
10. Kaufman, op. cit., p. 392.
11. In the perception of real movement, for instance, a moving object stimulates all the intermediate points on the retina during its passage from point *a* to *b*. The perception of apparent movement occurs even though the intermediate points on the retina are not stimulated. Also, apparent movement occurs only

within certain rates of stimulation across the retina, far more limited in range than those under which real movement is perceived. Real movement produces a blur at very rapid speeds, whereas apparent movement produces the blurry effect called 'phi' at speeds lower than those that yield optimal movement ('beta'). Other marked differences have also been reported; for example: 'A line in real movement affects the perceptibility of objects in its path; a line in illusory movement does not.' (Paul A. Kolers, 'The illusion of movement', *Scientific American*, October 1964, p. 6.)

12. J. O. Robinson, *The Psychology of Visual Illusion* (London: Hutchinson, 1972).
13. E. Sigman and I. Rock, 'Stroboscopic movement based on perceptual intelligence', *Perception* vol. 3 no. 1 (1974), p. 9.
14. M. Wertheimer, 'Experimentelle Studien uber das Sehen von Bewegung', *Zeitschrift fur Psychologie* 61 (1912), pp. 161–265.
15. J. W. Kling and Lorrin A. Riggs (eds), *Experimental Psychology* (2 vols), 3rd edn (New York: Holt, Rinehart and Winston, 1972), vol. I, p. 527.
16. A summary of Wertheimer's experiment can be found in Kaufman, op. cit., pp. 393–4. The debate between structural and Gestalt theories is treated in Julian Hochberg, *Perception* (New York: Prentice Hall, 1964).
17. This summary is adapted from Kling and Riggs, op. cit., vol. I, pp. 525–6 and Graham op. cit., p. 581.
18. Other effects can be achieved, though in most films they are considered an annoyance. Certain image sequences involving overly large gaps between the successive locations of the stimulus can produce apparently discrete or saltatory (abrupt or jumpy) movement of the object. Sometimes rapid movements in a shot or jump cuts produce this effect as a result of crossing a perceptual threshold (partly dependent upon the visual angle subtended by the successive stimulus locations at the spectator's eye). For further treatment, see Edward Levonian, 'Perceptual threshold of discrete movement in motion pictures', *Journal of the Society of Motion Picture Engineers* 71 (April 1962), pp. 278–81. Some film-makers have deliberately explored questions of apparent movement. *Ray Gun Virus* by Paul Sharits, for example, produces gamma movement of the entire frame, one aspect of its investigation of the flicker phenomenon, while David Rimmer's *Surfacing on the Thames* sets out to eliminate the possibility of beta movement by an elaborate process of freeze frame printing and lap dissolves.
19. Summarised in Graham, op. cit., pp. 581–2.
20. W. Neuhaus, 'Experimentelle Untersuchung der Scheinbewegung', *Arch. ges. Psychol.* 75 (1930), pp. 315–458, summarised in Graham, op. cit., p. 582.
21. J. Beck, A. Elsner and C. Silverstein, 'Position uncertainty and the perception of apparent movement', *Perception and Psychophysics* vol. 21 no. 1 (1977), p. 33.
22. Levonian, op. cit., p. 280.
23. J. Beck and A. Steven, 'An after effect to discrete stimuli producing apparent movement and succession', *Perception and Psychophysics* vol. 12 no. 6 (1972), p. 482.
24. Sigman and Rock, op. cit., p. 9.
25. Ibid.
26. Beck, Elsner and Silverstein, op. cit., p. 37.

[In the absence of Susan Lederman who was unable to attend, this paper was presented at the conference by Bill Nichols alone; his presentation was accompanied by a demonstration using a device for showing flicker and motion effects designed by Susan Lederman and the Department of Psychology of Queen's University, Kingston whom we wish to thank here for their help. T de L/SH.]

9. Implications of the Cel Animation Technique

Kristin Thompson

I. INTRODUCTION

If technology were the only factor determining the creation of motion pictures, animated films would logically share a prominence equal to that of live-action films in the history of the cinema. Certainly the optical toys generally credited with having led up to the invention of the *cinématographe*, were more often dependent upon drawings than photographs. Emile Reynaud's Praxinoscope projected a moving strip of images onto a screen for a paying audience in 1892, three years before the Lumière première; his strips were hand-drawn, did not repeat in cycles as the zoetrope bands did, and lasted for several minutes each. Photographed onto modern film stock, they can still be shown as animated cartoons. (After the invention of the *cinématographe*, however, Reynaud did not adapt his method by photographing the drawings onto a strip of film).

Technologically, then, the animated cartoon was possible as soon as cinema itself existed in any form. In historical fact, early film-makers attempted animated films only as isolated experiments. J. Stuart Blackton's *Humorous Phases of Funny Faces*, often credited as the first regularly distributed cartoon, was made more than ten years after the Lumière première, in 1906. Emile Cohl, Winsor McCay and others made animated films, but, popular though these may have been, they did not succeed in rivalling live-action films; they did not, that is, establish cartoons as a *regular* part of the motion picture programmes of the pre-feature film era.

Indeed, there seems to have been no real concept of the animated film as a distinct mode for many years. The term 'animated film' meant not just cartoons but any motion picture film (as in Cecil

Hepworth's 1897 title, *Animated Photography*). As late as 1912, Frederick A. Talbot makes cartoons a mere subset of his lengthy section on 'trick films' in *Moving Pictures; How They Are Made and Worked*.[1] Animation, then, constituted a minor aspect of special effects; quite possibly the majority of audience members at this period had never seen a cartoon. By 1920, however, E. G. Lutz is able to write a whole book on animation and entitle it *Animated Cartoons*.[2] At some point in the intervening eight years, animation had become recognised as a distinct type of film-making.

One probable reason why cartoon film production lagged so far behind the invention of its technology is expense. The technique of drawn photographed frames typically costs more and takes longer than photographed live action. The Lumière brothers could photograph, develop and project a film, all within a single day. An animated cartoon of a similar length would have required several week's work at that time. This has remained true ever since. Not all live-action films are cheaper than animated ones, of course, but animated films have tended to cost more.

It is difficult to determine when critics, historians and audiences began to recognise animated cartoons as a distinct mode. By about 1913, these films started to show up fairly regularly on theatre programmes. Even so, they might have remained an occasional novelty were it not for the invention of celluloid, or 'cel', animation, by Earl Hurd and John Bray, which combined several recently-developed techniques and was itself patented in 1915.

Cel animation consists of separating portions of a drawing onto different layers to eliminate the necessity for re-drawing the entire composition for each movement phase. In the mid-teens, Raoul Barré developed the method for the actual separation of the picture parts with his 'slash' system, whereby a drawing of an entire character could be cut apart and traced onto separate cels.[3] Thus, using the slash system, the background might be on paper at the lowest level, the characters' trunks on one sheet of clear celluloid and the moving mouths, arms and other parts on a top cel. For speech and gestures, only the top cel need be re-drawn, while the background and lower cel are simply re-photographed.

This technique not only saves labour time for a single artist, but it also allows specialisation of labour. That is, one person may do the background, while another does certain main poses of the character, and yet another fills in the phases between these major poses. In fact, the animation industry has followed this pattern, with key anim-

ators (doing the major poses), 'in-betweeners', and 'opaquers' (filling in the figures with opaque paint) in addition to those performing the specialised tasks of scripting and planning. The specialisation process and the establishment of the first production companies for animated films took place from about 1915–17 — at the same time as the establishment of the Hollywood motion picture production system in general (also characterised by greater and greater specialisation of tasks — the 'factory' system).

Thus cel animation originated within the industry of a single country, the USA, and that country was in the process (during World War I) of becoming the leading production force in world cinema. Partly as a result, the cel technique quickly became defined within relatively narrow boundaries. These boundaries had as much to do with the developing Hollywood conception of the animated film as with the actual technical properties of the mode. Hollywood defined the cartoon by its difference from live-action films and it has remained a secondary form ever since. One symptom of this subsidiary position has been its short length; another is its position as a prelude to the feature on most programmes. Hollywood's conception of cel animation has, I shall argue, been developed partly as a defence against the disruptive properties of animation. By trivialising animation, Hollywood has made it compatible with the classical cinema as a whole, making it appeal to the same audience viewing habits.

II. THE IDEOLOGY OF HOLLYWOOD CEL ANIMATION

As Stephen Heath points out in the opening essay in this volume, early cinema was sold as a novelty based upon a machine. The programmes of short films did not depend upon the viewer's ability to differentiate films from each other beyond the title (to avoid the repeated viewing which negates the notion of novelty). Only after about a decade does this dependence primarily upon novelty as an attraction seem to have declined. During the period 1907–12, the cinema as a commercial institution developed strategies for drawing spectators to specific films: the star system, the dominance of the story, the companies' trademarks, genres and the use of elaborate spectacle. Films were now familiar enough that the novelty of the machine had become naturalised through familiarity. An ideology of the realism of depicted events had taken over.

Perhaps it is not coincidental that the decline of the novelty effect in live-action films coincided historically with the commercial beginnings of animation. These animated films echoed what had appealed to the spectator of more than a decade earlier: they appeared as novelties. As with live-action, the cartoons were also promoted as products of a mechanical process. Many of the early cartoons contained references to their unique mode of production. In Emile Cohl's films, a live-action hand occasionally enters the frame to manipulate the figures. Winsor McCay appears in live-action frame segments of both *Little Nemo* and *Gertie the Dinosaur*, where he makes bets with sceptics that he can make drawings move. In *Little Nemo* there follow scenes of McCay at work, surrounded by huge stacks of paper and barrels of ink. (His other films sometimes contain written prologues describing the laborious process which has produced the moving drawings). John Bray's first film, *The Artist's Dream* (1913), contains a similar live-action frame which motivates the animated portion as a dream. Other examples include the Fleischer brothers' 'Out of the Inkwell' series. References to the animation process are also a common device in later cartoons, such as *Duck Amuck* (1953).

For the film industry, the idea of films as magical, extraordinary things is valuable. This is evidenced by the continuous reference to Hollywood as 'the dream factory' (often by people within the industry). Clearly Hollywood does not want people to take movies too much for granted. As an institution, its strategy has always been largely to mystify the process of film-making. (Even when film-making appears in Hollywood films, the depiction inevitably opts for glamour and mystery rather than technological accuracy).

This conflict between the impulse towards naturalisation of films on the one hand and the desire to retain their novelty effect on the other confers a considerable value upon the animated film. The early cartoons place great emphasis on the marvel of mechanically reproduced movement; *Little Nemo* presents nothing beyond the characters' display of their own ability to move. Within a few years after their appearance, cartoons had become a regular part of motion picture programmes (usually as a split reel along with a newsreel). The juxtaposition with live-action films provided a constant reminder of the mechanical magic of the motion picture apparatus. (Note that programmes made up entirely of cartoon shorts were never part of Hollywood's appeal to the audience; only much later did this become an accepted practice and then only in

Europe). Cartoons also imitated live-action films, in that they quickly came to depend on stars (often derived from popular comic strips) and narrative. But always there remained the emphasis on the mechanics of production. Virtually everything written on animated films throughout their history has concentrated on the 'how-to' aspects. This contrasts with the writing done on live-action films, which is less concerned with the minutiae of technique. (One exception to this generalisation exists — the special effects film, which relates closely to, and sometimes depends upon, animation; here, too, the emphasis is often upon 'magic', as with the inevitable references to the special effects 'wizard').

During the late teens, twenties, and up into the fifties, film-makers and audiences maintained this ideological view of animation's difference; animation could do things live-action could not, and hence it came to be assumed that it *should* do only these things. As a result, cartoons did not opt for the naturalism of imitating live-action films. (Disney's impulse towards realism, described by Richard Schickel,[4] occurs mainly in his feature films, which are much closer to live-action features than are his shorts of the same period). Instead, cartoon production was broadly stylized, usually in imitation of comic strips; it used caricature, stretchiness and flatness in general defiance of the laws of nature. These are all familiar aspects of animation. Hence, only certain types of narratives were considered appropriate to the animated medium: all cartoons were supposed to be comic. Possibly this view originated partly from the fact that virtually all the animators of the silent period came into the business from being newspaper comic strip artists (Disney, coming from commercial art, was the first major exception). Also, comedy has traditionally been a mode which motivates extreme departures from canons of verisimilitude (as when Groucho advises the audience to go out to the lobby during a musical interlude in *Horse Feathers*). Since comedy so easily permitted the stylization thought 'natural' to the animated film, an ideological view of cartoons as comic developed.

Along with comedy, animated film narratives frequently drew upon fantasy, magic and traditional stories as a motivation for stylization. This encouraged an assumption that cartoons were for children, since they resembled narrative forms traditionally associated with children. For many years they appeared on programmes aimed at a 'family' audience and were sometimes constructed on several levels of humour to keep all ages entertained.

But a family audience is basically defined by the presence of children. As soon as films responded to television by in themselves aiming at specialised age groups, the animated cartoon declined as a regular part of theatre programmes.

The ultimate ideological result of the assumption that cartoons are for children was a trivialisation of the medium. The Hollywood ideology viewed cartoons as a minor subset of the cinema as a whole. Other genres — the documentary, experimental films and live action — have remained more prestigious to the present day; symptomatically, these other types are probably more frequently taught as separate college courses than is animation.

In sum, the ideology of Hollywood cel animation for many years was that cartoons are secondary to live action, virtually always comic and/or fanciful, for children and trivial. Such films were valuable for Hollywood because they brought the mystery of movie technology to the fore, impressing people with the 'magic' of cinema. Animation made cinema a perpetual novelty.

This situation seems to have lasted until the serious incursions into the market made by television in the fifties. In the mid-fifties television started buying libraries of old cartoons and then commissioning new films to be produced specifically as television series. Television at last revealed the implicit ideology of animation as a trivial children's form by putting its shows on at after-school hours, on Saturday mornings and in the early evening dinner hour. Now the large majority of the audience was children, with parents only occasionally watching along (most notably for the early syndicated Hanna–Barbera evening series and the later specials). Adults no longer see animated films on a regular basis and subsequent attempts to develop animated films specifically for an adult movie audience have been only sporadically successful.

Thus with the popularisation of television, animation from Hollywood has largely ceased to serve its traditional ideological function; it has indeed ceased to be a major force in American theatrical film-making. In a sense, the current trend towards special effects films (for example *Star Wars*, *Close Encounters of the Third Kind*) may be replacing it in that function. Audiences have gained a new orientation towards the mysterious, complex process of film-making, as promoted by articles in popular magazines. Interest in the cinema as a technical marvel has again been renewed, to Hollywood's greater financial advantage.

The Hollywood conception of the animated film has been

remarkably successful. Critics and theorists have largely avoided the subject, implicitly accepting the view of the cartoon as trivial. Those who do treat the animated film as an important form have often done so by comparing certain films with other, culturally accepted art forms; a UPA cartoon is seen as being like a Picasso or Modigliani painting.[5] Foreign and independent American film-makers who have attempted to create an alternative view of the animated film as a non-trivial mode have been only minimally successful. Frequently they have rejected cel animation as already ideologically tainted, due mainly to its typical subject matter. Alexandre Alexeïeff and Claire Parker created their pinboard specifically because, as Alexeïeff said, 'I considered the animated cartoon good for comics, not for the poetic atmosphere which was the life-substance of my engravings.'[6] Prior to the advent of television many of the most famous foreign animators worked in alternative forms such as puppet and silhouette animation. This tactic has allowed them to escape somewhat the stigma of the trivial cel cartoon. In order to receive serious attention, an animated film often needs to slide over into the more respectable classification of the 'experimental' film, as with John Whitney's computer work.

III. STRETCH AND SQUASH

'We use a great deal of perspective.'

Chuck Jones[7]

Although the Hollywood view of cel animation has been historically prevalent, some film-makers have approached the mode in entirely different ways. Indeed, I would argue that the cel technique has several unique features which would tend to promote formal play of a potentially disruptive kind. Hollywood film-making has largely recuperated these features by subordinating them to its ideological purposes.

Cel animation creates space in a manner more like the traditional graphic arts than live-action film-making. Animation uses the same depth cues (size, partial overlap, attached shadows, cast shadows, aerial perspective, detail perspective, texture gradient, linear perspective, colour, filled vs unfilled space and blurring of close objects[8]) and perspective systems as in painting or drawing; it also can add the depth cue of motion (temporal parallax — the shifting

of picture planes at different rates according to their real or apparent distance).

The crucial aspect of cel animation is its separation of the different foreground and background layers. Typically, the background layer(s) remains constant throughout a shot, while the cels for the moving figures must be frequently redrawn. This difference in the amount of work involved in the background and foreground tends to promote a split between the types of depth cues used in the separate layers. For the artist, the addition of more elaborate depth cues is easier in the backgrounds than in the figures themselves. Particularly in the cartoons of Disney, the Fleischer brothers, and Warner Bros, backgrounds tend to contain depth cues like attached and cast shadows, linear perspective, detail perspective, and occasionally even aerial perspective (the latter is apparent, for example, in Disney's Silly Symphony *Flowers and Trees* or in Clampett's *Bugs Bunny Gets the Boid*). The moving figures rely on far simpler cues like size, colour and overlap. It would be relatively difficult for animators and opaquers to match attached shadows on the figures from shot to shot. (Even Disney's remarkable technical skill is not always up to it; in *Pinocchio*'s scene of Gepetto going to bed, the highlight and shadow on his hair flicker from frame to frame).

In practice, this visual difference between backgrounds and figures has led to a considerable mixing of whole perspective systems within single films. The flat representation of space used in cel animation (except for Disney's multi-plane camera or the short-lived 3-D effort) means that the film is not dependent upon the lens for its formation of perspective, as live action is. Hence the same composition may contain elements rendered in a linear perspective system, while other elements employ an isometric system. The frame illustration (Plate 1) from an early Merrie Melody, *Smile, Darn Ya, Smile* (1931, Hugh Harman–Rudolf Ising) contains a crude example of the potential conflict of perspective systems; here the streetcar appears in an unsteady cross between linear and isometric perspective, sitting on a track done with a distinct linear vanishing point: the car appears to be askew on the tracks. Other shots of the tracks straight-on indicate that the tracks' ties are supposed to be parallel and fairly close together.

In this case, the mixture results from the crudeness of the drawing. But much of the perspective mixture and distortion of cel animation comes from specific strategies animators have worked out

to deal with the special features of the mode. Animators have developed two terms — 'stretch' and 'squash' — to describe the distortions of characters' figures which occur in time; a character being hit might stretch, while one dropped from a height would squash upon striking the ground. In spite of the character distortion, the backgrounds and other figures remain unchanged, which produces a further conflict between perspective systems. The figure in such cases is rendered in a system somewhat analogous to anamorphic perspective. Traditional anamorphic art-works typically attempt to force the viewer to move to a precise spot from which the picture appears relatively undistorted. In cartoons the viewer does not move; instead, the distortion usually has a narrative motivation. In the frame (Plate 2) from the Warner Bros film *Draftee Daffy* (Robert Clampett, 1943), the character's head is squashed. The narrative situation has him reacting as he watches Daffy's off-screen fall to earth after a bomb blast; the violence is displaced onto the figure of the man and thus motivates the use of squash. Not every instance of squash has a narrative motivation, however. McCay's *Little Nemo* includes a brief segment (Plate 3) in which Nemo stands bowing in the centre, presenting his two friends at either side, who stretch up and squash down rhythmically. Here showing off the novelty of the cartoon mode provides the only excuse for the device.

In addition to utilising the depth cues and perspective systems of the traditional graphic arts, cel animation has developed its own perspective peculiarities, resulting from the demands of the medium. Camera movements have to be simulated frame-by-frame in most cases. A track in any direction is relatively simple; a lengthening of the background provides the space necessary to allow the camera's apparent shift. But a pan presents greater difficulties. Were the camera simply to swivel, as in live-action, the background would become increasingly slanted away from the lens. Hence apparent 'pans' must be handled as tracks, with the camera moving without swivelling. The appearance of a pan arises from false perspective cues. The centre of the pan must be rendered as the largest portion, with two vanishing points, one at either end of the pan. The resulting background drawing is like linear perspective turned inside out, with its centre protruding rather than receding. Chuck Jones is particularly adept at this, using numerous pans up and down buildings, or around the interiors of rooms. Plate 4 is a composite, showing several stages of a tilt-up from *Hare Conditioned*

(1945) assembled into an approximation of the original background drawing. On the screen, the distortion tends to disappear, since only small portions of the drawing are visible at any one time; the result is often a remarkably good simulation of a pan. Nevertheless, the false perspective used in 'pans' can be seen during screening by anyone aware of its presence.

Finally, cartoon drawings sometimes use or imitate perspective cues of live-action filming. Cutting into a space may establish spatial relations, and cartoons use analytical editing in a way similar to live-action They also can imitate the effects of different lens lengths; some backgrounds incorporate the curving, distorted appearance of near objects characteristic of a wide-angle lens. Jones's *The Aristo-cat* (1943) has a sequence in a library where the shelves curve upward toward the foreground; the cat in this scene diminishes rapidly in size as he backs into a corner. Overhead shots of buildings also occasionally create concave lines flaring out toward the top to imitate the wide-angle lens effect.

Cartoons handle temporal relations in a necessarily conventional way. In live-action, action usually occurs in 'real time' (a term in animation indicating any footage shot and projected at the same rate); there is a reasonably clear distinction between this standard speed, slow or fast motion, and freeze-frames. But speed in the animated film involves something closer to a continuum. The difficulty of re-drawing every frame leads to short-cuts which affect temporal relations. Full animation usually uses exactly the same composition for two successive frames; only a high-budget film or a very fast movement will use change at every frame. This is not detectable in a screening, but already the rhythm of movement tends to differ from live-action.

Cel animation encourages the use of freezes for portions of a scene not involved in the action. One absolutely static figure may stand next to a frantically moving one. Even when both figures are moving, the difference between frames on one can be increased greatly to render the illusion of speed, while the other figure could be done with very small changes, resulting in slowness. Again, this contrast of speeds tends to differentiate animation from live-action.

But speed in the animated cartoon does not depend only on the amount of change between cels. Hollywood animators have developed a whole set of conventions for signifying speed, quite apart from the actual speed of the figures' motion. As far as I have been able to determine, there are no general names for these

conventions as there are for spatial distortion; they are, however, the temporal equivalents of stretch and squash in spatial relations.

In 'squashing' time, the animator reduces the apparent time of an action, often by using a conventional speed indicator. For example, a character's move across a room might be rendered with the figure as simply a streak of paint; a similarly fast track across the background may reinforce the illusion of an action so fast it becomes a blur. Chuck Jones uses this method quite often; a streak of paint with several sets of eyes may constitute the entire figure in a couple of successive frames — the movement across a room occupying only these two frames. (No strictly comparable effect is possible in live-action, since a pan or track exactly with the moving character would render only the background plane as a blur).

A rare device of superimposed image occurs in Jones's *Conrad the Sailor* (1941). As Daffy runs into the frame and stops suddenly, his figure appears as several superimposed Daffies, which run in separately and join together to form a single, solid Daffy (Plate 5). This device, unusual though it is, demonstrates that signifiers for speed need not themselves occur quickly. The joining-up of the multiple Daffies takes longer than a single figure running quickly into the frame would. Animators could devise any number of similar techniques with each being a purely conventional signal for speed.

Metaphors provide another type of speed signal. In *Draftee Daffy*, Daffy's runs through the house seem to become faster and faster, as his body changes into a lightning bolt and a shower of sparks. Here the figure remains virtually static in the frame, while the backgrounds move quickly behind it. Again, the conventional signal suggests a speed which is not actually there in the figure itself.

One of the most interesting speed indicators involves the use of multiple figures of the same character. This tends to occur in very fast actions; Robert Clampett often uses this method as an alternative to Jones's blurs of paint. In such a scene, the images of the character multiply in the frame, often combining with stretch effects. Sometimes the character may grow extra hands, feet or heads. The illustration from *Draftee Daffy* (Plate 6) shows a frame with at least five Daffies running in various directions. Clampett has even been able to suggest this frantic movement without having the multiple, black Daffies merge into each other: he makes two of the figures lavender-coloured, to separate the Daffies visually. This device depends partly on the assumption that the audience will perceive the action indistinctly in projection. Yet once we know

they are present, they become quite easy to spot; the purple Daffies are apparent in *Draftee Daffy*, even at 24 frames per second. But invisibility is not entirely necessary. The multiplication of characters or their limbs is a familiar convention of comic strip art as well; there it is entirely visible to the perceiver.

Other conventional devices indicate 'stretched' time, in addition to the obvious approach of using little change between frames. Cartoons offer considerable potential for prolonging an event. This does not necessitate overlapping editing of the Eisensteinian variety, since movement can occur before backgrounds which extend for any distance. We have all seen cartoons in which characters move through rooms that appear to be miles long, as the same background drawing is run through again and again; the characters repeatedly pass the same lamps and doorways. This prolongation results simply from identical repetition within a single action. A similar effect often occurs in figure movement; the literal re-use of the same set of cels (for example, for walking, waving arms, laughing gestures) is called a 'cycle'. An action in cycles may take place at a relatively fast pace, but the repetition will make the entire action last longer. A cartoon may also prolong action by having a character move through a series of different backgrounds during the execution of a single basic action; this happens especially in scenes of lengthy falls. Clampett's *Falling Hare* (1943) ends with the extremely prolonged fall of an aeroplane.

Cartoons stretch time in another, simpler way by introducing freezes – the repeated photographing of the same composition. Tiny freezes are virtually inevitable in cel animation. They can be brief, as with Daffy's annoyed glances out in *Duck Amuck*, or quite lengthy. Generally the freeze is less noticeable in cartoons than in live action, since the device appears so frequently; as Norman McLaren has pointed out, for most animation techniques, including cel, 'the static image is the easiest footage to obtain, and the mobile the most difficult.'[9] These freezes do not typically signify a break in the temporal flow (as is frequently the case in live-action freezes); rather, they slow it down.

Another method for slowing down action resembles freezing: individual portions of the character move in turn while the others remain frozen. Quite often, when the Coyote falls off a cliff, his movement out of the frame begins with his legs, which then stretch to permit his body to remain suspended in space; the body then leaves, with the neck stretching, and finally the head follows. The

slash system of doing cels makes this temporal segmentation possible.

All these devices of spatial and temporal construction offer the cel film a great potential for disruption of expectations. The separation of elements onto different levels allows the artist complete control over each, plus the possibility of creating contradictions. Like Escher's engravings, cartoons could systematically build an impossible space as a locale for narrative action. (Systematically, that is, as opposed to the *Smile, Darn Ya, Smile* frame, which mixes perspective systems through simple miscalculation). The same would be true for time.

Jones's *Duck Amuck*, for example, systematically undermines the depth cues of the background layer. First, Daffy moves past a background with multiple depth cues. Within the same shot, the colour disappears, followed by the outlines, to leave a white void behind Daffy (Plate 7). As he moves along, farm settings merge into arctic ice fields, and so on, all without a cut. To a certain extent, this contradictory space is matched by contradictory time. When the image becomes apparently mis-framed, the Daffy of the lower half climbs up to confront the Daffy of the 'previous' frame. The two images which have served to create successive movements join on a single frame of film. A few other films have used isolated devices of this sort. Some employ the *Persona* trick of apparently breaking the film (for example the Fleischers' *Boonland* (1938) and Jones's *Rabbit Punch* (1947)). But *Duck Amuck* is perhaps the furthest a Hollywood film has gone in utilising the technique of cel animation to undermine conventional cartoon structures.

IV. CONCLUSIONS

This study's implications for the Hollywood cinema go beyond the animated films themselves. We have seen how cartoons use some devices which are potentially very disruptive (for example, mixtures of perspective systems, anti-naturalistic speed cues). As we might expect within the classical Hollywood system, however, narrative and comic motivations smooth over these disruptions. Even a film as radical in its devices as *Duck Amuck* remains quite readable to an audience accustomed to watching Daffy in his more characteristic films. As always, film techniques and technology are not in themselves radical; they become so only when used within the structure of a complete film.

PLATE 1 *Smile, Darn Ya, Smile*

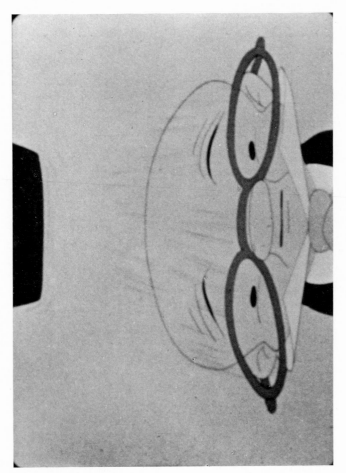

PLATE 2 *Draftee Daffy*

PLATE 3 *Little Nemo*

PLATE 4 *Hare Conditioned*

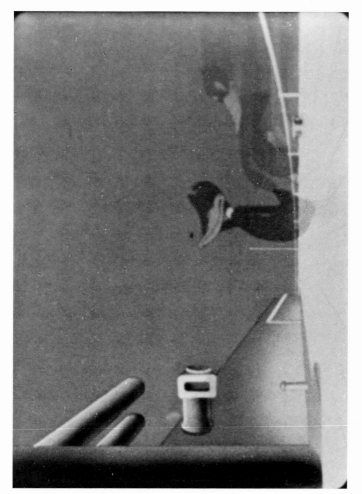

PLATE 5 *Conrad the Sailor*

PLATE 6 *Draftee Daffy*

PLATE 7 *Duck Amuck*

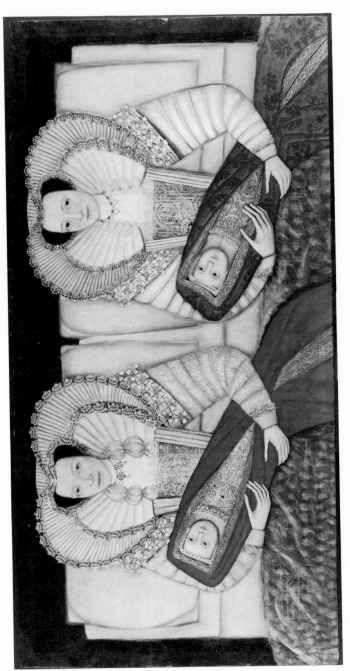

PLATE 8 *The Cholmondeley Sisters*

A counter-example to the Hollywood cinema would be an animated film such as Robert Breer's *Fuji* (1974). Breer has taken one of the (apparently) least daring and flexible devices of cel animation, the rotoscope.[10] The bulk of the film consists of crude rotoscoped outlines of human figures and the landscapes of Mt Fuji, with flickering washes of changing solid colors. Yet Breer juxtaposes this footage with the original live-action footage used for the rotoscoping and even in some places traces directly around the figures in the live-action images. The images repeat and vary with no narrative progression.

The mixture of live action and cel animation is nothing new; Hollywood has often used this technique. But Breer's use of the rotoscoping to combine shaky, dim images with crude tracings goes against the entire Hollywood ideology of technical smoothness, the mystification of the novelty of movement and the use of animated films for comic, trivial narratives. Breer's images go frame by frame, but the change is so great that the illusion of movement occasionally almost disappears, to be replaced by an effect that approaches a flicker technique. In spite of *Fuji*'s neutral subject matter, it is a quite radical cel film, because it uses a system of devices that opposes the ideology of the classical Hollywood cartoon.

Recent study of the live-action film has demonstrated that a large middle ground lies between the avant-garde and the historically dominant classical Hollywood system. Without eschewing narrative structures, film-makers like Bresson, Ozu, Tati, Eisenstein and many others have created alternative formal approaches. In animation, this middle ground has historically consisted primarily of film-makers (for example, Alexeieff and Parker, Lotte Reiniger, Ladislas Starevitch, Oskar Fischinger) working in non-cel modes. Relatively few cel cartoons have been made using alternative approaches comparable to those in live action.

The fact that cel animation lends itself so readily to disruptive formal strategies suggests one reason why the conservative Hollywood ideology of cartoons developed as it did (making it difficult to break away from its system without going to an opposite extreme). Since disruption unmotivated by narrative is unwelcome in the classical system, Hollywood needed to tame the technology. Trivialisation provided the means. While the classical Hollywood system as a whole may have been a relatively limited definition of cinema, the animated films made within that system had even narrower boundaries.

NOTES

This article emerged from a course taught by the author at the University of Wisconsin, Summer, 1978; thanks to David Bordwell and Janet Staiger for their comments on the manuscript.

1. Frederick A. Talbot, *Moving Pictures, How They Are Made and Worked* (Philadelphia: J. B. Lippincott Company, 1912).

2. E. G. Lutz, *Animated Cartoons* (New York: Charles Scribner's Sons, 1920).

3. This and other information about the early invention of animated films from Nat Falk, *How To Make Animated Cartoons* (New York: Foundation Books, 1941), pp. 17–18.

4. Richard Schickel, *The Disney Version* (New York: Avon, 1968).

5. See title pages, Robert Benayoun, *Le Dessin animé après Walt Disney* (Paris: Jean-Jacques Pauvert, 1961). UPA (United Productions of America) was set up in the 1940s by a breakaway group of animators from the Disney Studios and developed a distinctive and highly influential style, usually described in such terms as 'economical vivacity', 'spare elegance' and so on.

6. Robert Russett and Cecile Starr (eds), *Experimental Animation* (New York: Van Nostrand Reinhold Company, 1976), p. 92.

7. Mike Barrier, 'An Interview with Chuck Jones', *Funnyworld* no. 13 (Spring 1971), p. 6.

8. As listed in Daniel J. Weintraub and Edward L. Walker, *Perception* (California: Brooks/Cole Publishing Co., 1966), pp. 22–9.

9. Russett and Starr, op. cit., p. 123.

10. A rotoscope is a projection device which allows the film-maker to trace, frame by frame, live-action footage.

10. Machines of the Visible

Jean-Louis Comolli

INTRODUCTION

One of the hypotheses tried out in some of the fragments here gathered together would be on the one hand that the cinema—the historically constitutable cinematic statements—functions with and in the set of apparatuses of representation at work in a society. There are not only the representations produced by the representative apparatuses as such (painting, theatre, cinema, etc.); there are also, participating in the movement of the whole, the systems of the delegation of power (political representation), the ceaseless working-up of social imaginaries (historical, ideological representations) and a large part, even, of the modes of relational behaviour (balances of power, confrontations, manoeuvres of seduction, strategies of defense, marking of differences or affiliations). On the other hand, but at the same time, the hypothesis would be that a society is only such in that it is *driven by representation*. If the social machine manufactures representations, it also manufactures *itself* from representations—the latter operative at once as means, matter and condition of sociality.

Thus the historical variation of cinematic techniques, their appearance-disappearance, their phases of convergence, their periods of dominance and decline seem to me to depend not on a rational-linear order of technological perfectibility nor an autonomous instance of scientific 'progress', but much rather on the offsettings, adjustments, arrangements carried out by a social configuration in order to represent itself, that is, at once to grasp itself, identify itself and itself produce itself in its representation.

What happened with the invention of cinema? It was not sufficient that it be technically feasible, it was not sufficient that a

camera, a projector, a strip of images be technically ready.[1]
Moreover, they were already there, more or less ready, more or less
invented, a long time already before the formal invention of cinema,
50 years before Edison and the Lumière brothers. It was necessary
that something else be constituted, that something else be formed:
the *cinema machine*, which is not essentially the camera, the film, the
projector, which is not merely a combination of instruments,
apparatuses, techniques. Which is a machine: a *dispositif* articulat-
ing between one another different sets – technological certainly, but
also economic and ideological. A *dispositif* was required which
implicate its motivations, which be the arrangement of demands,
desires, fantasies, speculations (in the two senses of commerce and
the imaginary): an arrangement which give apparatus and tech-
niques a social status and function.

The cinema is born immediately as a social machine, and thus not
from the sole invention of its equipment but rather from the
experimental supposition and verification, from the anticipation
and confirmation of its *social profitability*; economic, ideological and
symbolic. One could just as well propose that it is the spectators who
invent cinema: the chain that knots together the waiting queues, the
money paid and the spectators' looks filled with admiration.
'Never', say Gilles Deleuze and Claire Parnet, 'is an arrangement-
combination technological, indeed it is always the contrary. The
tools always presuppose a machine, and the machine is always social
before it is technical. There is always a social machine which selects
or assigns the technical elements used. A tool, an instrument,
remains marginal or little used for as long as the social machine or
the collective arrangement-combination capable of taking it in its
phylum does not exist.'[2] The hundreds of little machines in the
nineteenth century destined for a more or less clumsy reproduction
of the image and the movement of life are picked up in this 'phylum'
of the great representative machine, in that zone of attraction,
lineage, influences that is created by the displacement of the social
co-ordinates of analogical representation.

The second half of the nineteenth century lives in a sort of frenzy
of the visible. It is, of course, the effect of the social multiplication of
images: ever wider distribution of illustrated papers, waves of prints,
caricatures, etc. The effect also, however, of something of a
geographical extension of the field of the visible and the represent-
able: by journies, explorations, colonisations, the whole world

becomes visible at the same time that it becomes appropriatable. Similarly, there is a visibility of the expansion of industrialism, of the transformations of the landscape, of the production of towns and metropolises. There is, again, the development of the mechanical manufacture of objects which determines by a faultless force of repetition their ever identical reproduction, thus standardising the idea of the (artisanal) copy into that of the (industrial) series. Thanks to the same principles of mechanical repetition, the movements of men and animals become in some sort more visible than they had been: movement becomes a visible mechanics. The mechanical opens out and multiplies the visible and between them is established a *complicity* all the stronger in that the codes of analogical figuration slip irresistibly from painting to photography and then from the latter to cinematography.

At the very same time that it is thus fascinated and gratified by the multiplicity of scopic instruments which lay a thousand views beneath its gaze, the human eye loses its immemorial privilege; the mechanical eye of the photographic machine now sees *in its place*, and in certain aspects with more sureness. The photograph stands as at once the triumph and the grave of the eye. There is a violent decentring of the place of mastery in which since the Renaissance the look had come to reign; to which testifies, in my opinion, the return, synchronous with the rise of photography, of everything that the legislation of the classic optics – that geometrical *ratio* which made of the eye the point of convergence and centring of the perspective rays of the visible – had long repressed and which hardly remained other than in the controlled form of anamorphoses: the massive return to the front of the stage of the optical aberrations, illusions, dissolutions. Light becomes less obvious, sets itself as problem and challenge to sight. A whole host of inventors, lecturers and image showmen experiment and exploit in every way the optical phenomena which appear irrational from the standpoint of the established science (refraction, mirages, spectrum, diffraction, interferences, retinal persistence, etc.). Precisely, a new conception of light is put together, in which the notion of wave replaces that of ray and puts an end to the schema of rectilinear propagation, in which optics thus overturned is now coupled with a chemistry of light.

Decentred, in panic, thrown into confusion by all this new magic of the visible, the human eye finds itself affected with a series of limits and doubts. The mechanical eye, the photographic lens,

while it intrigues and fascinates, functions also as a *guarantor* of the identity of the visible with the normality of vision. If the photographic illusion, as later the cinematographic illusion, fully gratifies the spectator's taste for delusion, it also reassures him or her in that the delusion is in conformity with the norm of visual perception. The mechanical magic of the analogical representation of the visible is accomplished and articulated from a doubt as to the fidelity of human vision, and more widely as to the truth of sensory impressions.

I wonder if it is not from this, from this lack to be filled, that could have come the extreme eagerness of the first spectators to *recognise* in the images of the first films – devoid of colour, nuance, fluidity – the identical image, the double of life itself. If there is not, in the very principle of representation, a force of disavowal which gives free rein to an analogical illusion that is yet only weakly manifested by the iconic signifiers themselves? If it was not necessary at these first shows to forcefully deny the manifest difference between the filmic image and the retinal image in order to be assured of a new hold on the visible, subject in turn to the law of mechanical reproduction . . .

I. THE CAMERA SEEN

The camera, then.

For it is here indeed, on this *camera-site*, that a confrontation occurs between two discourses: one which locates cinematic technology in ideology, the other which locates it in science. Note that whether we are told that what is essential in the technical equipment which serves to produce a film has its founding origin in a network of scientific knowledges or whether we are told that that equipment is governed by the ideological representations and demands dominant at the time it was perfected, in both cases – discourse of technicians on the one hand, attempts to elaborate a materialist theory of the cinema on the other – the example given is *always* that which produces the cinematic *image*, and it *alone*, considered from the sole point of view of *optics*.[3]

Thus what is in question is a certain *image* of the camera: metonymically, it represents the whole of cinema technology, it is the part for the whole. It is brought forward as the *visible part* for the *whole of the technics*. This symptomatic displacement must be

examined in the very manner of posing the articulation of the couple Technology/Ideology.

To elect the camera as 'delegated' representative of the whole of cinematic equipment is not merely synecdochical (the part for the whole). It is above all an operation of reduction (of the whole to the part), to be questioned in that, *theoretically*, it reproduces and confirms the split which is ceaselessly marked in the technical practice of cinema (not only in the practice of film-makers and technicians and in the spontaneous ideology of that practice; but also in the 'idea', the ideological representation that spectators have of work in cinema: concentration on shooting and studio, occultation of laboratory and editing) between the *visible* part of the technology of cinema (camera, shooting, crew, lighting, screen) and its '*invisible*' part (black between frames, chemical processing, baths and laboratory work, negative film, cuts and joins of editing, sound track, projector, etc.), the latter repressed by the former, generally relegated to the realm of the unthought, the 'unconscious' of cinema. It is symptomatic, for example, that Lebel, so concerned to assert the scientific regulation of cinema, thinks to deduce it only from geometrical optics, mentioning only once retinal persistence which nevertheless is what brings into play the specific difference between cinema and photography, the synthesis of movement (and the scientific work which made it possible); at the same time that he quite simply forgets the other patron science of cinema and photography, photochemistry, without which the camera would be no more precisely than a *camera obscura*. As for Pleynet's remarks, they apply indiscriminately to the quattrocento *camera obscura*, the seventeenth century magic lantern, the various projection apparatus ancestors of the *cinématographe* and the photographic apparatus. Their interest is evidently to indicate the links that relate these diverse perspective mechanisms and the camera, but in so doing they risk not seeing exactly what the camera hides (it does not hide its lens): the film and its feed systems, the emulsion, the frame lines, things which are essential (not just the lens) to cinema, without which there would be no cinema.

Hence it is not certain that what is habitually the case in practice should be reproduced in theory: the reduction of the hidden part of technics to its visible part brings with it the risk of renewing the domination of the visible, that *ideology of the visible* (and what it implies: masking, effacement of work) defined by Serge Daney:

Cinema postulated that from the 'real' to the visual and from the visual to its filmed reproduction a same truth was infinitely reflected, without distortion or loss. In a world where 'I see' is readily used for 'I understand', one conceives that such a dream had nothing fortuitous about it, the dominant ideology – that which equates the real with the visible – having every interest in encouraging it But why not, going further back still, call into question what both serves and precedes the camera: a truly blind confidence in the visible, the hegemony, gradually acquired, of the eye over the other senses, the taste and need a society has to put itself in spectacle, etc. The cinema is thus bound up with the Western metaphysical tradition of seeing and vision whose photological vocation it realizes. What is photology, what could be the discourse of light? Assuredly a teleological discourse if it is true, as Derrida says, that teleology 'consists in neutralizing duration and force in favour of the *illusion* of simultaneity and form'.[4]

Undeniably, it was this 'hegemony of the eye', this specularisation, this ideology of the visible linked to Western logocentrism that Pleynet was aiming at when stressing the pregnancy of the quattrocento perspective code in the basic apparatus: the image produced by the camera cannot do otherwise than confirm and reduplicate 'the code of specular vision such as it is defined by the renaissant humanism', such that the human eye is at the centre of the system of representation, with that centrality at once excluding any other representative system, assuring the eye's domination over any other organ of the senses and putting the eye in a strictly divine place (Humanism's critique of Christianity).

Thus is constituted this situation of *theoretical paradox*: that it is by identifying the domination of the camera (of the visible) over the whole of the technology of cinema which it is supposed to represent, inform and programme (its function as *model*) that the attempt is made to denounce the submission of that camera, in its conception and its construction, to the dominant ideology of the visible.

If the gesture privileging the camera in order to set out from it the ideological chain in which cinema is inscribed is theoretically grounded by everything that is implied in that apparatus, as in any case by the determining and principal role of the camera in the production of the film, it too will nevertheless remain caught in the same chain unless taken further. It is therefore necessary to change

perspective, that is, to take into account what the gesture picking out the camera sets aside in its movement, in order to avoid that the stress on the camera – necessary and productive – is not reinscribed in the very ideology to which it points.

It seems to me that a materialist theory of the cinema must at once disengage the ideological 'heritage' of the camera (just as much as its 'scientific heritage', for the two, contrary to what seems to be stated by Lebel, are in no way exclusive of one another) and the ideological investments in that camera, since neither in the production of films nor in the history of the invention of cinema is the camera alone at issue: if it is the fact that what the camera brings into play of technology, of science and/or ideology is determining, this is so only in relation to other determining elements which may certainly be secondary relative to the camera but the *secondariness* of which must then be questioned: the status and the function of what is covered over by the camera.

To underline again the risk entailed in making cinema function theoretically entirely on the *reduced model* of the camera, it is enough to note the almost total lack of theoretical work on the sound track or on laboratory techniques (as if the sight of light – geometrical optics – had blocked its work: the chemistry of light), a lack which can only be explained by the dominance of the visible at the heart of both cinematic practice and reflection. Is it not time, for example, to bring out the ideological function of two techniques (instruments + processes + knowledges + practice – interdependent, together to realise an *aim*, an objective which henceforth constitutes that technique, founds and authorises it), both of which are on the side of the hidden, the cinematic unthought (except by very few filmmakers: Godard, Rivette, Straub): *grading* and *mixing?*

II. COVERING OVER AND LOSS OF DEPTH OF FIELD

No more than in the case of the 'close-up' is it possible to postulate a continuous chain (a filiation) of 'depth-of-field shots' running through the 'history of cinema'. No more than in the case of the 'close-up' (or of any other term of cinematic practice and technical metalanguage) is the history of this technical disposition possible without considering determinations that are *not exclusively technical* but economic and ideological: determinations which thus go beyond the simple realm of the cinematic, working it over with

series of supplements, grasping it on other scenes, having other scenes inscribe themselves on that of cinema. Which shatter the fiction of an autonomous history of cinema (of its 'styles and techniques'). Which effect the complex articulation of this field and this history with other fields, other histories. Which thus allow the taking into account, here for the particular technical procedure of depth of field, of the regulation of the functions it assumes – that is to say, of the *meanings* it assumes – in filmic signifying production through codes that are not necessarily cinematic (in this instance: pictorial, theatrical, photographic), allow the taking into account of the (economic/ideological) forces which put pressure for or against the inscription of this regulation and these codes.

For historian – aestheticians like Mitry and theoreticians like Bazin to have let themselves fall for a determination of filmic writing and of the evolution of cinematic language by the advances of technology (development and improvement of means), to fall, that is, for the idea of a 'treasure house' of techniques into which film-makers could 'freely' dip according to the effects of writing sought, or, again, for an 'availability' of technical processes which located them in some region outside of systems of meaning (histories, codes, ideologies) and 'ready' to enter into the signifying production, it was necessary that the whole technical apparatus of cinema seem so 'natural' to them, so 'self-evident', that the question of its utility and its purpose (what is it used for) be totally obscured by that of its utilisation (how to use it).

It is indeed of 'strength of conviction', 'naturalness' – and, as a corollary, of the blindness on the part of the theoreticians – that we must talk. Mitry, for example, who notes the fact that deep focus, almost constantly used in the early years of cinema, disappears from the scene of filmic signifiers for some 20 years (with a few odd exceptions: certain films by Renoir), offers strictly technical reasons as sole explanation for this abandonment, hence establishing technology as the last instance, constituting a closed and auton-omous circuit within which technical fluctuations are taken as determined only by other technical fluctuations.

From the very first films, the cinematic image was 'naturally' an image in deep focus; the majority of the films of Lumière and his cameramen bear witness to that depth which appears as constituent of these images. It is in fact most often in out-of-doors shooting that depth in the period finds its field. The reason is indisputably of a technical nature: the lenses used before 1915 were, Mitry stresses,

'solely f35 and f50', 'medium' focal lengths which had to be stopped down in order to produce an image in depth, thus necessitating a great deal of light, something to be found more easily and cheaply outside than in the studio.

One must then ask why, precisely, these 'medium' focal lengths only were in use during the first 20 years of cinema. I can see no more pertinent reason than the fact that they restore the spatial proportions corresponding to 'normal vision' and that they thereby play their role in the production of the impression of reality to which the *cinématographe* owed its success. These lenses themselves are thus dictated by the codes of analogy and realism (other codes corresponding to other social demands would have produced other types of lenses). The depth of field that they permit is thus also that which permits them, that which lays the ground for their utilisation and their existence. The deep focus in question is not a supplementary 'effect' which might just as well have been done without; on the contrary, it is what *had* to be obtained and what it was necessary to strive to produce. Set up to put its money on, and putting its money wholeheartedly on, the identification – the desire to identify, to duplicate, to recognise specularly – of the cinematic image with 'life itself' (consider the fantastic efforts expended over decades by hundreds of inventors in search of 'total cinema', of complete illusion, the reproduction of life with sound and colour and relief included), the ideological apparatus cinema could not, in default of realising in practice the technical patent for relief, neglect the production of effects of relief, of effects of depth. Effects which are due on the one hand to the inscription within the image of a vanishing perspective and on the other to the movements of people or other mobile elements (the La Ciotat train) along vanishing lines (something which a photograph cannot provide, nor *a fortiori* a painting; which is why the most perfect *trompe-l'oeil* minutely constructed in conformity with the laws of perspective is powerless to trick the eye). The two are linked: in order that people can move about 'perpendicularly' on the screen, the light must be able to go and take them there, it requires a depth, planes spaced out, in short the code of artificial perspective. Moreover in studio filming, where space was relatively tight and lighting not always adequate, the backgrounds were often precisely painted *trompe-l'oeil* canvases which, while unable to inscribe the movement in depth of the characters, at least inscribed its perspective.

We know what perspective brings with it and thus what deep

focus brings into the cinematic image as its *constitutive codes*: the codes of classic Western representation, pictorial and theatrical. Méliès, specialist in 'illusion' and interior shooting, said as early as 1897 of his Montreuil 'studio': 'in brief, it is the coming together of a gigantic photographic workshop and a theatrical stage'. No more exact indication could be given of the double background on which the cinematic image is raised, and not fortuitously but explicitly, deliberately. Not only is deep focus in the early cinematic image the mark of its submission to these codes of representation and to the histories and ideologies which necessarily determine and operate them, but more generally it signals that the ideological apparatus cinema is itself produced by these codes and by these systems of representation, as at once their complement, their perfectionment and the surpassing of them. There is nothing accidental, therefore, or specifically technical in the cinematic image immediately claiming depth, since it is just this depth which governs and informs it; the various optical instruments are regulated according to the possibility of restoring depth. Contrary to what the technicians seem to believe, the restoration of movement and depth are not effects of the camera; it is the camera which is the effect, the solution to the problem of that restoration.

Deep focus was not 'in fashion' in 1896, it was one of the factors of credibility in the cinematic image (like, even if not quite with the same grounds, the faithful reproduction of movement and figurative analogy). And it is by the transformation of the conditions of this credibility, by the displacement of the codes of cinematic verisimilitude from the plane of the impression of reality alone to the more complex planes of fictional logic (narrative codes), of psychological verisimilitude, of the impression of homogeneity and continuity (the coherent space-time of classical drama) that one can account for the effacement of depth. It will not then be a question merely of technical 'delays': such 'delays' are themselves caught up in and effects of the displacement, of this replacement of codes.

It seems surprising indeed (at least if one remains at the level of 'technical causes') that a process which 'naturally' dominated a large proportion of the films made between 1895 and 1925 could disappear or drop into oblivion for so long without – leaving aside a few exceptions, Renoir being one – film-makers showing the slightest concern (so it seems).

Everything, Mitry assures us, stems from 'the generalisation of panchromatic stock round about 1925'. Agreed. But to say that –

offered with the weight of the obvious – and to pass on quickly to the unsuitability of the lighting systems to the spectrum of this emulsion is exactly *not to say* what necessity attaches to this 'generalisation', what (new) function the new film comes to fulfil that the old was unable to serve. It is to avoid the question as to what demands the replacement of an emulsion in universal use and which (if we follow Mitry) did not seem so mediocre by another which (still according to Mitry) was far from its immediate equal. As far as we know, it is not exactly within the logic of technology, nor within that of the economics of the film industry (in the mid-twenties already highly structured and well-equipped) to adopt (or impose) a new product which in an initial moment poses more problems than the old and hence incurs the expense of adaptation (modification of lighting systems, lenses, etc.) *without somewhere finding something to its advantage and profit.*

In fact, it is a matter not simply of a gain in the sensitivity of the film but also of a gain in *faithfulness* 'to natural colours', a *gain in realism.* The cinematic image becomes more refined, perfects its 'rendering', competes once again with the quality of the photo-graphic image which had long been using the panchromatic emulsion. The reason for this 'technical progress' is not merely technical, it is ideological: it is not so much the greater sensitivity to light which counts as 'being more true'. The hard, contrasty image of the early cinema no longer satisfied the codes of photographic realism developed and sharpened by the spread of photography. In my view, depth (perspective) loses its importance in the production of 'reality effects' in favour of shade, range, colour. But this is not all.

A further advantage, that is, that the film industry could find 'round about 1925' in imposing on itself – despite the practical difficulties and the cost of the operation – the replacement of orthochromatic by panchromatic stock depends again on the greater sensitivity of the latter. Not only did the gain in sensitivity permit the realignment of the 'realism' of the cinematic image with that of the photographic image,[5] it also compensated for the loss of light due to the change from a shutter speed of 16 or 18 frames per second to the speed of 24 frames per second necessitated by sound. This 'better' technical explanation, however, can only serve here to re-mark the coincidence of the coming of the talkie and the setting aside of depth, not to provide the reason for it. Although certain of its effects are, that reason is not technical. More than one sound film before *Citizen Kane* works with depth; the generalisation of large

aperture lenses even does not exclude its possibility: with the sensitivity of emulsions increasing and the quantity of light affordable, there was nothing to prevent – technically – the stopping down of these lenses (if indeed, as Renoir did, one could not find any others). So it is not as final 'technical cause' that the talking picture must be brought into the argument; it is in that in a precise location of production – distribution (Hollywood) it re-models not just the systems of filmic writing but, with them and directing this bringing up to date, the ideological function of the cinema and the economic facts of its functioning.

It is not unimportant that it be – in Hollywood – at the moment when the rendering of the cinematic image becomes subtle, opens up to the shades of greys (monochrome translation of the range of colours), thus drawing nearer to a more faithful imitation of the photographic images promoted (fetishised) as the very norms of realism, that Speech and the speaking Subject come onto the scene. As soon as they are produced, sound and speech are plebiscited as *the 'truth' which was lacking* in the silent film – the truth which is all of a sudden noticed, not without alarm and resistance, as having been lacking in the silent film. And at once this truth renders no longer valid all films which do not possess it, which do not produce it. The decisive supplement, the 'ballast of reality' (Bazin) constituted by sound and speech intervenes straightaway, therefore, as *perfectionment and redefinition of the impression of reality*.

It is at the cost of a series of blindnesses (of disavowals) that the silent image was able to be taken for the reflection, the objective double of 'life itself': disavowal of colour, relief, sound. Founded on these lacks (as any representation is founded on a lack which governs it, a lack which is the very principle of any simulacrum: the spectator is anyhow well aware of the artifice but he/she prefers all the same to believe in it), filmic representation could find its production only by working to diminish its effects, to mask its very reality. Otherwise it would have been rejected as too visibly factitious: it was absolutely necessary that it facilitate the disavowal of the veritable sensory castrations which founded its specificity and that it not, by remarking them, prevent such disavowal. *Compromises* were necessary in order that the cinema could function as ideological apparatus, in order that its delusion could take place.

The work of suturing, of filling in, of patching up the lacks which ceaselessly recalled the radical difference of the cinematic image was not done all at one go but piece by piece, by the *patient*

accumulation of technical processes. Directly and totally programmed by the ideology of resemblance, of the 'objective' duplication of a 'real' itself conceived as specular reflection, cinema technology occupied itself in improving and refining the initial imperfect *dispositif, always* imperfect by virtue of the ideological delusion produced by the film as 'impression of reality'. The lack of relief had been immediately compensated for (this is the original impression of reality) by movement and the depth of the image, inscribing the perspective code which in Western cultures stands as principal emblem of spatial relief. The lack of colour had to make do with panchromatic stock, pending the commercialisation of three-colour processes (1935–40). Neither the pianos nor the orchestras of the silent film could really substitute for 'realistic sound': synchronised speech and sound – in spite of their imperfections, in truth of little weight at a time when it is the whole of sound reproduction, records, radios, which is affected by background noise and interference – thus considerably *displace the site and the means (until then strictly iconic)* of the production of the impression of reality.

Because the *ideological* conditions of production – consumption of the initial impression of reality (figurative analogy + movement + perspective) were changing (if only in function of the very dissemination of photo and film), it was necessary to tinker with its technical modalities in order that the act of disavowal renewing the deception could continue to be accomplished 'automatically', in a reflex manner, without any disturbance of the spectacle, above all without any work or effort on the part of the spectator. The succession of technical advances cannot be read, in the manner of Bazin, as the progress towards a 'realism plus' other than in that they accumulate realistic supplements which all aim at reproducing – in strengthening, diversifying, rendering more subtle – the impression of reality; which aim, that is, to reduce as much as possible, to minimise the gap which the 'yes-I-know/but-all-the-same' has to fill.

What is at stake in deep focus, what is at stake in the historicity of the technique, are the codes and the modes of production of 'realism', the transmission, renewal or transformation of the ideological systems of recognition, specularity, truth-to-lifeness.

III. 'MORE REAL' OR MORE VISIBLE?

The reinforcement of 'effects of the real' is the first and foremost reason for Bazin's interest in deep focus. In a number of famous texts (notably *The evolution of cinematic language* and *William Wyler or the Jansenist of mise en scène*) and with reference essentially to the films of Orson Welles and William Wyler (a choice which is not without overdetermining Bazin's discourse), he makes deep focus the means and the symbol of the irreversible accomplishment of the 'realist vocation of the cinema', of the 'realist rejuvenation of narrative'.

A series of principles are set up which follow from what is for Bazin a truly *first principle*: 'the immanent ambiguity of reality', which montage and even classic Hollywood editing had reduced to a single meaning, to a single discourse (that of the film-maker), 'subjectivising the event to an extreme, since every element is owing to the decision of the *metteur en scène*'; whereas filming with deep focus safeguards the ambiguity because it participates in 'an aesthetic of reality' and offers the spectator 'the possibility of carrying out at least the final stage of the editing him or herself'.

Thus 1) the real is ambiguous; 2) to give a representation of it that is fragmented (because of montage or the work of the writing) is to reduce this ambiguity and replace it with a 'subjectivity' (a meaning: a 'view of the world', an ideology); 3) because deep focus brings the cinematic image closer to the 'normal' retinal image, to 'realist' vision, and shows literally *more* things, *more 'real'*, it allows the reactivation of that 'ambiguity' which leaves the spectator 'free'; aims, that is, at abolishing the difference between film and reality, representation and real, at confirming the spectator in his or her 'natural' relationship with the world, hence at reduplicating the conditions of his or her 'spontaneous' vision and ideology. It is not for nothing that Bazin writes (not without humour) in the course of a discussion of *The Best Years of our Lives*: 'Deep focus in Wyler's film is meant to be liberal and democratic like the consciousness of the American spectator and the film's heroes.'

On the one hand, duplication of the ideological effects of the impression of reality, of the 'normality' of specular representation; on the other, *revelation* (in its exact Christian sense) of 'the natural ambiguity and unity' of the world.

To this 'revelation' according to Bazin of 'the immanent ambiguity of reality' by deep focus, Mitry opposes 'the fact that the real of film is a mediated real: between the real world and us, there is

the film, the camera, the representation, in the extreme case where there is not in addition an author'. He writes: 'It is supremely naive to think (as Bazin does) that because the camera automatically records an element given in reality, it provides us with an objective and impartial image of that reality By the very fact that it is *given in an image*, the real captured by the camera lens is structured according to formalising values which create a series of new relations and therefore a new reality – at very least a new appearance. The *represented* is seen via a *representation* which, necessarily, transforms it.'

Secure in his insistence against Bazin on the distinction film/real, Mitry fails to see how, far from acknowledging the difference, film tends to reduce it by proposing itself as adequate to the norms of perception, by ceaselessly restoring the illusion of the homogeneous and the continuous, which is precisely the basis of Bazin's error – the postulation as the same value of the unifying functions of both perception and film representation. It was then inevitable that Mitry should end up sharing Bazin's view of deep focus. Against Bazin, he stresses the otherness of film to the real but fails to recognise the process of repression of which that otherness is the object and the place of the spectator in that process. The film is abstracted from its social inscription into an absolute realm where the 'truth' of its nature ('fragmentation of the real into shots and sequences') takes precedence over that of its reading (reconstitution, suturation). Like Bazin – though not, of course, without shades of difference – he then comes to consider that, because it reduces such fragmentation, deep focus is indeed productive of an 'increase in realism': it is seen as (ontological realism) capturing, as the classic shot does not, 'the event globally, in its real space-time', restoring 'to object and setting their density of existence, their weight of presence' (Bazin's formulations taken over by Mitry) and as (psychological realism) replacing 'the spectator in the true conditions of perception'; that is to say, coherence, continuity and finally 'ambiguity'. On condition that deep focus does not become an omnivalent principle substitutive for every other formula of *mise en scène*, Mitry declares himself 'perfectly in agreement with Bazin'.

Nothing is less certain than that deep focus is in this way – particularly in the films of Welles and Wyler, the obligatory example since Bazin – responsible for an 'increase in realism'; and this exactly in that it inscribes in the image, more successfully than any other filming process, the *representational code of linear perspective*.

We are thus faced with a contradiction: for Bazin the intervention of deep focus increases the realist coefficient of the cinematic image by completing the virtues (the virtualities) *already* inscribed in that image, by perfecting it, by giving literally *more field* to its 'ontological realism'. For Mitry this cannot be the case since by stressing the artificiality (the otherness) of the cinematic image, it is just such a 'realism' that he refuses, merely conceding that deep focus – because it produces a 'more global' and relatively less discontinuous space – comes closer to certain effects of ordinary perception; that is to say, it brings back and reinscribes in the image the (at least psychological) *conditions* of an increase in realism. For the first, this *more* is *added*; for the second, it tends to cancel out a *less*, to fill a lack. The contradiction between Bazin and Mitry is also a contradiction in Mitry, since the system of differences and specificities which constitutes the cinematic image as an other of the world, offered as its double, does not abolish the particular case of the deep focus image. In his illusion, Bazin is more coherent than Mitry, the person who denounces the illusion as such, for the stress on the constitutive differences and specific codings of the image must, as deep focus demonstrates, be accompanied by a simultaneous stress on the *work* of these codings (their *raison d'être* and their goal), which is to produce their own miscognition, to give themselves over as 'natural' and hence to mask the play of differences.

It is from the basis of this *positive* contribution accorded deep focus by both Bazin and Mitry that the *double game* of the coding of the cinematic image (its 'transparency', since it is not by being re-marked as such that it functions) operates, insofar as the 'supplement of realism' that deep focus is held to produce cannot be produced without distorting and emphasising the codes of 'realism' already 'naturally' at work in the image: a supplement that is *excessive* in relation to the system of (perspective/cultural) norms which ground the impression of reality and maintain the category of 'realism'.

IV. DENATURALISING DEPTH

The theatre in *La Cecilia* as tipping over of the fiction, as superimposition, disphasing, dislocation of two representations, one over the other, one against the other.

This doubling-splitting of the scene that the inscription of the theatre produces in the film is produced in the shot by deep focus.

The decision was taken with the cameraperson Yann Le Masson, to use almost throughout short focal length lenses which give a field that is sharp in its distance, a space divided into planes set out in depth, backgrounds as legible as foregrounds. Paradoxically, this was not in order to strengthen the realism of the image (deep focus as 'more real') but in order to make the shot theatrical: to act along the verticality of the image in the same way that in the theatre one can perform along the vertical axis of the stage, in its depth, making dramatic use of what is the central condition of the Italian stage (governed by linear perspective): a theatrical space that is immediately and totally perceptible, a set given over straightaway and entirely to vision. With the proviso that what is arranged on the theatrical stage in the real depth of the given space necessarily becomes in the filmic image a spacing out in the plane of the frame, a lateral – vertical decentring of the 'subjects' (otherwise what is in the foreground would always mask what comes behind). With the proviso also that the short focal lengths, which alone allow the apprehension of this depth, which do so with a forceful emphasis on perspective, bring with them at the same time as the background depth a more or less considerable deformation of the lateral edges of the field. This is why cinematic deep focus does not slip into the 'naturalness' of linear perspective, but inevitably stresses that perspective, accentuates it, indicates its curvature, denounces the visual field it produces as a construction, a composition in which there is not simply 'more real' but in which this more visible is spatially organised in the frame, dramatised. Deep focus does not wipe out perspective, does not pass it off as the 'normality' of vision, but makes it readable as coding (exteriorisation of the interiorised code); it de-naturalises dramatises it. The relationship which is established within the frame and in the duration of the scene between the actions or figures in the foreground and those in the backgrounds functions not only as a 'montage within the shot' (opposed by Bazin to classic Hollywood editing) but also as the reinscription of a theatrical space and duration, in which the legibility of meanings goes via a movement of the eye, in which the playing of the actors is a playing of *relationship* to the others and to the elements of the décor, in which the bodies are always held in space and time, never abstract. (The abstraction is the method and the result of the analysis of the concrete contradictions: a body in a space, in relation to other bodies; speech first of all as accent, delivery, diction; a discourse as mode of behaviour, symptom,

relational crisis; political conflicts as dramatic conflicts – the political, in other words, not as (autonomous, free floating) discourse or (magisterial) lesson, but as movement, as trace, mark on faces, gestures, words; in short, theatre).

V. NOTES ON REPRESENTATION

The most analogical representation of the world is still not, is never, its reduplication. Analogical repetition is a false repetition, staggered, disphased, deferred and different; but it produces *effects* of repetition and analogy which imply the disavowal (or the repression) of these differences and which thus make of the *desire* for identity, identification, recognition, of the desire for the *same*, one of the principal driving forces of analogical figuration. In other words the spectator, the ideological and social subject, and not just the technical apparatus, is the operator of the analogical mechanism.

There is a famous painting of the English school, *The Cholmondeley sisters* (1600–10) (Plate 8), which represents two sisters side by side, each holding a baby in her arms. The two sisters look very much alike, as do the babies, sisters and babies are dressed almost identically, and so on. Confronted with this canvas, one is disturbed by a repetition that is not a repetition, by a contradictory repetition. What is here painted is the very subject of figurative painting: repetition, *with*, in this repetition, all the play of the innumerable differences which at once *destroy* it (from one figure to the other, nothing is identical) and *assert* it as violent *effect*. Panic and confusion of the look doubled and split. The image is *in* the image, the double is not the same, the repetition is a fiction: it makes us believe that it repeats itself just because it does not repeat itself. It is in the most 'analogical' representation (never completely so), the most 'faithful', the most 'realistic', that the *effects of representation* can be most easily read. One must be fooled by the image in order to see it as such (and no longer as a projection of the world).

Is it that cinema begins where *mise en scène* ends, when is broken or left behind the machinery of performance, of the actor and the scenario, when technical necessity takes off the mask of art? That is roughly what Vertov believed and what is repeated more or less by a whole avant-garde in his wake – with categories such as 'pure cinema', 'live cinema', *'cinéma vérité'* – right up to certain experimental films of today. It is not very difficult to see, however, that

what is being celebrated in that tradition of 'non-cinema' is a visible with no original blemish that will stand forth in its 'purity' as soon as the cinema strips itself of the 'literary' or 'theatrical' artifices it inherited at its birth; a visible on the right side of things, manifesting their living authenticity. There is, of course, no visible not held in a look and, as it were, always already framed. Moreover, it is naive to locate *mise en scène* solely on the side of the camera: it is just as much, and even before the camera intervenes, everywhere where the social regulations order the place, the behaviour and almost the 'form' of subjects in the various configurations in which they are caught (and which do not demand the same type of performance: here authority, here submission; standing out or standing aside; etc.; from one system of social relation to another, the place of the subject changes and so does the subject's capture in the look of others). What Vertov films without *mise en scène* (as he believes) are the effects of other *mises en scène*. In other words, script, actors, *mise en scène* or not, all that is filmable is the changing, historical, determined relationship of men and things to the visible, are dispositions of representation.

However refined, analogy in the cinema is a deception, a lie, a fiction that must be straddled – in disavowing, knowing but not wanting to know – by the *will to believe* of the spectator, the spectator who expects to be fooled and wants to be fooled, thus becoming the first agent of his or her own fooling. The spectacle, and cinema itself, despite all the *reality effects* it may produce, always gives itself away *for what it is* to the spectators. There is no spectator other than one *aware* of the spectacle, even if (provisionally) allowing him or herself to be taken in by the fictioning machine, deluded by the simulacrum: it is precisely *for that* that he or she came. The certainty that we always have, in our heart of hearts, that the spectacle is not life, that the film is not reality, that the actor is not the character and that if we are present as spectators, it is because we know we are dealing with a semblance, this certainty must be capable of being doubted. It is only worth its risk; it interests us only if it can be (provisionally) cancelled out. The 'yes, I know' calls irresistibly for the 'but all the same', includes it as its value, its intensity. We know, but we want something else: to believe. We want to be fooled, while still knowing a little that we are so being. We want the one and the other, to be both fooled and not fooled, to oscillate, to swing from knowledge to belief, from distance to adherence, from criticism to fascination. Which is why realist representations are successful: they allow

this movement to and fro which ceaselessly sets off the intensity of the disavowal, they sustain the spectator's pleasure in being prisoner in a situation of conflict (I believe/I don't believe). They allow it because they lay out a contradictory, representative space, a space in which there are both effects of the real and effects of fiction, of repetition and difference, automatic devices of identification and significant resistances, recognition and seizure. In this sense, analogical fiction in the cinema is bound up with narrative fiction, and all cinematic fictions are tightened, more or less forcefully, by this knot of disavowal which ceaselessly starts and starts again with the continual *petitio principii* of the 'impression of reality'. The capturing power of a fiction, whether the fiction of the analogical reproduction of the visible or the fictions of cinematic narrative, depends always on its self-designation as such, on the fact that its fictive character is known and recognised from the start, that it presents itself as an artificial arrangement, that it does not hide that it is above all an apparatus of deception and thus that it postulates a spectator who is not easily but *difficultly* deceivable, not a spectator who is blindly condemned to fascination but one who is complicit, willing to 'go along'.

Fictional deceits, contrary to many other systems of illusions, are interesting in that they can function only from the clear designation of their deceptive character. There is no uncertainty, no mistake, no misunderstanding or manipulation. There is ambivalence, play. The spectacle is always a game, requiring the spectators' participation not as 'passive', 'alienated' consumers, but as players, accomplices, masters of the game even if they are also what is at stake. It is necessary to suppose spectators to be total imbeciles, completely alienated social beings, in order to believe that they are thoroughly deceived and deluded by simulacra. Different in this to ideological and political representations, spectatorial representations declare their existence as simulacrum and, on that contractual basis, invite the spectator to *use* the simulacrum to fool him or herself. Never 'passive', the spectator, works. But that work is not only a work of decipherment, reading, elaboration of signs. It is first of all and just as much, if not more, to play the game, to fool him or herself out of pleasure, and in spite of those knowledges which reinforce his or her position of non-fool; it is to maintain – if the spectacle, its play make it possible – the mechanism of disavowal at its highest level of intensity. The more one knows, the more difficult it is to believe, and the more it is worth it to manage to.

If there is in iconic analogy as operative in cinema the contradictory work of difference, non-similitude, false repetition which at once found and limit the deception, then it is the whole edifice of cinematic representation that finds itself affected with a fundamental lack: the negative index, the restriction the disavowal of which is the symptom and which it tries to fill while at the same time displaying it. More than the representative apparatuses that come before it (theatre, painting, photography, etc.), cinema – precisely because it effects a greater approximation to the analogical reproduction of the visible, because it is carried along by that 'realist vocation' so dear to Bazin – is no doubt more profoundly, more decisively undermined than those other apparatuses by everything that separates the real from the representable and even the visible from the represented. It is what resists cinematic representation, limiting it on all sides and from within, which constitutes equally its force; what makes it falter makes it go.

The cinematic image grasps only a small part of the visible; and it is a grasp which – provisional, contracted, fragmentary – bears in it its impossibility. At the same time, film images are only a small part in the multiplicity of the visible, even if they tend by their accumulation to cover it. Every image is thus doubly racked by disillusion: from within itself as machine for simulation, mechanical and deathly reproduction of the living; from without as single image only, and not all images, in that what fills it will never be but the present index of an absence, of the lack of another image. Yet it is also, of course, this structuring disillusion which offers the offensive strength of cinematic representation and allows it to work against the completing, reassuring, mystifying representations of ideology. It is that strength that is needed, and that work of disillusion, if cinematic representation is to do something other than pile visible on visible, if it is, in certain rares flashes, to produce in our sight the very blindness which is at the heart of this visible.

NOTES

1. See 'Technique et idéologie', *Cahiers du cinéma* no. 229 (May–June 1971), pp. 9–15; translation 'Technique and ideology: camera, perspective, depth of field', *Film Reader* no. 2 (1977), pp. 132–8.
2. Gilles Deleuze and Claire Parnet, *Dialogues* (Paris: Flammarion, 1977), pp. 126–7.

3. With M. Pleynet – 'Economique, idéologique, formel' (interview), *Cinéthique* no. 3 (1969) – the focus of attention is voluntarily and *first of all* on *one* of the component elements of the camera, the *lens*. For J.-P. Lebel – *Cinéma et idéologie* (Paris: Editions sociales, 1971), chapter I – who cites the phenomenon of 'persistence of vision', the rèference-Science, constantly invoked, is *geometrical optics*: the laws of the propagation of light.

4. Serge Daney, 'Sur Salador', *Cahiers du cinéma* no. 222 (July 1970), p. 39.

5. In the general readjustment of codes of cinematic 'realism' produced in Hollywood (according, of course, to its ideological and economic norms and objectives: for its profit and for that of bourgeois ideology) by the coming of sound, the codes of the strictly photographic 'realism' of the filmic image are re-defined specifically (but not exclusively) in relation to the increasingly important place occupied by the photographic image in bourgeois societies in relation to mass consumption. This place has something to do with that of gold (of the fetish): the photo is the money of the 'real' (of 'life') assures its convenient circulation and appropriation. Thereby, the photo is unanimously consecrated as general equivalent for, standard of, all 'realism': the cinematic image could not, without losing its 'power' (the power of its 'credibility'), not align itself with the photographic norms. The 'strictly technical' level of the improvements of optical apparatus and emulsions is thus totally programmed by the ideology of the 'realistic' reproduction of the world at work in the constitution of the photographic image as the 'objective representation' *par excellence*. Ideology system of coding, which in its turn that image renews.

11. The Place of Visual Illusions

Maureen Turim

A young girl, braids and bangs of dark brown hair, a pleated red plaid skirt, is taken by the hand by her mother into a ladies' store, a shopping space, a commercial place. Amidst racks of price tagged merchandise, she finds her favourite refuge, her site of excitement, her place of play — she always, every time, abandons her mother to the fluorescence of fashion and encloses herself in a three-way mirror.

Inside the enclosure the images are repeated as an infinite series, a folded space in which front and back are fragmented and super-imposed, where repetitions are varied by eye or body movements or the movements of parts of the mirror itself. These movements realign the reflections, changing shapes, changing relationships, moving from recognition to uncanny effects of abstraction and to the disappearance of recognition, there where the mirror should be forever returning the subject to her sense of self, she is lost in the mirror, lost in delight, joy, discovery; lost, also, in fear and fascination. She has found an experience which traces its pattern-ings deeply within her memory. This mirror game of lost and found, this wavering uncertainty of image, place, subject absorbs her, sucks her away from the commercial order outside for some time

Some time later a woman traced of that girl enters a sculptural room composed of mirrors, designed by an artist, Larry Bell. Superimposed as they are on layers of memory traces, the reflections now attain a greater infinity, as they will again, differently, before a painting by Picasso entitled *Girl in the Mirror*, where swirls of brightly painted patterns multiply to create a new triangle, a three-sided space of interaction between the woman viewing and the two figures in the painting, each already multiply

represented frontally and in profile. And again, but differently, the traces reappear as she enters so many luminous zones that, for want of a better word, we will call avant-garde films.

Why draw this narrative as a figure of my discourse? In order to speak of the function of avant-garde films in the context of the history and ideology of the cinematic apparatus, I have told a story of mirrors, vision and art as a prelude to an argument. This argument questions the proscriptive position which sees an ideologically 'correct' film-making practice as anti-illusionist. It questions the notion of limiting the critical concerns surrounding avant-garde film to discussion of 'ontology', 'materialism', 'anti-illusionism' and 'reflexivity'. There is a history to this critical position which has dominated the strategies of such journals as *Artforum*, *Film Culture* and *Studio International* in their sympathetic criticism of these films. Bazin is seen as having correctly described the ontology of narrative film and the avant-garde is said to emanate from a 'different ontology'.[1]

Recently, Peter Wollen took up the 'different ontology' argument and expanded on previous renditions by tracing Bazin's ontological argument through some of its more complex articulations.[2] Like the others, however, Wollen seems to accept Bazin's arguments as having correctly named the 'essence of narrative cinema'. Thus narrative cinema is forced into a single dimensional negative example, the 'opposite' in an opposition. On the other side we find, in Wollen's theory, two avant-gardes, also compared with and opposed to each other: the films of Godard and Straub/Huillet, which grow out of a materialist analysis of history and social structures and an attack on 'the illusion of reality' in classical narrative films and the American avant-garde, whose 'materialist' practice consists of the examination of film materials. With the American avant-garde reduced to this function alone, Wollen then criticises the anti-illusionism of the avant-garde for proscribing 'any heteronomous signification' and ending up in a 'kind of tautology, an involution of the illusionist project itself'.

We can only wonder how far the determined argumentation of the poorly conceived pun on 'materialism/film material' will be pushed and how many critical tautologies can be set up which circumscribe with their assumptions their own conclusions. The avant-garde has been encased in a rhetorical arsenal aimed at granting or denying these films power as tools or weapons in an ideological struggle.

I suggest that these films need to be seen and heard differently, and that the questions of ideology and the cinematic apparatus need to be re-framed in the light of that viewing experience. I wish to disengage the rhetorical offense in order to analyse an avant-garde functioning that recalls the story of the girl and the mirror; I want to speak of films which become sculptural objects, zones of express-iveness, creating a space of intersubjective activity in the margins of the commercial structures that dominate mass culture and other artistic practices, tied as those artworks are to gallery exploitation.

The fact that those film objects have historically resisted commercial exploitation or marketing is part of the experience of their viewing, although it does not, in itself, carry or validate an ideological position of contestation. The charge of elitism lurks in the wings, along with a charge of 'empty formalism', lack of meaning, no referential signification. But, again, it is a question of looking—how we have learned to look for signification in the image and in film. These films gain their signification in posing that question, in a historical context of image making and image theory. They ask us questions about ourselves.

I wish, therefore, to emphasise how this group of films challenges what the early writings in film semiotics described as the coding of signifying matter into textual systems (in classical and modernist films). Christian Metz, for example, considered a group of films which display a textual singularity confined within a shared ordering pattern, a process of mixture of codes originally analysed in terms of narrative segmentation and temporal and spatial articu-lation.[3] Such analyses provide the basis from which we can explore how avant-garde films differ in their use of coding processes and the mixture of codes. Analogy no longer operates in the same way, mimesis itself becomes a terrain of exploration.

The hermeneutics of narrative form, which dominates the classical narrative film's structure and is most often retained in some changed (inverted, open-ended, elliptical, contradicted) form in modernist film, is violated in the work of the current avant-garde; both developmental logic and the fullness of pluricodic expression are gone, but surprisingly strong traces of narrative remain in some films or parts of films in which representation orders the component matter (sound and image, what Metz would call 'signifying matter'). Concepts such as 'filmic writing' and 'filmic text' become suspect, and give way to a notion of writing which can only be understood as an inscription of traces.

If we come to these films only with a methodology aimed at reading them for signification, they will appear empty, mysterious, perhaps even pernicious. While the proponents of a model of reading the image, Roland Barthes and Jean-Louis Schefer,[4] were able to establish a theory for how units of meaning are constituted in the image and how ideology is constituted by these units of meaning, they have been forced to admit that reading is an inadequate way to account for the activity of the image. It is avant-garde film (along with experimental video and contemporary painting) which emphasises this inadequacy. Barthes' development of the concept of excess in his essay 'The Third Meaning' and Schefer's drawing on Kristeva's concept of paragrammatic space (the tension of negation created by the redistributive function of poetic language) only begin to address the force of images in which representation and narrative are of reduced consequence. Excess and paragrammatic space are even less successful tools in the consideration of images lacking iconographic representation.

With this recognition, I am drawn back to the story with which I began this paper, and to the theorists who can account for the relation of art to childhood experience, Anton Ehrenzweig and Jean-François Lyotard. It is no accident that the figures of children keep recurring in their theoretical writings, in Ehrenzweig's attention to the non-syncretic scanning vision of the child, and in Lyotard's critical metaphor of free expenditure of energy, the youthful pyromaniac, in 'L' acinéma'.[5] The child's perception is developing, not yet trained in a structure of reading, is as much involved in responding to energy flow as it is in figuring out what information is there to be decoded. This brings me to remark on the differences between my mirror story and the famous analytical narration of Jacques Lacan; my little girl is already much older than his baby — the mirror to which she returns is not planar and unifying, but sculptural, multi-faceted, fragmented and abstracted. Instead of forming the self, symbolically, it opens the tension of fragmentation, thus taking her back to before the mirror stage, to the imaginary. The subject is newly engaged in a play of libidinal energy.

It is Lyotard who has effectively described the economy of this type of subject–object interaction – what he calls 'libidinal economy' – as the flow of force and affects within a human body, between bodies and between bodies and objects. But the danger of a purely Lyotardian analysis is that, in its concentration on the

description of the apparatus of libidinal engagement, it tends to ignore the representation that remains in the art object. Once this release of the force of the imaginary is accompanied by representational elements, it becomes important to consider how concepts such as architecture, landscape, bodies, violence, curiosity and memory are being presented.

So, in analysing the functioning of specific *avant-garde* films, I see the need to speak of their relation to the history of representation in images and their specific representational references, as well as to their function as modes of engaging the subject in libidinal investment. Since there is so much variety in avant-garde films, since the component matter of sound and image is always being differently inscribed, the project is huge. But the following analysis of Barry Gerson's *Luminous Zone* will serve to show how one can approach films considering both the history of filmic representation and the manner in which abstract structuration affects the imaginary.

The title itself is suggestive of particular aspects of light and shape with a punning reference to erogeneity. Luminosity suggests a quality of light, light emanating from within its source, as in a candle flame, an ember or a light bulb; the light represented in *Luminous Zone* is reflected light (sunlight and a handheld light source positioned behind the camera in certain shots). The actual light we see during the film projection is also reflected light, bounced off the screen. 'Luminous' then is a deliberate reference to the illusion of the screen as a shining object. 'Zone' is also complexly suggestive; although the film concerns five separate referential spaces, and each of them is presented in fragmentation, 'zone' remains singular. This directs us not only to the five zones but to the zone of projection, the space of light on the screen, the light which fascinates because it is a generator of illusions. We are directed to the tension between abstraction and representation, to the uncanny mixture of what can be understood as natural or unnatural. As with contemporary painting, the titling of films involving abstract structuration can serve as a crucial element of the film's functioning by creating references which affect the film's viewing. Sound and voiced and written language are other ways of moulding and transforming the actual perception process.

Luminous Zone is also illustrative of how space can be redefined within a representation, in this case through the use of mattes in shifting positions. This spatial redefinition is not only a framing and

re-framing, but also a cause of the film image's sharing certain sculptural principles with Gerson's paracinematic sculptures: long boxes with binocular viewers at one end and a 'scene' set up on cut-outs (some in motion) spread back through the depth of the box, with a light source or rear projection of a film at the far end. The representation achieved involves spatial illusions and tricks, the label 'paracinematic' referring to the overlap between the sculptures and cinematic concerns. The film presents an equally strong statement on this overlap and the role of visual illusion in perception.

Some of the mattes operate as did the oval mattes used to create the vignette shot in silent film; they serve as an adjunct focusing device, another way of selecting and concentrating the spectator's vision, indicating what is of central interest. But mattes could also be used to hide something from view, to play with spectators' visual drives, encouraging fetishism, the centring of value on an object or part object, or to tease the viewer's voyeuristic tendencies by blocking that which could be seen behind a censoring barrier, the border which limits the full view. When Gerson re-works the matte as a contemporary element of the avant-garde image, he calls up simultaneously both visual and psychic investments. But the objects of the representational image submitted to the mattes are not the culturally coded objects of fetishism or censorship; thus it becomes misleading to retain a terminology which in the history of psychoanalytic and critical thought is linked to a negative critique. The matte process invests architectural and atmospheric spaces with an attention to their colour, texture, and slightest movements. The sensuality involved is the enjoyment of the perceptual processes.

There are several types of movements and energy transformations inscribed in these images: the changing matte and shapes, the changing image sizes, the changing spatial relationships, the changes in degrees of abstraction or representational recognisability, the changes in light and colour, the movements of objects within the representation, plus a jiggling image. This rhythmic pulsing creates a temporal aspect to the fascination, as we become engaged in the overall rhythm of change orchestrated on so many disparate levels.

To return to the ideological questions I posed earlier, I wish to compare the functioning of mechanisms of visual fascination in the avant-garde with those that occur in classic narrative film. Laura

Mulvey, in 'Visual Pleasure and Narrative Cinema', has presented an interesting analysis of scopophilia in narrative film and Metz, in 'The Imaginary Signifier', analysed the operation of the imaginary within the symbolic as a reactionary lure embedded in a signifying practice.[6] The mechanisms by which the subject is placed in relation to viewing and to the object – that is to say, scopophilia, voyeurism and fetishism – have been criticised as ideologically dangerous activities for films to indulge in, regardless of the representation within the film image itself.

Analyses of how these mechanisms function within representational imagery, and changes in relation to the control they have exerted upon us historically (particularly in visual advertising) are positive goals. It is in this context that it seems important to speak of the place of a film which abstracts those processes, and has us relate differently to them than we would within a representation which served other levels of ideological articulation. The abstraction allows us to contemplate those processes to exist in the space of their interaction. We can speak of films demanding an open viewing in a very specific sense; a creative gesture inscribes dynamic energy exchanges, but also exposes the dynamics of this process of visual stimulation. A space and time is given over to the experience and analysis of the constitution of the subject.

Another possibility that the avant-garde has considered is the exploration of a conceptual aspect of film viewing, as in Hollis Frampton's *Poetic Justice*, for example. The film reduces the expressive power of colour and light, and instead concerns itself with the relationship between language and cinema, between discourse and viewing. A close-up on a table top comprises the image, as typed pages of a film script are placed one by one into the image. The conceptual project fails on the fact that the image itself, the table, and the rhythmic entrance of the pieces of paper bearing the description of the film that we understand we will not see, have their own visual fascination. Even within highly conceptual films, then, one still has to consider the sensual elements of filmic expression; this does not mean that avant-garde film cannot successfully articulate the interactions between perception and cognition, image and language, abstraction and representation, affectivity and signification. The films are of interest because they pose just these theoretical questions, even as they admittedly function as fascinating objects. The two are not mutually exclusive, as the current debate on the cinematic apparatus often assumes.

I would like to end with a question: what kind of films should be made, should be seen? Can we still allow film to employ visual processes if we are going to mount the kind of ideological critique in which discourse is the only safe ground?

NOTES

1. Cf. Annette Michelson, 'Film and the radical aspiration', *Film Culture* no. 42 (Fall 1966), pp. 34–42; and Regina Cornwell, 'Some formalist tendencies in the current American avant-garde film', *Studio International* no. 948 (October 1972), pp. 110–14.
2. Peter Wollen, 'Ontology and materialism in film', *Screen* vol. 17 no. 1 (Spring 1976), pp. 7–23.
3. Christian Metz, *Film Language* (New York and London: Oxford University Press, 1974) and *Language and Cinema* (The Hague and Paris: Mouton, 1974).
4. Roland Barthes, 'The Third Meaning', *Artforum* vol. 11 no. 5 (January 1973) and Jean-Louis Schefer, *Scénographie d'un tableau* (Paris: Seuil, 1969).
5. Lyotard's writings include commentary and expansion on theories Ehrenzweig presents in two works: *The Hidden Order of Art* (Berkeley: University of California Press, 1967) and *The Psychoanalysis of Artistic Seeing and Hearing* (London: Sheleon, 1965). The theories of Lyotard to which I refer here are developed in: *Discours, figure* (Paris: Klincksieck, 1971); *Des Dispositifs pulsionnels* (Paris: Union Générale d'Editions, 1973); *Dérive à partir de Marx et Freud* (Paris: Union Générale d'Editions, 1973); *Economie libidinale* (Paris: Minuit, 1974); and 'The Unconscious as Mise-en-Scène', in Michel Benamou and Charles Caramello (eds.), *Performance* (Madison: Coda Press, 1978), pp. 87–98.
6. Laura Mulvey, 'Visual Pleasure and Narrative Cinema', *Screen* vol. 16 no. 3 (Autumn 1975), pp. 6–18; Christian Metz, 'Le signifiant imaginaire', *Communications* no. 23 (1975), pp. 3–55; translation 'The Imaginary Signifier', *Screen* vol. 16 no. 2 (Summer 1975), pp. 14–76.

12. Technology and Ideology in/through/and Avant-Garde Film: An Instance

Peter Gidal

'Though, in one sense, our family was certainly a simple machine . . . it had all the honour and advantages of a complex one.' *Tristram Shandy*

Since 1966, members of the London Film-makers Co-operative have thought it necessary to have equipment at hand in order to allow for the making of films. Whatever ideologies of 'spontaneity' can be read through this, the fact of the matter is that equipment was bought and built to that end. Malcolm Le Grice built some machinery and, together with David Curtis, persuaded one person to give money to assemble and buy more. The sum was not in excess of £3000. Stated rationale: expense; concepts like 'non-alienated labour' were current. The Co-op thus ended up with a 16mm printer and a 16mm developer, as well as editing equipment, viewer, rewinds, lenses, grading strips, etc. A film-maker could shoot footage and see it in negative and then in positive within a few hours in black and white, within a couple of days in colour. The control of the process by the individual was not an individualism. It was the possibility of having access into and thereby through and thereby onto the possible processes of representation. A freeze frame in a final film is no longer within the context of eternity/infinity when you have been holding a strip of original master material while the printstock noisily continues through the printer constantly copying the 'same' image. The metaphysic of silence and stillness was, if not annihilated, certainly lessened considerably. Such

knowledge could be gained by one person working with one machine. No ethic of petit bourgeois handworker. No aesthetic of individual genius. You sit there with a machine and you are process, no more or less than the machine, because the handling is necessary yet does not cause an effect – quite a different matter from painting, for example – which somehow seems 'higher' or 'greater' or 'separable'. The effect and the cause are in direct relation, even though transformations take place at each 'stage'. These transformations, in that they are operable and operative within the process, are seeable as relations: acts have effects. On the other hand, this kind of procedure does not give rise to a bland empiricism or, worse, positivism, because each move in process can or can not be transformed through chance, through random event, through unknown machinations (Marx: 'what had considerable impact on my methodology was that . . . by mere accident I leafed through'). These 'unknowns' have specific determinate effects, which thus matter and are of matter, but what was important was that there could develop in this practice of cinema no aesthetic/ethic of mechanistic or idealist causality.

The spontaneous, untheorised practice of film (when it was this, often it was unspontaneous, theorised) at this stage of the Co-op was a concrete social production, one which involved determinate modes, relations, etc. Later these operations will have to be taken up and analysed. At this point, suffice it to say that such a practice made for the possibility of films which, through the context of their production, already disallowed a position of imaginary knowledge for the spectator, equally disallowing for the spectator a position – identified with the camera/film-maker – of superiority. The context of some of the work done as well as the processes which the films betrayed (during viewing, film-as-projected) forced the viewer into a position of attempting a relation to the production, even if a contradictory one. Signification as problematic function; the apparatus as a whole as difficult, ungiven, laborious ('value only exists when someone receives it'[1]); images as (re)produced, the image being an image of an image, something learnt some years later through other routes by those more theoretically inclined (and often 'forgotten' by many of the film-makers).

When you loop a strip of master film material (threading) onto a printer and attempt to pull it through in order to 'see' how the reproduction will appear if the original is *not* led through automatically on the sprocket-wheel, you are attempting to set up a

difference between image and its reproduction. If, then, because of the mechanism (the machine *per se*), occasionally, the sprocket-wheel catches the sprockets of the master material which you are trying to pull through freely and the result – within 24 hours – is screened moments wherein the illusion of real-time-represented (movement at 24 frames per second) is worked against 'the rest' of the material which was slipped through and which (therefore) blurred betraying hardly a three-dimensionally-acceptable movement at all, *then* you have set up a contradictory representation: holding and not holding a series of reproductions into (the) terms of (a) representation.[2] Thus the final film section (as illustration here I am speaking of one segment) works in and on the terms of representation as they 'necessitate' opacity, clarity, an identifying of *what is*, for what it means. At a second level, each frame as visual impetus or stimulus is a signifier and works (in clusters) on the viewer, and the differences there have determinate effects. Thus, spontaneous or not, work with one possible operation through one aspect of one machine at the London Film-makers Co-operative in, say, 1969 could yield a specific kind of work on representation that another system of technology could not. This is one of a great number of possible specific examples leading to the general. Commercial laboratory processing could not yield this kind of work on/in film, regardless of whether or not theorisation had reached a point of desiring such a work. The ideology of this spontaneous-or-not practice is another matter: we know, of course, that unequal development allows for all sorts of overdeterminations (determinations in the last instance not withstanding). The ideological implications of such work could 'go' several ways, some of which I have hinted they did not go. The abstract expressionist ethic had worn off by this time in London, if not in the United States, and held little attraction for those working in the Co-op in the manner described. The film-makers at this time, 1966–9, were mostly ex-art students, aware of Pollock, de Kooning, Giacometti, certainly aware also of Rauschenberg, Malevitch, Warhol, Moholy-Nagy, aware of modernism and Kafka and *Tristram Shandy* and greyness and urban lower middle-class income; they were aware of the Campaign for Nuclear Disarmament and British socialism which left less room for utopia than did American and European left-movements; they were aware of Hollywood and *cinéma vérité* and Godard and surrealism and underground cinema.[3]

My point is that the ideological implications of such a technologi-

cal practice were ones which had importance for the context of making the work, the context for viewing the works (and the commercial dominant cinema as well), the context for rejecting the past painterly ideologies, the context for intervention in dominant modes of discourse not in the profilmic but in the filmic, in duration, and its non-suppression, problematising the imaginary, realigning continuity in dominant narrative in such a way that continuity and contiguity were two crucially different concepts and constructs, and so on. The concrete and the abstract became *one* for the film-makers who handled materials; an image of 'reality' with its significations became no longer purely an abstract, a meaning, a symbol, a metaphor, a literariness . . . and no longer a concrete, a documentation, a kitchen-sink/coal-board cinema of realism; the reinvigoration of, for example, Bazinianism was built *out* at this stage. As too were various positions for the viewer, since the context for the obvious manipulation of continuity of space and time, the perspective illusion of the lens, was materially attacked: cuts were made and procedures effected which no longer permitted such continuity. Or, when readings overdetermined the inscriptions, as they often do, at least a difficulty was organised as to the unconscious flow via rhythmic linearity making that difficult. Superimpositions of negative and positive and positive on positive were made which so densened the 'image' that a flatness (only, at most) was produced, not a new dark catholic space of depth (as in Bresson's *Mouchette*) but a heavy grey flatness disallowing a safe distance from the screen surface and a secure cohesive subject-position, viewpoint; a situating, unidentified. Bindings were surely there, psychoanalytic and otherwise, but the secure binding of positionality was not as holdable, not 'as' sutured.

The fact that work at the Co-op was in conditions of non-subsidy and so without pay may or may not have been an impetus to some but again the technology was not given as given, rather as barely there, and then only with the utmost work. It was necessary for the film-makers to work the machinery, and not only to keep it working but, in the process, to build more machinery in order to allow for more production: i) for more people, out of socialist principles, of access and a base for a practice rather than just a spontaneous utilisation; ii) for more adequate experimentation (no matter if that 'experimentation' was in some minds an unquestioned good, in other minds a play, a game, a learning, in others still a necessity for cinema, in others yet the necessity for one kind of cinema to do

battle with another; these schemes are precisely that, and in no one could one of four possibilities be isolated, though two perhaps . . .). So work had to be done by those involved and work was done: building a cinema, projecting, cleaning, writing about films. Thus already, based on the material necessity for an audience, a critical context had to be developed. If you want an audience to see your films (no matter how that *want* is defined), you need to write about the works *in advance*. So certain critical work was done in those – and other – interests, further elaborating the 'machine' called the Co-op, that *apparatus* of experimental film (the term fits precisely). It now became impossible to separate the critical context in which the films were seen and presented from the further work and the retrospective thought about the works and the capacities of specific machines, together with the capacities of the film-makers, was inseparable from the capacities of the social space to allow, to a certain degree, a certain social practice to take place. This social practice, namely Co-op films in London, was thus processed through and into and from an ideological space and a theoretical ideology soon to be recognised as such.

What are the interests of a machine (if we are not to get anthropomorphic, not to mention anthropomorphised)? The interests are in continued functioning: when working with a machine such as a printer, you invest in the machine an interest to continue functioning; you invest the machine with your notion of continued operability, its necessity for continued functioning within the parameters given it by its structures as apparatus in the interests of performing whatever function it is made to perform – printing a film, for instance, holding a strip of film in place to avoid a blur which undermines narrative continuity. The machine is thus placed within the realm of technical functioning, within which it stays: its fixations and those of the operators are coterminus. You have the same teleology for it as you think it has by definition. So that when the machine is kept up to standard, kept running, and you then wish to experiment, the experimentation takes place within these parameters, unless something goes wrong or conscious force is permitted, for some reason. It is that area which allows for determinate effects such as the aforementioned example of a strip of film sliding through off the claw, catching by mistake. Another example would be receiving a certain film stock for which neutral-density filter does not have the desired effect. Another again would be developing positive as negative (and/or finding out that the two

require the same process, within limits). Yet another would be the fact that when shooting light through a very dark shot, an iris effect takes place, a circle of light which expands or contracts as the scene may become lighter or darker. So that on a dark (technically: thick, as in thick negative, opposed to light, thin negative) master material getting darker, with enormous amounts of light being shot through in order to 'get' an image (the original darkness being, or not, another 'error' possibly: not 'enough' light), you end up with a constantly stutteringly changing iris-effect. This circle of light, when the image reaches a certain point of 'acceptable' (normal) lightness, opens up so wide that in effect it is no longer an iris 'on top of' – or through – an image but enlarges to become in effect coincident with the rectangle of the frame: that is, it disappears (in fact, it is a much larger iris, so large that it allows for the film frame rectangle to exist within *its* unseen parameters). This change of iris-effect as materially given as determined by quantity of light makes for a relation of viewable image that forces an interrelation to be made from this inscription; an interrelation of quantity of light and shape of representation (or, at first, shape of reproduction). I am writing here merely about one shot, one usage, one procedure, one possibility, one aspect of technique, as far as such can be isolated descriptively, as a part of the apparatus experimental cinema.

The machine's technical functioning and continued technical functioning is subsumed by the parameters the film-maker has given for that specific and particular machine, and finally, of course, by the machine 'itself'. Now with the example above, the film-maker could decide to make this function one which integrates into a film at a different level of light, thus necessitating filters which could dissolve the iris-effect sooner, or later. The film-maker may see as an effect of this effect that to construct a film from higher or lower density stock would in one case or another be beneficial to a given aim or desire, which may seem to be ('spontaneously') satisfied without a reason formulated to him or herself. This would then necessitate a control of the speeds of the printer, speed and light being contiguous principles in cinematographic reproduction. Thus relation is set up to the speed of the machine and this question becomes 'possible'. The example is a schema for the 'simple' process of the kind of decision which names as 'smooth running' or 'efficient operation' of a machine those particulars which assert themselves through the process of the machine itself. The technical functioning and the standards by which experimentation is possible become at

once the limits, within which proficiency and its ideology maintain, and become the limits which can be broadened as in such an example, a broadening which makes one machine out of another. And this process is one which is essentially given in the kind of social practice which the London Film-makers Co-operative workshop was, and is. It is through such positioning of the machine that the positioning of the meanings of the film works over the last ten years was seen by those who worked around, through and in the Co-op; it is this which is the context again for the film work and its meanings, though it does not – obviously – enclose them. The 'interests' of the machine, which I hesitantly spoke of, should now be clearer: they assert themselves precisely as the re-mechanisation of certain technical possibilities and the meanings given through them, disallowing 'the machine' its status as fascistic giver of meaning, constantly militating against the process as dominant overdetermining of meaning repressive of the social practice of cinematics.

Where does the *camera* come into all this? Certainly, it is not used *for*, or *toward*. It, in fact, *is* the seduction for viewing the way the erotic object vague hidden but there *is*. But how? Via the scopophilic pleasure imbibed in through possibilities of looking (being seen or not being seen, gaze broken or not broken, etc.), in any case resistible, recuperable, and hence a false location of the problematic. Thus the focus on the view-*through* (keyhole), the focus on voyeurism as placed *either* in the category of not-being aware (conscious) of watching the forbidden, feeling 'like' a voyeur (in that case *not* being one), *or* of necessarily being aware but doing it anyway, resisting that awareness, allowing the drive its fulfilment precisely in its unlawfulness, though of course sanctioned to the point of legal/ social *measures not being taken*. The camera is taken up in that space of definition of voyeurism or its undecidedness, and the machine for recording (in the first instance) sets in motion a series of further operations which position themselves dialectically: each film-making act in relation to each other, only in relation to each other. Various inscriptions result, again inseparably from the positionings and arrestation-attempts inculcated by such. For example, a splice is not 'splice', nor is it 'a splice'; the conscious(ness) implied thereby – of pure knowledge versus materialist dialectic – is false: a splice differs and differs its meaning(s) when, for instance, it is an inscription, one of many, upon: a series of frame(d) close-ups, a long-shot preceding a close-up, an out-of-focus long-shot at first

inseparable from a close-up due to its out-of-focusness, an in-focus close-up at first inseparable from a 'cloudy' long-shot (whether of an object, a space, or whatever), and so on. Such matters orientate the cohesive positioning of the subject-viewer via the constant imaginary; such matters materialise differently the function and the degree – or lack of it – of fetishisation of the splice (mark) itself, for example. Also bear in mind here that a splice-mark is an image, a reproduction, a photographic image, as is every cinematic device given through projection of film through a projector. This is not an ontological inference but rather a description, an effect, a determinate effect of a photochemical process. Some seem acutely unaware of this. 'Similarly', certain effects of certain cinema-technological operations have certain meanings, though neither the technology nor the effects nor the meanings (nor anything else) are ontological (and if anything were, it would have to be avoided – voided – the way biologism has to be, no matter what the state of any proof happens to be at any time).[4]

Metz has written:

> that which is the object of this study: various optical effects obtained by the appropriate manipulations, the sum of which constitutes *visual*, but not *photographic*, material. A 'wipe' or a 'fade' are visible things, but they are not images or representations of a given object. A 'blurred focus' or 'accelerated motion' are not photographs in themselves, but modifications of photographs. 'The visible material of transitions', to quote Etienne Souriau, is always extradiegetic. Whereas the images of films have objects for referents, the optical effects have, in some fashion, the images themselves, or at least those images to which they are contiguous in the succession, as referents.[5]

On the wrongness of which the following remarks need to be made:

1. Optical effects *are* photographic inscriptions; 2. The status of 'given object' is to be severely questioned, to say the least; there is no difference of photographic status whether it be a 'blurred image' or 'an object'; 3. 'Modifications of photographs' fails to see *photographs* as processes and not transparencies; 4. 'The visible material of transitions' is a highly questionable material in anything other than the most conventional commerical narrative film, so it must be remembered that Metz is not writing about *film* but about a specific

kind of film, and we are forced to reject prescriptiveness in the form of descriptiveness; 5. 'The visible material of transitions is always extradiegetic' is not true in most films: conventional commerical narrative, structural/materialist, New American Cinema, Old French Surrealism, what have you; 6. The last sentence quoted, on optical effects and their reference, is true only for the most crudely conventional films, is untrue of most avant-garde films of interest.

With regard to all this, look at a film – *Spot the Microdot* (Malcolm Le Grice, 1970), to name one of dozens.

At the same time, however, it is important to combat the simplistic misreading of avant-garde film practice's historical relation to technological development. Avant-garde film practice in England since 1966 has not in the main been determined by technological development, so that, for example, optical printers, quality of film stock, computors, advanced colour processing all have nothing to do with the experimental work done over the last ten years. This is first of all because such materials were indeed not available, and also because the (materialist) beginnings of a practice (as it stemmed from its relation to various other social practices) did not privilege consumption on that level as its implicit or explicit ideological form. The lesson of various art forms, for instance, was read as *not* coincident with capitalist expansion. As it happened, for economic reasons, specifically, East German Orwo film stock was often used, at a cost of approximately £1 per 400 feet (11 minutes) of black-white negative, one-tenth the cost of Kodak film. This fast 400 asa stock obviously does not allow as much detail, hence larger grain due to lower resolution of the image (or the less controllable temperature in the developing process at the Co-op). Though Orwo's range is the same as Kodak's, for all Co-op workshop processes the black-to-white spectrum (range in fact) is more muted (grey!). The cause for this is imprecise development (over or under) or imprecise exposure (over or under) resulting in reduced contrast. Thus lighting must be on a more sophisticated level to achieve contrast, if this is desirable (which means merely that the objects one filmed, or the people, had to be correctly measured for reflected light – a simple still-camera light-meter sufficed). There is another fact here though as well: not only did Co-op members use technologically less advanced means, in addition 'technologically advanced means' refers in many cases to *less* sophisticated materials, less precision, less room for manoeuvre. In

other words, the *Siege of Lucknow* photograph (Salt Print) of 120 years ago has a fine grain image which is 'unobtainable' now through 'normal' (namely much smaller) cameras and, therefore, camera-negative sizes, or with 'normal' camera lenses. Similarly, the average photographic paper cannot manage anything near the fine grain quality of a Woodburytype of 100 years ago (see, for example, Thomson and Smith's, *Street Life in London*, 1877), fades quicker, is less resistant to moisture, etc. Another example, Technicolor, no longer used for motion pictures, employed three black-and-white negatives that were then dyed, which allowed virtually no fading; the more modern process uses film material that is itself dyed whatever colours are wanted, thus producing negative fading. In photographic reproduction, to give yet another example, gravure is, for economic reasons, hardly utilised, thereby denying the production of finer resolution and – in perception terms, though not in physical, photochemical process terms – greater depth of field.

So in many cases 'technological advance' is synonymous with democratisation, which means in this practice greater crudity, less possibility, less advance. Or rather, advance is defined as everyone having a camera without a handground lens or one that matches its possibilities, printing on paper that is extremely limited and limiting in possibility and in its solution, and so on. This is not to push for elitist 'quality' as opposed to democratisation; it is to show the uneven development of both in various cases, depending obviously in the last, and often in the first, instance on the economic interests at work. The four categories mentioned – optical printing, advanced colour processing, film stock quality, computors – do, of course, come under the heading 'technological advance'; simply, that 'advance' is redefined in the cases of film stock qualities and processing.

A parallel in the United States would be the work of Warhol which abnegated certain technological refinements in the interests of non-mystification of materiality, and as a distancing device/ operation, which enabled a beginning again: experimentation through the practice instead of an idealist 'moving forward' from one practice, cinema, to another, technology *per se* (which is not to say that technology *per se* exists). For us, the project was one of the inseparability of the technology from the ideological and the inseparability of both from representations/constructings. By insep-arability one is referring here not to any singularity or univocality or

to some amorphous conglomerate but to integrated practices which figure on, in and through one another.

The point is not to humanise technology in the guise of an attack: technology does not present itself to certain functions through ideological 'need'. There is no reason, that is, to assume that the lens as the most perfect example of the reproduction of Renaissance perspective was invented at the right time because of technology's embodiment of ideology. This may have been the case, of course, but it need not have been. Similarly, the camera as possibility for reproduction: an invention that 'could' have been made 200 years earlier as all but one of the 'elements' existed. It waited out its time. But not necessarily. We must not let the 'ideological' (pure and simple) become overdetermining at the expense of – amongst other categories – the economic in the last instance. A further danger is that of seeing technology as the embodiment of ideological subject positions (for example, Renaissance space for the subject viewer), a technicism which then labels as idealist constitutive productions which combat that placement of the subject-position. If the final arbiter of materialism is the current technology, we are inside an opportunism (in the Leninist sense) and an effective relation called sublimation; but in the interests of which class? Of what kind of power relations? Of what kind of sexed positioning? Of what kind of materialism? For a materialist analysis and position, it is thus important not to privilege the technology, the instruments for the production of meaning (or meaninglessness). Which is not to say that inventions just happen, happen on a neutral ground; it is to say that there are a complex of determinations and that, whatever these determinations and whatever the conjuncture and the specific effects/ affects, we are still never in a position of finality – neutrality – and ultimate reason. To historicise inventions, even in the interests of combating bourgeois science, is to give a teleology to technology's ideology, to biologise and humanise a social practice (technological advancement) and forget that ideology is not simply presented and not simply represented. Otherwise, technology would be a simple matter, a reflection of a certain ideology: for example, the positioning of the male subject in capitalism, in *his* space, is obviously not the only positioning achievable with or without technology, with reference to the cinematic apparatus; there is uneven development. A 10:1 zoom lens on an Arriflex camera can, through a certain labour, formulate a fragmented, uncohesive subject position; a pinhole in a Rice Krispies box can,

through a certain labour, formulate pure Renaissance perspective solidity and transparency.

Several problems arise in connection with the practice at the London Film-makers Co-op as here described:

1. An ideology of process was evident in the procedures of work and relating to a fetishisation of process, finding its way into the profilmic discourse, let alone the intervention on the filmic. Hence one can oppose, at an initial stage, the fetishisation of work/process/technique to the concept of necessary labour, processing something into something else (other). *Process* must be brought back into the vocabulary minus its fetish meaning.

2. In the same way, *material* must not be understood as vulgar materialism merely because of the pragmatism its utilisation as a concept in some beginnings implies. The machine seen for what it is/does: function . . . factory . . . in process . . . not mechanistic . . . a materialist process . . . no other work form capable at that stage – 1966–76 – of producing work on and in and through represen-tation. This was opposed to Godard's aestheticisation of the political combined with a romantic/fascistic individualism, a seductive criss-crossing of cultural and other language/image possibilities. Our production attempted to rest on other matters.

3. *Duration* in printing/projecting technically shows aspects of (non) discontinuity, producing the machine as the whole apparatus rather than its opposite: the specific fetish. The inability to deal with de-signifying works or semioticity denying works arrives at a pseudo-apparatus close to Stalin's 'efficiency' through concepts such as 'deconstruction' (alienation from, and recuperation to, the machine in its mechanistic form) and 'popular memory' representations. Mechanistic repetition – for example, loops – produced contradic-toriness through duration, the mechanism producing itself as separate from the profilmic; not a metacinema but a force of separation and difference referring to just that.

4. There is no film which *subverts* the real, that which is; the (a) placing of the viewer in contradiction in that case being confused with a (the) placing of the viewer in a totalised and totalising apprehension of (seeming) knowledge, or, equally in keeping with the dominance of what *is*, the placing of the viewer in a position of

ambiguity, each 'moment' a *frisson* of desire to 'figure out', precisely, what is happening and why, with the answers always present even if not duly – unduly – given. That which is, the material real, is only subvertable by another material real, not by any material image of a material real. Film which subverts the real is idealist, *because it cannot*. One real subverted by another can be revolution, but different social practices are collapsed if one thinks film subverts life *as opposed to ideological conflict* (a conflict exactly of positions in knowledge, through knowledge). Surely a non-obsessive in life is not radically criticised by the image of an obsessive in the cinema.[6]

5. As to *anti-humanism*, necessary even when not evident as a conscious concept to film-makers (theory often lags behind practice): the machine as a critique of humanism, a) durable and unendurable, b) ineffable stare. The latter is machinistic, as in other cases, within another techno-historical space, the non-stare is machinistic—Rodchenko's disavowal[7] of naval perspective so the machine-isticness is linked to the non-normativeness of the code, the persistence away from, in difference to, another, not merely defined by some 'connection' to machine or to a specific machine-analog (machine-like, machine-likeness). Which is why the machineness is present in *Chelsea Girls* and *13 Most Beautiful Women* (both by Warhol) and not in automat photographs (for instance). The anti-humanism also of the de-bodied, de-sexed, towards an uneasy consumption forcing production, as inculcated (meaning, in fact, active viewing: constant dialectic, constant repositioning, resituating; with 'situating' understood not as some idealist 'newness' for the subject, from moment to moment or otherwise, but as a replacement, a newness and originality nevertheless).

6. The difficulty of identifying space as inhabited by certain techniques/images is only of interest if the identification, as in structural/materialist avant-garde film, of the techniques/usages is of equal difficulty; otherwise, it is always a metalanguage and a fetishisation of whatever (of whatever: process, image-making, subject position, the look, the naturalisation of sound, etc.). Avant-garde does not mean good conscience films relying on signifieds, nor crypto-melodramas 'in a different' light such as *Tom, Tom, the Piper's Son* (Jacobs), *Thank You, Jesus, for the Eternal Present* (Landow), *Straits of Magellan* (Frampton), *Rameau's Nephew by Diderot (Thanx to Dennis Young) by Wilma Schoen* (Snow), *Epileptic Seizure Comparison* (Sharits) and other *men*, nor landscape films

whose mimesis and solidity as text and therefore also as viewer-situating is justified as a literalness.

7. There is a further difficulty with *process*. 'Process' was a term used by certain London film-makers around 1966–9 with reference to one another's works and to the overall interests which they felt their films represented. But 'process' can imply the artist-subject and this was criticised in the early seventies with an emphasis on the material trace and the notion of inscriptions of such. The question arose as to the artist-subject implied, for example, through hand-held shaky camera movements (lighting, angle, distance, speed, and so on, not to mention profilmic event, were equally determinants, were discussed as such); the question as to these camera-movements was that of the positioning of the artist 'behind', present in its (determinately his) absence. The 'answer' to this 'question' was that *de-subjectivisation* was possible through, for example, repetitions and retake working on similar or same profilmic material – the notion of a series of camera-functions and editing-functions which would de-subjectivise the resultant projected film-segment's procedure. This would then undermine or negate the ideal (idealist) viewer's ideal subject-centre outside the film-trace's inscription. The project embarked upon through this critique was to make of the procedures a system wherein the viewer does not find him or her 'self' (the gaze, trapped[8]), to disallow identification into procedure the way abstract-expressionism (and expressionism) so often did not (identi-fication is a concept which could never except structures of self-identification). The answer, though, tended towards a mechanistic materialism when its implications were not fully grasped: privileged status was given to the inscription *on* – in – the film-image (rec-tangle), thereby lionising the trace (explicitly) and subscribing to crude distanciation and perceptual positivism (implicitly). Such distanciation and reliance on the privileged place for the image (deconstructed or not) was also inseparable from a reliance on meaning as given, the signified as solidified in capitalist patriarchy, only to be 'questioned' through the reproductions presented (a metaphysical intervention) or through the mode of the repro-duction's presentation (another metaphysic). 'Deconstruction' tu-rns out to be juxtaposition and the 'non-denial of history' and the 'social spaces of meaning' turn out to be fixation on metaphor. The overdetermination by social meaning of everything else refuses materialist practice the indulgence in setting up, figuring an image,

a sequence, and then somehow contradicting, deconstructing, repositioning it. What finally had to be learnt was that neither the process with the concomitant subject-creator established nor the framed inscription of trace 'out there' would suffice for a materialist practice. Process would have to be repossessed for and in materialism, which it then was. So would subject, structure, perception, economy, sexuality, art, . . .

NOTES

1. Christine Delphy, *The Main Enemy* (London: Women's Research and Resources Centre, 1977), p. 31.
2. 'In *Condition of Illusion* what is not achieved is the stabilisation of reproduction into the terms of a representation: effectively, the materials of reproduction that are engaged by the film are not stabilised into representation, the photograph given precisely as a holdable moment (why else a photograph if not for that?). The distinction between reproduction and representation is important, though difficult. In a sense, all the films of yours that I have seen are full of the materials of reproduction held off of – not fixed into – representation. Duration and narrative thus come apart, narrative being exactly fixing, stabilisation. In the phrase "reproduction of reality", reality itself means a specific set of reproduced reproducible representations, positions, stabilities, clarities – representation is a series of positions for the spectator in relation to a certain clarity of position and meaning . . .' Stephen Heath, in conversation, Cambridge 1976.
3. For treatment of problems of influence, see Peter Gidal and Malcolm Le Grice, 'Letters from Gidal and Le Grice', *Millenium Journal* no. 2 (Summer 1978), pp. 50–55.
4. See my letter on ontology in *Screen* vol. 17 no. 2 (Summer 1976), pp. 131–2; and on structural-materialism, my letter in *Afterimage* no. 7 (Summer 1978), pp. 120–123.
5. Christian Metz, 'Trucage et cinéma', *Essais sur la signification au cinéma* II (Paris: Klincksieck, 1972), p. 173; translation 'Trucage and the Film', *Critical Inquiry* (Summer 1977), p. 657.
6. 'I've seen *Wavelength*, now show me something that has some signifieds; enough of the signifier', Julia Kristeva, in conversation, New York 1976.
7. Cf. Rosalinde Sartorti and Henning Rogge, *Sowjetische Fotografie 1928–32* (Munich: Hanser Verlag, 1975).
8. A current myth is that every gaze is broken by the return of the look, the look back, and that every film has to be a trap for the gaze.

Discussion

Laura Mulvey I think the way in which Peter Gidal started with the actual constitution of the London Film-makers Co-op, situating his practice there, cannot be overlooked. It reminded me of points concerning the production of commodities under capitalism made by Marx in the second volume of *Capital*, where he distinguishes between a first department which is the production of commodities for production, commodities themselves becoming means of production, and a second department which is the production of commodities for consumption. In the case of film, the first department would be the industry that produces the apparatus, the equipment, as a means of production for the second department, the film industry as we think of it which then produces a commodity, film, for consumption in cinemas. What is striking is how the film industry works within that first/second interrelated department way and how avant-garde or other experimental film has grown out of the production-of-the-means-of-production side, the first department, producing 'miniaturised' equipment not intended as a means of production but as itself a commodity, marketed as such. So, in the experimental film world, we are consumers of 16mm and 8mm equipment and the great question that hangs over us is as to the nature of the commodity that we are then producing – and one hears of developments in America of independent film-makers selling actual copies of their films to art galleries, which brings us right back to the object as commodity. The experimental film world has not solved this problem of where and what we are: is our destiny in art galleries, in independent circuits, through political activity? And we have to face the problems of the apparatus and the expense involved in making and showing films; 16mm sound film especially demands equipment which is outside the financial capacity of many of the people who are our natural audience.

There are a number of other things that I also wanted to mention, one being the whole question of fascination. I was very struck by Jean-Louis Comolli who talked to us of watching *Riddles of the Sphinx*

in terms of fascination. In many ways, I would want to pass the same comment on to Peter Gidal, because I find his film, *Condition of Illusion*, very fascinating , very involving and very pleasurable to watch – the slippage of the there and the not-there, the trying to form things, produces suspense. There is a kind of natural tendency of the spectator to form a narrative internally or externally, whether the film-maker wants you to or not, which is a way in which the object up there on the screen escapes possible intention. As a film-maker, I feel that the theory that, as it were, surrounds my film-making is always elusive when it comes actually to making a film; it is very difficult to make a film which is 'theoretically correct' because elements of desire and the unconscious and so on always enter into it. Then, to come back to pleasure, I wanted to point out, against the often held view that this is not pleasurable, that there is a certain pleasure in the eruption of the apparatus into a narrative even if disruptive. In classic Hollywood film eruption of, say, a very excessive crane movement or a very excessive tracking movement may come in as a disruption but is also extremely pleasurable, giving you that sense of *élan*. To a certain extent, the same thing goes for avant-garde work: the marking of the apparatus, the underlining of focus/de-focus in *Condition of Illusion*, has a pleasurable side, and which brings us back to fascination too.

Peter Gidal I think there is a real danger in seeing avant-garde film as a kind of solidified whole, or rather as a kind of vague unity with slight differences; I think there is absolute opposition often not only between one film-maker's work and another's, but also between one film and another – we know this is the case in theatre and literature but seem not yet to know that this is the case in film. For instance, I am embarrassed to have *Luminous Zone* even in the discourse when we are talking about a materialist practice of film. There is a body of avant-garde work which has, through one mechanism or another, recuperated itself, usually because of a lack of theorisation, and to the point where works in the last five or six years are re-establishing all the grounds for illusionism, for an illusionist practice. For instance, in much of Paul Sharits's work there is an absolute establishing of a deep space, of a kind of perspectival Renaissance illusionism which is very rarely talked about; people talk about grain but in a lot of films the grain becomes a new kind of three-dimensional substance – it happens to be a vague, abstract substance in the sense that there are no figures, no ostensible narrative,

but nevertheless a deep space is established and the whole thing is recuperated back to its starting point. There is a very strict distinction to be made between those films and some other films that have been produced both in the United States and in England. . . . Another thing which you mentioned which is very important, I think, is the fact that the spectator does form a narrative. Here we come to a huge question: how does one force a reading? We all know that one cannot force a reading. The films set up a certain kind of area and parameter within which they are read, you want to force certain readings, but we know that we cannot force readings. But then I am not happy either with the answer that says therefore the film is an 'open text'. . . . A whole new thing seems to be coming out of France of 'openness', that you can break completely the familial, break completely certain mechanisms which exist very strongly merely by . . . like that quotation from Lyotard in *Woman/Discourse/Flow*: 'the movement of desire is not that of transgressing the limit, but rather in pulverising the field itself into a libidinal surface. . . .' I find this a very dangerous idea and I do not think there is an 'open text'.

Christian Metz Just a few words in connection with the idea of experimental cinema as a challenge to 'Metzian semiotics', an idea with which I totally disagree. First, from the beginning on, semiotics was an endeavour to de-mystify dominant cinema; and it was not so easy in 1963 or 1964 to say that narrative cinema was coded when the very principle of the ideological dominance of that narrative cinema is to pretend to be uncoded. Second, there are many places in my writings in which I indicate shifts in relation to the problem of experimental cinema: in the second volume of the *Essais sur la signification au cinéma*, in certain pages of *Le Signifiant imaginaire*, in my last book entitled *Essais sémiotiques*. Third, the theoreticians of experimental cinema often use notions – and they are right to do so – such as *code, operation, process of production, mirror stage, signifier, displacement,* and so on, notions which come precisely from semiotics, 'Metzian' or not. Experimental cinema on the one hand and semiotics on the other are both different modes of challenging dominant cinema . . .

Sandy Flitterman I would like to ask Peter Gidal and Maureen Turim how they see the positions they have developed in their papers concerning avant-garde film as relating to the feminist struggle.

Peter Gidal This is really difficult. I have what may be called an ultra-left position because, in terms of the feminist struggle specifically, I have had a vehement refusal over the last decade, with one or two minor aberrations, to allow images of women into my films at all, since I do not see how those images can be separated from the dominant meanings. The ultra-left aspect of this may be nihilistic as well, which may be a critique of my position because it does not see much hope for representations for women, but I do not see how, to take the main example I gave round about 1969 before any knowledge on my part of, say, semiotics, there is any possibility of using the image of a naked woman – at that time I did not have it clarified to the point of any image of a woman – other than in an absolutely sexist and politically repressive patriarchal way in this conjuncture. It went further, though I cannot here describe my whole film practice with regard to problems of figures and figuring in cinema and the relation that is implied through male and female whether a woman is present or not present, in her absence, but my position has led me to the point where there are no women or men in my films. There are obvious contradictions: for instance, the use of a photograph of a woman in *Condition of Illusion*, all my films have photographs in them or through them or whatever and that is a problem which one could elucidate; but, simply stated, that is my position.

Maureen Turim I am very intrigued and concerned at the same time by the dominance of males as producers in the area of film I talked about, though there are a number of women doing work in that area – Bette Gordon, for example, who is here today. I think that both men and women working in this area of avant-garde production, setting up relationships for examination rather than necessarily creating a discourse on illusionism *per se*, conceive of what they are doing in terms of the sort of gesture which may in fact have the same kinds of connections with intersubjectivity, with the experience of intersubjectivity on their part, that I talked about in my opening story and that I was concerned with in the practice of this male film-maker Barry Gerson. Where sexual difference enters into the childhood experience is something that very much interests me – at what stage are we going to deal with sexual differentiaton, is there on some level a child who is really this non-differentiated sexual being or/and at what stage is that then differentiated, limited, construed, focused in a different way? This is a serious

question that has to be posed theoretically around these problems of intersubjectivity.

Jean-Louis Comolli I should like to come in on the question of avant-garde film, remembering particularly some of the films we have just seen, such as Gerson's *Luminous Zone* or Gidal's *Condition of Illusion*. These are films which interest me enormously as experiment, as work on precise parameters that are then varied (this being almost a definition of experiment), and the remarks I want to make are those at once of a spectator and a film-maker concerning a certain number of problems or dangers or risks that certain types of cinematic experimentation of this kind can have. Let me stress that these remarks have not been worked through and are offered simply in the context of this discussion.

The first point I want to make is that all these films, differently but equally, play on optical effects; which leads to an effect of fascination on the spectator whose look is held by a *dispositif* that gives him or her spectacle to be seen. Even if that spectacle is not an analogical figuration of the real, it is no less of the order of the visible; the visible is not simply what is figured analogically, it is also abstract visible, non-figurative visible. For me, then, there is in these films the risk not of reposing the questions of the traps of the ideology of the visible but, on the contrary, of valorising, multiplying, finally rendering triumphant that ideology of the visible in which we are caught. A second point is that these films or certain parts of these films—but this is not the case with *Riddles of the Sphinx*, for example—seem to me to work on a very simple principle, that of the small-scale theoretical model: there is a theory at the beginning of the film, a set of theoretical positions that the film applies, and when the film is over, the same theoretical themes are there, the same theoretical propositions serve to read the film. Thus what one has is a consumption in which the signifiers of the film are consumed in a prior knowledge and a posterior knowledge which are exactly the same—in other words, these are 'texts' in which few things are transformed, or even nothing at all.

Gidal You must be blind.

Comolli I am blind and we are all blind. A further point is that avant-garde movement of these films supposes an absolute domination of certain cinematic forms and I wonder if this is really the

case, I wonder if we are still in a historical moment of the domination absolutely of a particular cinematic form. My own belief is that, on the contrary, we are in a moment in which different cinematic forms have appeared which compete with the dominant Hollywood form and that this kind of avant-garde cinema is in some way a little behind. What one might have been able to think of as necessary between the thirties and fifties, when the imperialism of Hollywood forms was precisely massive and powerful, is less so today; the avant-garde has a history in the history of cinema but that history is thought ahistorically, is not articulated to the different contradictions and transformations, to the changes in the balance of power between historical forms of cinema. Again, another point that worries me is that this cinematic avant-garde, and I am still thinking of the few examples we have seen here, does not think representation within the set of the systems of representation operative in society, and, in particular, it does not think its own relation to pictorial representations – I am struck, for example, by the fact that Peter Gidal's *Condition of Illusion* does not think its relation to a certain form of abstract painting, or at least proceeds as though what has already been gained in the modifications of codes of representation by painting was not gained for cinema; just as in Barry Gerson's *Luminous Zone*, the exercise in framing, everything seems to go on as though the work of Mondrian had been to no purpose.

Gidal Eight words: it sounds like Radek's speech against James Joyce.

Comolli No, I think not, I am raising problems, questions that need to be worked through towards a different kind of discussion. One more remark, however. With regard to the films that we have seen, I have the feeling that what is involved is a particular kind of cinema that might be called a cinema by and for professors. The word 'professor' brings with it the question of power, the power of the person who has the knowledge – a question that is apparently never posed by the subjects who make these films. 'Professor' can also be specified by the term 'doctor': these are films by and for doctors, 'doctor' in the double sense of possessor of learning and person who gives medical treatment.

Gidal Doctors also *take out* sutures.

13. The Cinematic Apparatus: Problems in Current Theory

Jacqueline Rose

A paradox seems to be emerging from recent developments in film theory. On the one hand, within feminism, the debate about sexuality is being posed increasingly with reference to construction or representation (the dialogue with psychoanalysis). In this debate, the cinematic image is taken as both the model of and term for a process of representation through which sexual difference is constructed and maintained. This is in direct continuity with what has always been for women an attention to the 'image', the necessity recognised by feminism, and in a sense specific to it, of posing the political problem in terms of the constructed image: at its simplest, the question of 'how we *see* ourselves'; more especially for cinema, the question of woman as spectacle. What is crucial about these discussions is that they *start* from the question of sexual difference, this being the concept, or position, on which the analysis is based. On the other hand, as a corrective to earlier tendencies in semiotics (the problem of formalism[1]) and to the reductive ways of conceptualising the cinematic apparatus (simple notions of determination by the technological), an appeal is being made to psychoanalysis which seems systematically to ignore the question of sexual difference. This is all the more striking in that the appeal continually draws on concepts from psychoanalysis which were only produced in response to that question and hence can only be justified by it—or not, as the case may be (feminism's critique of psychoanalysis).

My concern here is not to enter into the debate within feminism about psychoanalysis but rather, taking up arguments made by

Jean-Louis Comolli in his paper in the present volume, to look at something of this elision of sexual difference in current theorisation of the cinematic apparatus, to show how the concept of sexual difference functions as the 'vanishing point' of the theory and to suggest some of the possible repercussions for ways of thinking about film-making practice for women. *

I

The first question which needs to be asked is what is at stake in Comolli's use of 'analogy'. Initially it seems to work against two equally inadequate versions of cinematic history: cinematic perfectibility as the direct product of technological progress; cinema as a set of heterogeneous social machines. Analogy serves to draw together the various instances of the cinematic apparatus – optics and the camera (realism and the ontology of the visible), the process of production (the perfect reproducibility of the photographic image, film as industrialised commodity), the process of projection (the spectator's identification with camera and/or fiction); referring in each case to a kind of technological programming of a desire for recognition.

In its original formulations, this was the basis of Metz's introduction of the concept of the imaginary into the meta-psychology of film. It was then already clear that the main problem of that introduction was its definition of the last of these three instances (the process of projection) in terms of the first (ontology of the visible), so that the imaginary fantasy of the spectator was his or her identification with a world mistaken as real (the cinema is always an image). By confining the concept of the imaginary within the debate about realism, Metz made the spectator's position in the cinema (the fantasy of the all-perceiving subject) a mirror-image of the error underpinning an idealist ontology of film (cinema as a ceaseless and gradually perfected appropriation of reality). More importantly, it made the delusion of the spectator the *effect* of that ontology, so that what was seen to be at work constantly correcting the delusion was an awareness that the cinematic image, despite its perceptual richness, was in fact not real, an awareness present alongside the delusion itself.

* This piece was written in response to questions formulated at a feminist discussion held during the conference; I should like to thank the women who helped in that formulation.

This was the first appearance of the concept of disavowal in the metapsychology of film; its adherence to a theory of perception and the problems thus produced were evident:

> Before this *unveiling of a lack* (we are already close to the cinema signifier), the child, in order to avoid too strong an anxiety, will have to double up its belief (another cinematic characteristic) and from then on for ever hold two contradictory opinions (proof that the real perception has not been without effect for all that).[2]

On re-reading this now, the difficulties seem overwhelming. Firstly, since the effect of the cinematic apparatus is to conceal its distance from, or construction of, reality, how can it be compared with this instance of traumatic perception? Secondly, and crucially for feminism, the concept which Metz draws on is in itself problematic precisely *because of* the status it accords to the instance of perception (which is the basis of Metz's comparison). What the example refers to in Freud, and Metz completes the reference, is the discovery of female anatomy to the boy child, its 'revelation'. Apart from the difficulty of the exclusively male construction of the reference, the problem is its account of this moment exactly as a revelation, whereas in fact it is clear that the perception of an absence can have meaning only in relation to a presence or oppositional term, to a structure—that of sexual difference—within which the instance of perception *already finds its place*. This is the stress of those concepts developed by Freud—such as after-effect—which fight against the notion of immediate causality implicit in the passage quoted (and, it must be said, in certain aspects of Freud's own work) and which place the assumption of sexual difference within a structure of differences held elsewhere (the phallus as always already privileged) without which the moment of perception would strictly have no meaning. Thus it is that the aspect of the concept of disavowal which is most problematic within psychoanalytic theory itself and, not coincidentally, which has been most strongly objected to by feminism (the sight of castration, nothing to be seen as having nothing, Irigaray's '*rien à voir équivaut à n'avoir rien*'[3]), the concentration on the visual as *simply* perceptual, is the very aspect that Metz imports into the theory of the spectator's relation to the screen. The paradox is that the instance of disavowal only has meaning in relation to the question of sexual difference but is used within the theory only in relation to the act of perception itself. What this also

means is that the illusion of imaginary identity is challenged solely by the unreality of the image (difference as the difference from the real object); that is, any challenge to the imaginary remains within the terms of the imaginary itself.

Note too for the moment that another effect of all this is the virtual disappearance of the concept of the unconscious: disavowal as a conscious 'I know, but . . .' – 'I know that it's not real, but I'll pretend while I'm here that it is.' This is important as it can easily produce discussion as to the intelligence or otherwise of the mass spectator-consumer of film (this explicitly appears in Comolli's argument and will be considered later). It is also an essential distinction for feminism if disavowal is to be maintained in its relation to sexual difference without being open to justifiable feminist criticism (real inferiority as the automatic deduction from a real perception).

To describe the cinematic apparatus as a 'machine of the visible' seems at first sight to be in direct line with this way of looking at cinema. In fact, Comolli's description introduces a number of changes into the original argument from the basis of his work on technology, changes that are in a sense correctives to some of the problems just raised but in a way that again elides the central term of difference and that can this time be seen to have an immediate bearing on the idea of political cinema.

Analogy operates at a further level: as a reference to the industrialised series and to standardisation, with cinema as part of the mechanical manufacture of objects whose mass production at the end of the nineteenth century coincided with a social multiplication of images and a notion of the world as appropriatable through its visibility. This suggests another form of disavowal, that of the process of production itself, all those aspects of the technological apparatus—photochemistry, grading, mixing—that are made subordinate to the visual image which the cinema perfects (or whose perfection the cinema reproduces) at a time when that image knows a real instability (photography as a potential disturbance or decentring of Renaissance vision—optical aberrations, refractions, retinal persistence, etc.). The photographic image is seen as the norm to which the cinema conforms. Thus, for example, the transposition of depth of field to shade, range and colour is taken as the response to developments in the photograph, as well as being part of a displacement of the codes of cinematic realism onto the more complex planes of narrative and fictional logic.

Now given the various elements of this argument, which would seem to demand a number of different ways of thinking about cinematic practice (the question of process and/or narrative), why do the concepts of analogy and disavowal reappear with such remarkable conformity to Metz's original definition? The problem is all the more striking in that there are specific questions which Comolli's work raises only to evade. First, what is the effect of the extension of the concept of analogy into the description of cinema as industrialised machine if not to reinforce the idea of cinema as simply the reproduction of imaginary identity? Cinema thus appears as a type of analogical machine for the programming of identity, a process written into the origins and history of the apparatus itself, something that would have to be argued against specifically in the case for a political cinema. Secondly, what is the pertinence of stressing the invisible aspect of cinematic process if not to reintroduce, positively, the idea of film process and the material production of the image back into the film-making activity? And finally, given the emphasis on conformity to the photographic image ('it might be you', cinema as the possible recognition of oneself on screen) and the corresponding emphasis on forms of narrative logic, what types of identification and recognition are at stake? Remember that Metz distinguished cinematic identification from primordial mirror-identification on the grounds that the spectator did *not* actually see his or her own body on screen, and also placed narrative identification as secondary in the cinema to identification with the camera itself.[4] Comolli's use of analogy and self-recognition brings this 'secondary' identification – the history of specific forms of narrative organisation and of the images through which they have been produced and secured – back to the centre of the debate.

The answer to these questions is complex but the issues are not followed through in that complexity. Something of what happens can be grasped if one looks, precisely, at the way that Comolli uses the concept of disavowal. Here, it can be seen most clearly as a conscious 'I know, but . . . ', relating to the fictional nature of cinematic representation (not quite identification with camera or character but rather with the world as seen). From this basis, it is translated into a privileging of the cinematic institution as the system of representation in which the threshold of mystification is at its lowest and whose radical potential is therefore highest. Disavowal is thus imperceptibly turned into a matter of intelligence

or manipulation:

> there is no uncertainty, no mistake, no misunderstanding or manipulation

and from there:

> it is necessary to suppose spectators to be totally imbecile, completely alienated social beings, in order to believe that they are deceived and deluded thoroughly by simulacra

which leads to a specific justification and privileging of cinema:

> yet it is also, of course, this structuring disillusion which offers the offensive strength of cinematic representation and allows it to work against the completing, reassuring, mystifying representations of ideology[5]

(This could almost be Brecht on the potential of cinema before he was brought up against censor, camera, subjective inserts . . .). The political potential of cinema is written into the process of disavowal itself (the 'I know' before the 'but . . .') and is simply a reversal of that process.

The point is not that there is anything wrong with constructing a positive theory of cinema on an incorrectly used concept of disavowal (an 'academic' objection); rather, it is that this has only been possible – as a kind of saving of cinema against industrial fetishism (in Marx's sense now) – by ignoring the real concept of difference which the use of disavowal constantly solicits and then at once loses 'sight' of, and which, if it were addressed, would demand a very different type of attention to the way that sexual difference and identification is constructed across the cinematic space.

Take, for example, the model which Comolli uses for the cinema's self-designation as fiction, an analogical reproduction which is and is not a reproduction, and hence contains a potentially activated difference. It is surely no coincidence that that model is a painting of two women, 'a famous painting of the English school, *The Cholmondeley Sisters* (1600–10)'; mothers and babies, alike and not alike, the reflection of each other but not quite. The model is illuminating in the very problems it raises. For what is the nature of a parallel between an image which is the effect of the suppression of

the terms of its construction as in cinema and an image in which identity is split across two almost identical images? How can we refer to this image as if it simply represented that process of construction without addressing the socially recognisable forms through which identification is played out – reproduction/ repetition posed twice over in the image of the sisters and their own reproduction again (the babies they hold)? And that the problem of representation be found across these two images of women un- avoidably raises the question of woman *as* image, woman as guarantor and sanction of the image against the latent trouble *of* the image, the panic of the look produced ('panic and confusion of the look').

This question of woman in the image as safeguard against the trouble of the image is surely what is at issue in any feminist discussion of cinema, and yet the model is taken and overlooked in this sense (ironically thereby confirming its function). What this produces is a definition of social relations, when they appear in the argument, purely in terms of submission and authority (the inverse corollary to a stress on manipulation of the visible world) – 'all that is filmable is the (changing, historical, determined) relationship of men and things [sic] to the visible . . .' – and then within Comolli's own film, *La Cecilia*, a use of woman in which her relationship to the cinema (the question of woman as image) is never posed – the woman as plenitude, totality of cinema, given as spectacle from the terms of her first appearance to the men, or else as disturbance, the figure troubling community and image, breaking across the frame in those shots of her conversations, lying on the grass, with this or that member of the commune.

There seems, indeed, to be a direct sequence here: analogical repetition, disavowal, conscious knowledge, political cinema; with difference as either distance from reality or the social relations of men and things, and sexual difference as the missing term. It is, in fact, only because difference is set up in the argument through the notion of distance from reality that, in discussion, Comolli is able to justify the nature of the image of the woman, her use in this film, on the grounds that there was only this woman, that this *was* the reality (the history he is describing at the expense of, forgetting, the history of his description, of cinema itself, these images).

II

Something about the body, and hence potentially about the constitution of sexual difference, is nonetheless constantly present in these arguments. Thus Metz concluded his discussion of fetishism by reference to the cinema as a 'body', *physis*, literally material,[6] this being the precondition of its continuing effectivity; and through all the considerations of physical process (the repressed of cinema), the idea is finally there that what is lost is the very material or substance of cinema, a body to be recovered *for* cinema, and perhaps against the other bodies, the recognisable relations and identifications, played out on screen. Put like this, the idea has its attractions, the notion of a space that might be created against the dominant forms of cinematic representation. It is in this context that Comolli reintroduces depth into the image field as part of a theatricalisation of the shot, depth against cinema, and so against manipulative forms of fictional logic, 'bodies in space' . . . women in depth? Which is the danger, if the relationship between the problem of woman as image and the creation of an alternative narrative space is not formulated as such. For what happens here is that woman and space 'in depth' are identified as marginal, fetishised, one could say (what else can an insistence on depth outside its historically attested connotations really be?).

This question of process is one that comes up again and again. At its simplest, it goes as follows: once one starts to talk about a difference or break in the system of representation, to what extent does one remain, or have to remain, within the same psychoanalytic economy? Moments when the diegesis is broken in musical comedy or the internalisation of process into certain types of avant-garde film practice (and the two examples are often cited together), is this simply the difference beneath the disavowal? Perhaps even more difficult when recognised as that of sexual difference, because of the place and the image of woman then produced (the negative term). Or is it a more primordial difference, prior to or outside that construction, somehow retrievable through the very mobility which the photographic image sets itself to halt? The desire is to get outside the forms of representation which demand and reproduce the socially coded objects of fetishism (at least recognised here as such) – Lyotard's 'must the victim be on stage for *jouissance* to be intense?'.[7] It is surely not by chance that the example he uses to raise that question again refers to a woman: the Swedish *posering* in which the

erotic object is fixed and immobile, *posed*, woman as the object of the spectator's gaze who thus enjoys off bodies at a distance – in depth? ('Presently there exists in Sweden an institution called the *posering*, a name derived from the *pose* solicited by portrait photographers: young girls rent their services to these special houses, services which consist of assuming, clothed or unclothed, the poses desired by the client. It is against the rules of these houses – which are not houses of prostitution – for the clients to touch the models in any way . . . it must be seen how the paradox is distributed in this case: the immobilisation seems to touch only the erotic object while the subject is found overtaken by the liveliest agitation.')[8]

Two separate points seem to be involved here, both of which need to be formulated in relation to feminism. On the one hand, there is the discussion as to types of object represented. This raises, for example, the whole question of the 'relative potency' of images as indicated by Peter Gidal's films and his accounts of their practice: the avoidance of the socially coded objects of fetishism, the refusal to produce and reproduce film images of women and hence the refusal to use images of women in his films: with the – symptomatic – duality that this then imposes in the theory: against anthropomorphic identification through the narrative relations of human figures and also, the inevitable stressed addition to the general rule, against images of women, specifically, in particular, in or out of conventional narrative (which exactly echoes Laura Mulvey's emphasis in her essay 'Visual Pleasure and Narrative Cinema': that the image of the woman is the best way of stopping narrative flow without trouble, unpleasure[9]). At one level this position is clear, if pessimistic: the objects to be subjected to the film process should not be the culturally received objects of fetishism and censor. The fact that it is the image of the woman that here causes the split in the theory, forcing the film-making activity to think itself on two fronts, foregrounds this very problem of woman and representation. On another level, and on the other hand, it can produce an effect which seems worrying and which relates to the general notions of space and economy that are introduced into certain discussions of avantgarde film. Thus in Maureen Turim's paper in the present volume, the general undecidability and fluctuation of spatial representation has as its analogy (no coincidence again) the model of the girl-child caught in and playing off a series of refracted mirrors: pre-mirror phase, unconstituted, fragmented, and at the same time defined,

recognised as a girl, placed as somehow before representation and then projected onto the breakdown of cinematic space. Once again the impetus is clear: the attempt to place woman somewhere *else*, outside the forms of representation through which she is endlessly constituted as image.

The problem is that this sets up notions of drive, rhythmic pulsing, eroticisation of energy pre-representation, a space of 'open viewing', film process itself as socially – and sexually – innocent. Film process is then conceived as something archaic, a lost or repressed content ('continent'), terms to which the feminine can so easily be assimilated, and has been in classical forms of discourse on the feminine as outside language, rationality, and so on; arguments which are now being revived as part of the discussion of psycho-analysis and feminism, the search for a feminine discourse, specific, outside.[10]

The dangers are obvious. That such arguments overlook the archaic connotations of these notions of energy and rhythm for women, at the same time that they render innocent the objects and processes of representation which they introject onto the screen, is again not by chance.[11]

It may be possible to identify the problem more specifically by looking at the kind of theoretical discussion from which something of these arguments is drawn. Lyotard, in an article entitled 'The Unconscious as *Mise en Scène*', takes Freud's 1919 essay 'A Child is Being Beaten' and sets it against *The Interpretation of Dreams*, as sexuality against meaning. Freud is seen as moving away from language to drive, and the contradictions in the fantasy described in 'A Child is Being Beaten' are taken as the model for the breakdown of representation. In fact, Freud's essay illustrates at its clearest the relation of drive *to* representation (this latter not being a primary message even in *The Interpretation of Dreams* but fractured and problematised), to the problem of femininity no less, the fantasies of the female patients revealing exactly the difficulties and structur-ation of feminine sexuality across contradictions in subject/object positions, areas of the body, the desire of the woman indeed 'not a clear message'[12] (whoever said it was?). Note also that Freud uses this very essay to attack Adler's theory of 'masculine protest' as the cause of all repression – why then, Freud asks, do boys suppress only the homosexual object and not the passive fantasy? The essay demonstrates that male and female cannot be assimilated to active and passive and that there is a potential split always between the

sexual object and the sexual aim, between subject and object of desire. What it could be said to reveal is the splitting of subjectivity in the process of being held to a sexual representation (male *or* female), a representation without which it has no place (behind each fantasy another which simply commutes a restricted number of terms). All this needs to be spelt out because Lyotard uses Freud's essay for the idea of different, non-theatrical, representational space, a 'pictorial space of virtual bodies', another space again of 'open' viewing. We have to ask what, if the object itself is removed (the body or victim), is or could be such a space of open viewing (fetishisation of the look itself or of its panic and confusion)? And what does this do for feminism? Other than strictly nothing, dropping all images of women; or else an archaising of the feminine *as* panic and confusion, equally undesirable, simply a re-introjection as feminine—the pre-mirror girl—of the visual disturbance against which the image of woman classically acts as guarantee.

The aim in all this is for a model of desire which might be feminine, or at least outside the structuration of sexuality inherent in classic forms of representation. For, returning to the concept of disavowal, to redefine that concept as the question of sexual difference is necessarily to recognise its phallic reference, how woman is structured as image around this reference and how she thereby *comes to* represent the potential loss and difference which underpins the whole system (and it is the failure to engage with this that is the problem with Metz's and Comolli's work). What classical cinema performs or 'puts on stage' is this image of woman as other, dark continent, and from there what escapes or is lost to the system; at the same time as sexuality is frozen into her body as spectacle, the object of phallic desire and /or identification. There seems to be a genuine double bind here which reproduces itself on the level of the theory: for, if it is in relation to this phallic reference that woman is defined as different or outside and the organisation and cohesion of cinematic space is always also the securing of that reference, then the other side of this – the disturbance or trouble behind the cohesion itself – cannot be brought back into the cinematic space *for* women without thereby confirming the negative position to which she was originally assigned.

The problem appears in feminist discussion of what a feminine desire might be and can be posed interestingly with regard to Comolli's film – how exactly do we desire the woman in *La Cecilia*?

On the one hand, there is the argument that it is some primordial desire that the image of the woman as full activates or potentiates (moment of fusion of, say, Lyotard and Klein[13] – a different space being a primordial archaic feminine sexuality, exactly woman in depth); and on the other, less immediately attractive for feminism perhaps, the argument that if she is desired at all, it can only be across a masculine identification, the only place within cinema for desiring a woman being a form of control through the look (the question of Sternberg's *Morocco* – what is really at stake when Dietrich kisses the woman in the café?).

From this a further question can emerge, that of woman's own desire for her position as fetish (the splitting of subjectivity across masculine/feminine, the disjunction between anatomy and identification is perhaps at its clearest here since the woman is taken to desire herself but only through the term which precludes her). The question is posed by a very different film practice, that of Aimee Rankin and Steven Fagin's *Woman/Discourse/Flow*, a film in which the problems of cinema as 'generalised strip-tease' ('cinema with its wandering framings, wandering like the look, like the caress,. . . a kind of permanent undressing, a generalised strip-tease'[14])and of 'seeing oneself seeing oneself' (the risks inherent in recentring the spectator's look) are given specifically as the problem of the image of the woman in cinema. The film attempts to demonstrate the image of woman as the very difficulty of cinema: writing used not just as a punctuating or literalisation of the image but equally of the woman's body as image (the body of the woman is written over and across with a whole theory of cinema and a whole romance of the woman, typed cards fixed to her body, phrases traced directly on her skin); our seeing Rankin filming her own body (the body therefore inseparable from the gaze through which it is constituted); that body gradually identified and framed, and then its loss precipitating the breakdown of the recognisable cinematic space (the camera beginning a random pattern of movement which obliterates the field of vision, the depth of the image and its body). Which is not to say that there are not difficulties in the film: the relationship which seems to be posited between the woman's body and the grain of the film, body and grain as a kind of initial purity, the latter the natural process of the former (the focus pull at the start of the first shot of the woman's body which takes us from the texture of film and skin into the argument of cinema and her image), the way in which the written discourse across the body of the woman

can be seen as mascarade, the embodiment of a master discourse; and then, perhaps as a corrective to this, the moments when the engagement with the cinematic image seeks to address another political space, more familiar notions, 'under his gaze', 'he doesn't care what I am inside', a different idea of oppression of women.

Which leads to the further question of how to formulate in and through cinema, if one can at all, the relation between this constitution of the feminine and other forms of oppression and subjection for women, the attempt to hold the relation between the two, clearly the impetus behind Laura Mulvey and Peter Wollen's *Riddles of the Sphinx*. In one way, this is the other side of a query which is constantly raised for women: how to engage at all from a feminist position founded on notions of immediate or personal experience, the knowledge of one's own history, with forms or concepts of representation which depend for their analysis on the idea of the unconscious; how to move against the very language used, and then, the question of *Riddles*, 'what would a politics of the unconscious be?'

There is no simple answer, but what is crucial to both these films is that they deal with the problem of cinema and the image of the woman simultaneously, the one as the problem of the other. They do so differently. Mulvey and Wollen's film attempts to create a series of positive images for women (the imaginary *for* women) which might also be seen as identifying women, through the very difficulty of this attempt, with what is archaic, outside, regressive even (the movement of the film's narrative, the story of the central character, Louise, as the move back from the impossible political struggle to her personal and finally prehistoric past).

Posing the question in these terms—the problem of woman and cinema, the problem of cinema as that constitution of the feminine described here—is the logical outcome of putting the concept of sexual difference back into discussion of the cinematic apparatus. To say that it has been overlooked is simply to confirm the very problem that I have tried to outline.

NOTES

1. The turn to psychoanalysis was undoubtedly part of the response to this problem of formalism, recognised in Metz's own work as the need

for an account of the ceaseless working over by the particular film of the codes of cinema, the displacement of the cinematic in and through the filmic text. A similar shift can be seen in literary semiotics in the movement from structural typology to textual analysis, from the structural analysis of narrative to an opening of the text in its singular difference, its disturbance in and of narrative codes. In both cases attention is focused on the enunciation of the text (the place of reader, spectator) as against the enounced (the organisation of the fiction): 'the psychoanalytic itinerary. . . in comparison with the discourse of a more classical semiology shifts from attention to the *énoncé* to concern for the *énonciation*' (Christian Metz, 'Le signifiant imaginaire', *Communications* no. 23, 1975, p. 3; trans. 'The Imaginary Signifier', *Screen* vol. 16 no. 2, Summer 1975, p. 14). It can then be asked why the effects of this shift have produced such radically different results. On the one hand, in literary semiotics, the concept of sexual difference is posed as an inherent part of the redefinition (the placing and displacing of sexual difference taken as crucial in the process of writing itself), with an increasing stress on the 'revolutionary' or avant-garde text, 'text' against 'the work' (cf. Roland Barthes, 'From work to text', *Image—Music—Text*, London: Fontana, 1977, pp. 155–64), and on the activity of the reader in the text. On the other hand, in cinema semiotics, the problem of difference seems to have been elided with the consequences that this article attempts to specify, attention then directed above all to the classic fiction film and the spectator defined in respect of an imaginary, essentially passive cohesion. Some of this can be seen as a result of the privileging of the cinematic in Metz's work (the question is 'what contribution can Freudian psychoanalysis make to the study of the cinematic signifier?', Ibid., p. 12; trans. p. 28), such a privileging serving to hold off or delay the effects of that necessary account of the filmic, of the film text as a repeated 'death' of cinema—and of the terms of a 'more classical semiology'.

2. Metz, op. cit., p. 49; trans. p. 68.

3. Luce Irigaray, *Speculum, de l'autre femme* (Paris: Minuit, 1974), p. 54.

4. Metz, op. cit., p. 40; trans. p. 58.

5. Jean-Louis Comolli, 'Machines of the Visible', present volume pp. 140–1.

6. Metz, op. cit., p. 52; trans. p. 73.

7. Jean-François Lyotard, 'L'acinéma', *Cinéma: théorie, lectures* (special number of the *Revue d'esthétique*) (Paris: Klincksieck, 1973), p. 368; trans. 'Acinema', *Wide Angle* vol. 2 no. 3 (1978), p. 59.

8. Ibid., p. 366; trans. p. 57.

9. Laura Mulvey, 'Visual pleasure and narrative cinema', *Screen* vol. 16 no. 3 (Autumn 1975), pp. 6–18; Mulvey describes how the image of the woman can be a disturbance and rupture of narrative cohesion, but also how its transposition into spectacle (woman purely *as* image) serves to neutralise this disturbance, to hold it off.

10. See especially, Luce Irigaray, *Ce Sexe qui n'en est pas un* (Paris: Minuit, 1977).

11. Maureen Turim raises this explicitly in connection with Lyotard's work: 'But the danger of a purely Lyotardian analysis is that in its concentration on the description of the apparatus of libidinal engagement it tends to ignore the representation that remains in the art object', present volume pp. 146–7.

12. J. -F. Lyotard, 'The Unconscious as *Mise en Scène*', in Michel Benamou and Charles Caramello (eds.), *Performance* (Madison: Coda Press, 1978), p. 94.

13. *From* Freud, Melanie Klein concentrated on the pre-oedipal relationship between the mother and girl-child; *against* Freud (the concept of the phallic phase), Klein argued for the girl-child's early (re-)cognition of specifically feminine bodily sensations. In fact, by tracing the oedipus complex back to the earliest stages of child development, Klein can be said to have collapsed the concept of pre-oedipality altogether; while her insistence on early awareness of feminine anatomy can be seen to return the girl-child, and later the woman, to a natural bodily femininity against which everything else is then described as a defensive or secondary 'aberration'. The argument against the phallic phase is important, but the alternative proposed, with its implied reduction of women to the biological, perhaps reveals at its clearest why Freud's definition of the *construction* of sexuality around a reference whose privileging has both to be explained, and then refused in its effects, might be more useful for feminism than a return to any idea of the specifically, biological, feminine. (See Melanie Klein, 'Early Stages of the Oedipus Conflict' (1928), in *Contributions to Psychoanalysis*, London:Hogarth, 1948).

14. Metz op. cit., p. 54; trans. p. 74.

14. Through the Looking-Glass

Teresa de Lauretis

To undertake the study of the cinematic apparatus as a social technology, 'a relation of the technical and the social as cinema' implies, beyond a critical displacement of concepts central to the discourse on cinema, the posing of the facts of cinema and its conditions of possibility from a different 'point of theoretical-discursive articulation'; it also opens up, in the process of that displacement, other critical spaces in which the political instances of feminism and the relation of history and practice can effectively be posed.

Insofar as the cinematic apparatus operates in history, is traversed by and in turn produces ideological effects in social practice, the current debate on representation, identification, subjectivity, gender and sexual difference not only occupies a critical space within a historical materialist theory of the cinema, but directly invests its basic premises. A social being, woman is constructed through effects of language and representation; just as the spectator is the term of the moving series of filmic images, taken up and moved along successive positions of meaning, a woman, or a man, is not an undivided identity, a stable unity of 'consciousness', but the term of a shifting series of ideological positions. Put another way, the social being is constructed day by day as the point of articulation of ideological formations, an always provisional en-counter of subject and codes at the historical (therefore changing) intersection of social formations and her or his personal history; while codes and social formations define positions of meaning, the individual re-works those positions into a personal, subjective construction. A social technology, a textual machine of representation—cinema for example—is the semiotic apparatus in which

the encounter takes place and the individual is addressed as subject; cinema is at once a material apparatus and a 'signifying practice' in which the subject is implicated, constructed, but not exhausted. Obviously, then, woman is addressed by cinema and by film, as is man, yet the different modes of that address are far from obvious (and to understand them, to describe their functioning as ideological effects in subject construction is perhaps the main critical task confronting cinematic and semiotic theory).

As the sum of one's experiences as spectator in the socially determined situations of viewing, and in the relations of institutional discourses to the economics of film production, the dominant cinema specifies 'woman' in a particular social and natural order, sets her up in certain positions of meaning, fixes her in a certain identification. Represented as the negative term of sexual differentiation, spectacle-fetish or specular image, in any case obscene, 'woman' is constituted as the ground of representation and its stability, the looking-glass held up to man; but, as historical individual, the woman viewer is also positioned in the films of classical cinema as spectator-subject and thus doubly bound to that very representation which calls on her directly, engages her desire, elicits her pleasure, frames her identification and makes her complicit in the production of (her) woman-ness. On this crucial relation of 'woman' as constituted in representation to women as historical subjects depend at once the development of a feminist critique and the possibility of a materialist semiotic theory of subjectivity and culture.

It is therefore not simple numerical evidence (women hold up half of the sky) that forces a theory of the cinematic apparatus to hear the questions of women, but their direct critical incidence on its conditions of possibility. It is because this theory is posed in history and articulated in historically specific discourses and practices — semiotics, psychoanalysis, technology — that it cannot disengage itself from the trouble caused by woman, the problems she poses in *its* discursive operations; while those discourses have traditionally assigned to her a position of non-subject, the latter determines, grounds and supports the very concept of subject and the theoretical discourse itself. In this paper I will examine certain problematic assumptions and contradictions concealed in that discourse which have hindered and restrained the radical possibilities of cinematic theory even as they provided its initial impulse.

Two major conceptual models are involved in the current development of a theory of the cinema, from classical semiology to the more recent metapsychological studies, and in its formulation of concepts of signification, symbolic exchange, language, subject, unconscious, and so forth: a structural – linguistic model (cinema as 'language', as a formal system, a structural organisation of codes functioning according to a logic internal to the system) and a dynamic, psychoanalytic model (cinema as production of meaning, of imaginary, of unconscious, for a subject). In both cases, cinema being an apparatus of social representation, assumptions are made, whether implicitly (in the former model) or explicitly (in the latter), as to the conditions and modes of representation and address; those assumptions hinge on sexual difference and the relation of woman to sexuality.

Since Freud imposed the question of sexuality as an area of vital concern to both individual and social development, sexual difference has been taken up and dealt with, in one way or another, by any theorisation of cultural processes. In the two models under consideration, the relation of woman to sexuality is either reduced and assimilated to, or contained within, masculine sexuality. But whereas the structural–linguistic model, whose theoretical object is the formal organisation of signifiers, assumes sexual difference as a pre-established, stable semantic content (the signified in the cinematic sign), the psychoanalytic model theorises it in an ambiguous and circular way: on the one hand, sexual difference is a meaning-effect produced in representation; on the other, paradoxically, it is the very support of representation. Both models, however, contain certain contradictions which are produced textually and are thus historically verifiable for they can be located in the theoretical discourses and in the practices that motivate them.[1] For example, the equation woman: representation (woman as sign, woman as the phallus) and sexual difference: value founded in nature (woman as object of exchange, woman as the Real, as Truth) is not the formula of a naively or malignantly posited equivalence, but the end result of a series of ideological operations that run through an entire theoretical-discursive tradition. It is in these operations that a theory of the cinema must interrogate its models, as it interrogates the operations of the cinematic apparatus.

Excluding any consideration of address and of the social differentiation of spectators, excluding, therefore, the whole problematic of ideology and the subject's construction in it, the

structural – linguistic model assumes sexual differentiation as simple complementarity within a 'species', as biological fact rather than socio-cultural process. That assumption, only implicit in this model of the cinematic apparatus, is fully explicit in Claude Lévi-Strauss's theory of kinship which, together with Saussurian linguistics, constitutes the historical basis for the development of classical semiology. In the real world, says Lévi-Strauss, women are human beings (that is, like men), but their *social* function is that of chattels, objects, whose regulated possession and exchange among men ensures and maintains social order; and this is so universally because the incest prohibition, the historical event instituting culture, is found in all human societies. Although marriage regulations vary greatly throughout world societies, their underlying rules, kinship structures, are found to be identical '*by treating* marriage regulations and kinship systems *as a kind of language*'.[2] Having adopted the analytical method of structural linguistics in 'treating' kinship, Lévi-Strauss then says that women are signs, words spoken and 'exchanged' by men in social communication; but 'in contrast to words, which *have wholly become* signs [from what prior/other status?], woman *has remained* at once sign and value'.[3] Women, therefore, are objects whose value is founded in nature ('valuables *par excellence*' as bearers of children, food gatherers, etc.); at the same time, they are signs in social communication established through kinship systems.

The confusion or assimilation of the notion of sign (which Lévi-Strauss takes from Saussure and transposes to the ethnological domain) with the notion of exchange (which he takes from Marx, collapsing use-value and exchange-value) is not a chance one; it comes from an intellectual tradition, a set of discourses which for centuries has sought to unify cultural processes, to explain 'economically' as many diverse phenomena as possible, to totalise the real and, either as humanism or as imperialism, to control it. In positing exchange as a theoretical abstraction, a structure, and therefore 'not itself constitutive of the subordination of women', Lévi-Strauss overlooks the fact that 'the terms or items of exchange must *already* be constituted, in a hierarchy of value', which means that women's economic value must be 'predicated on a pre-given sexual division which must already be social'.[4] Such astonishing oversight may have occurred, I suggest, because his Saussurian model defines value entirely as a differential, systemic relation; but when he states that women are also persons, that is, contribute to the wealth of a culture (his humanistic appeal), then he is invoking a

Marxian notion of use-value—woman as labour power and/or concealed labour. Hence the confusion between woman as object of exchange, bearer of economic, i.e. positive value, and woman as sign, bearer of semiotic, i.e. negative value, of difference.

The universalising project of Lévi-Strauss, to conflate the economic and the semiotic orders into a unified theory of culture, *depends on* his positing woman as the functional opposite of subject (man), which in his syllogism automatically excludes the possibility of women's social role as subjects and producers of culture. It is not merely that in the real world women are held in the mute position of chattels; it is his own theory of kinship, his conceptualisation of the social, that inscribes them in a discourse where they are doubly negated as subjects: first because they are vehicles of men's communication, secondly because their sexuality is not cultural but 'natural', childbearing being a purely economic fact, a capacity for production such as that of a machine. Desire, like symbolisation, is a property of men:

> The emergence of symbolic thought must have required that women, like words, should be things that were exchanged. In this new case, indeed, this was the only means of overcoming the contradiction by which the same woman was seen under two incompatible aspects: on the one hand, as the object of personal desire, thus exciting sexual and proprietorial instincts; and on the other, as the subject [sic] of the desire of others, and seen as such, i.e. as the means of binding others through alliance with them.[5]

I have stressed the work of Lévi-Strauss because of its often underestimated influence on current neo-Freudian thought and, consequently, on the psychoanalytic model recently assumed by film theory. If we re-read the passage just quoted from *The Elementary Structures of Kinship* (1947) or, even more to the point, the essay on 'The Effectiveness of Symbols' (1949, reprinted in the first volume of *Structural Anthropology*) in the light of Jacques Lacan's work, we can see how the latter's linguistic conception of the unconscious as *locus* of the discourse of the other must pass through Lévi-Strauss's formulation of the unconscious as the organ of the symbolic function: no longer located in the individual psyche, as it was for Freud, the unconscious is a structuring process, the universal articulatory mechanism of the 'human mind', the structural condition of all symbolisation.[6] In the shift in focus onto the subject

consists Lacan's originality vis-à-vis Lévi-Strauss; the Oedipal law, as the point of entry of the subject into language, is the condition — a structural condition — of its interminable rite of passage through culture. But, as noted by Gayle Rubin, a same conceptual set underlies both theories:

> In one sense, the Oedipal complex is an expression of the circulation of the phallus in intrafamily exchange, an inversion of the circulation of women in interfamily exchange The phallus passes through the medium of women from one man to another—from father to son, from mother's brother to sister's son, and so forth. In this family *Kula* ring, women go one way, the phallus the other. It is where we aren't. In this sense, the phallus is more than a feature which distinguishes the sexes; it is the embodiment of the male status, to which men accede, and in which certain rights inhere—among them, the right to a woman. It is an expression of the transmission of male dominance. It passes through women and settles upon men. The tracks which it leaves include gender identity, the division of the sexes.[7]

The psychoanalytic model recently assumed by film theory, in acknowledging subjectivity as a construction in language, articulates it in processes (drive, desire, symbolisation) which depend on the crucial instance of castration and are thus finally possible only for the male: 'The interdiction against autoerotism, bearing on *a particular organ*, which for that very reason *acquires the value of an ultimate (or first) symbol of lack (manque)*, has the impact of pivotal experience.'[8] There is no doubt as to which particular organ is meant: the penis/phallus, symbol of lack and signifier of desire. Despite repeated statements by Lacan(ians) that the phallus is not the penis, the context of the terms I have emphasised in the quotation (there are others, similarly ambivalent) makes it clear that desire and signification are defined ultimately as a masculine process, inscribed in the male body, since they are dependent on the initial — and *pivotal*—experiencing of one's penis, on having a penis. In his discussion of *Encore*, Lacan's 1972/73 seminar devoted to Freud's question 'What does the woman want?', Heath remarks on Lacan's 'certainty in a representation and its vision' — Bernini's statue of Saint Teresa as the visible evidence of the *jouissance* of the woman:

where the conception of the symbolic as movement and production of difference, as chain of signifiers in which the subject is effected in division, should forbid the notion of some presence from which difference is then derived; Lacan instates the visible as the condition of symbolic functioning, with the phallus the standard of visibility required: seeing is from the male organ.

Against the effective implications of the psychoanalytic theory he himself developed, Lacan 'runs analysis back into biology and myth', reinstating sexual reality as nature, as origin and condition of the symbolic: 'The constant limit of the theory is the phallus, the phallic function, and the theorisation of that limit is constantly eluded, held off, for example, by collapsing castration into a scenario of vision;' thus, in the supposedly crucial distinction between penis and phallus, 'Lacan is often no further than the limits of pure analogical rationalisation.'[9]

Concepts such as voyeurism, fetishism, or the imaginary signifier, however appropriate they may seem to describe the operations of dominant cinema, however apparently convergent — precisely because convergent? — with its historical development as an apparatus of social reproduction, are directly implicated in a discourse which circumscribes woman in the sexual, binds her (in) sexuality, makes her the absolute representation, the phallic scenario. It is then the case that the ideological effects produced in and by those concepts, that discourse, perform, as dominant cinema does, a political function in the service of cultural domination including, but not limited to, the sexual exploitation of women and the repression or containment of their sexuality.

Consider a recent discussion of the pornographic film by Yann Lardeau in *Cahiers du cinéma*. The pornographic film is said relentlessly to repropose sexuality as the field of knowledge and power, power in the uncovering of truth ('the naked woman has always been, in our society, the allegorical representation of Truth'). The close-up is its operation of truth, the camera constantly closing in on the woman's sex, exhibiting it as object of desire and definitive place of *jouissance* only in order to ward off castration, 'to keep the subject from his own lack': 'Too heavily marked as a term — always susceptible of castration — the phallus is unrepresentable The porno film is constructed on the *disavowal of castration*, and *its operation of truth is a fetishistic operation.*'[10] The cinema, for Lardeau, is *pour cause* pornography's privileged

mode of expression. The fragmentation and fabrication of the female body, the play of skin and make-up, nudity and dress, the constant recombination of organs as equivalent terms of a combinatory are but the repetition, inside the erotic scene, of the operations and techniques of the apparatus — fragmentation of the scene by camera movements, construction of the representational space by depth of field, diffraction of light and colour effects, in short, the process of fabrication of the film from *découpage* to montage. 'It all happens as if the porno film were putting cinema on trial;' hence the final message of the film: '*it is cinema itself, as a medium, which is pornographic*'.

> Dissociated, isolated (autonomised) from the body by the close-up, circumscribed in its genital materiality (reified), [the sex] can then freely circulate outside the subject — as commodities circulate in exchange independently of the producers or as the linguistic sign circulates as value independent of the speakers. Free circulation of goods, persons and messages in capitalism — this is the liberation effected by the close-up, sex delivered into pure abstraction.[11]

This indictment of cinema and sexuality in capitalism as apparati for the reproduction of alienated social relations is doubtless acceptable at first. But two objections eventually take shape, one from the other. First: as the explicit reference to the models discussed earlier is posed in terms critical of the linguistic model alone, while the Lacanian view of subject processes is simply assumed, uncritically, Lardeau's analysis cannot but duplicate the single, masculine perspective inherent in a phallic conception of sexuality; consequently, it reaffirms woman as representation and reproposes woman as scene, rather than subject, of sexuality. Second: however acceptable it may have seemed, the proposition that cinema is pornographic and fetishistic resolves itself in the closure of syllogism; begging its question and unable to question its premise, such a critique is unable to engage social practice and historical change.

But, it may be counter-objected, the pornographic film is just *that* kind of social practice; it addresses, is made for men only. Consider, then, the classical Hollywood narrative fiction film, even the subgenre of the 'woman's film'.

Think again of *Letter from an Unknown Woman* and its arresting gaze on the illuminated body of Lisa/Joan Fontaine, the film the theatre of that. . . . With the apparatus securing its ground, the narrative plays, that is, on castration known and denied, a movement of difference in the symbolic, the lost object, and the conversion of that movement into the terms of a fixed memory, a construction of the imaginary, the object — and with it the mastery, the unity of the subject — regained.[12]

Again and again narrative film has been exposed as the production of a drama of vision, a memory spectacle, an image of the woman as beauty, desired and untouchable, desired *as* remembered; and the operations of the apparatus deployed in that production — economy of repetition, rimes, relay of looks, sound-image matches — toward the achieved coherence of a 'narrative space' which holds, binds, entertains the spectator at the apex of the representational triangle as the subject of vision.[13] Not only in the pornographic film, then, but in the 'woman's film' as well is cinema's obscenity the form of its expression and of its content.

The paradox of this condition of cinema is nowhere more evident than in those films which openly pose the question of sexuality and representation in political terms, films like Pasolini's *Salò*, Cavani's *Night Porter* or Oshima's *Empire of the Senses*. It is in such films that the difficulties in current theorisation appear most evident and a radical reformulation of the questions of enunciation, address and subject processes most urgent. For example, in contrast with the classic narrative film and its production of a fixed subject – vision, Heath asks us to look at Oshima's film as the film of the uncertainty of vision, 'a film working on a problem' — 'the problem of "seeing" for the spectator'.

Empire of the Senses is crossed by that possibility of a nothing seen, which is its very trouble of representation, but that possibility is not posed, as it were, from some outside; on the contrary, it is produced as a contradiction within the given system of representation, the given machine.[14]

By shifting to, and forcing on, the spectator the question of 'the relations of the sexual and the political in cinema', by marking out the difficulties — perhaps the impossibility — posed by their articulation in representation, the film includes the spectator's view

as divided ('the splitting of the seen'), disturbs the coherence of identification, addresses a subject in division. Thus, it is compellingly argued, the struggle is still with representation, not outside or against it; a struggle in the discourse of the film and on the film.

It is not by chance that women's critical attention to the cinema most often insists on the notions of representation and identification, the terms in which are articulated the social construction of sexual difference and the place of woman, at once image and viewer, spectacle and spectator, in that construction:

> One of the most basic connections between women's experience in this culture and women's experience in film is precisely the relationship of spectator and spectacle. Since women are spectacles in their everyday lives, there's something about coming to terms with film from the perspective of what it means to be an object of spectacle and what it means to be a spectator that is really a coming to terms with how that relationship exists both up on the screen and in everyday life.[15]

In the psychoanalytic view of film as imaginary signifier, representation and identification are processes referred to a masculine subject, predicated on and predicating a subject of phallic desire, dependent on castration as the constitutive instance of the subject; that is to say, they are *subject* processes only *insofar as* they are inscribed in a phallic order. And woman, in a phallic order, is at once the mirror and the screen — image, ground and support — of *this* subject's projection and identification: 'the spectator *identifies with himself*, with himself as pure act of perception'; 'as he identifies with himself as look, the spectator can do no other than identify with the camera.'[16] Image and representation, woman is 'cinema's object of desire', 'the sole imaginary' of the film, ' "sole" in the sense that any difference is caught up in that structured disposition, that fixed relation in which the film is centered and held'.[17]

What this theory of the apparatus cannot countenance, given its phallic premise, is the possibility of a different relation of woman as spectator–viewer to the filmic image, of different values and meaning-effects being produced for her, producing her, in identification and representation, as subject; in short, the possibility of other subject processes obtaining in that relation. This is the context of the debate, in avant-garde film practice and theory, around narrative and abstract representation, illusionist vs. structural–

materialist film (see the essay by Peter Gidal); and in the apparent incompatibility of the latter with feminist instances is the reason for seeking alternative models or economies of desire (see Maureen Turim's essay and the discussion following her and Gidal's papers). This is the context and the main area of feminist intervention (see the essay by Jacqueline Rose).

According to Mulvey, the woman is not visible in the audience which is perceived as male; according to Johnston, the woman is not visible on the screen. . . . How does one formulate an understanding of a structure that insists on our absence even in the face of our presence? What is there in a film with which a woman viewer identifies? How can the contradictions be used as a critique? And how do all these factors influence what one makes as a woman filmmaker, or specifically as a feminist filmmaker?[18]

'A film working on a problem'. This must be, provisionally, the task of the critical discourse as well: to oppose the simply totalising closure of final statements (cinema is pornographic, cinema is voyeurist, cinema is the imaginary, the dream-machine in Plato's cave, and so on), to seek out contradictions, heterogeneity, ruptures in the fabric of representation so thinly stretched — if powerful — to contain excess, division, difference, resistance; to open up critical spaces in the seamless narrative space constructed by dominant cinema *and* by dominant discourses (psychoanalysis, certainly, but also the discourse on technology as autonomous instance, or the notion of a total manipulation of the public sphere, the exploitation of cinema, by purely economic interests, etc.); finally, to displace those discourses from where they obliterate the claims of other social instances, erase the insistence of practice in history.

This is the critical work already undertaken, in and out of the institutional margins, by feminist film-makers, writers, teachers, and by people alerted to the women's movement's singular potential for social transformation by the very effort of containment and recuperation massively deployed by institutions such as cinema. The proliferation of liberal discourses on 'the role of women in . . .' corresponds to the revival of the 'woman's film' in the seventies and to the 'images of women' approach to film encouraged by the media and the publishing industry. Thus, instead of the films of Dorothy Arzner or Marguerite Duras, of Chantal Akerman or Jackie Raynal, we must see *Three Women, An Unmarried Woman, A*

Woman Under the Influence, Swept Away, Coma, and we look at
ourselves *Looking for Mr. Goodbar* or at *The Eyes of Laura Mars* — films
which re-stabilise 'woman' as representation, reassuring the men in
the audience and offering to women spectators a new and improved,
yet so familiar and equally reassuring, mirror, mirror on the
wall. . . .[19] If the cinema and the other media have become, as
Rosalind Coward has argued, a 'forum for competing definitions' of
woman's sexuality, of woman as a sexually defined being, and if the
female body — more publicly admitted than before, emphatically
displayed — 'is a site of particular significance in a struggle of
representations which guarantee particular ideologies',[20] it is not
enough merely to accuse all institutions and all representation as
reactionary. Women live in those institutions, participate in the
social construction of reality; and women are not essentially other,
possessed of a 'true nature' or existing outside of the social relations
and representations in which they are produced as women and
which they also (re)produce, as subjects, in practice. For this reason,
not our participation but our active resistance is required.

The struggle bears precisely on the critique of this alleged nature
of woman — the 'riddle of the nature of femininity' for which Freud
found an appropriately novelistic phrase, a good movie title, 'the
dark continent' —, a critique to be carried on in different discursive
registers, as many and as different as are the social apparati of
representation, including the discourse on cinema and the con-
ceptual models it implicitly or explicitly assumes. It is indeed the
pressure of a feminist critique that has challenged psychoanaly-
sis's ideology of mastery and the operations of its Oedipal logic in
narrative film;[21] that has, on the other hand, singled out, in the web
of its semiotic processes, the breaking points, the areas of rupture
and excess, the limits of the system;[22] or that has turned dominant
discourse inside out (and shown that it can be done) by subverting
its enunciation, unearthing the archaeological stratifications on
which it is built, radically altering the meaning-effect of its
representation. Thus Luce Irigaray, in 'The Blind Task of an
Ancient Dream of Symmetry', rewrites Freud's essay on
'Femininity' inscribing her own critical voice into his tightly woven
argumentation and creating an effect of distance, like a discordant
echo, which ruptures the coherence of address, divides meaning,
and continually dislocates the reader in that division.[23] Those
different discursive strategies are forms of cultural resistance, each
with a use-value for particular, not universal, situations of practice;

in affirming the historical existence of irreducible contradictions for women in language, they also challenge theory in its own terms, the terms of a semiotic space constructed in language, its power based on social validation and well-tested strategies of enunciation and address.

I have argued that a theory of cinema as a relation of the technical and the social can be developed only with a constant, critical attention to its discursive operations and from the awareness of their present inadequacy. I now want to suggest that the questions of representation and subject processes should be posed from a less rigid, less static or unified notion of meaning than is instated by an exclusive emphasis on the signifier and by a view of signification as always already determined in a fixed order of language. As one way of mapping the terrain in which meanings are produced, I suggest, it may be useful to reconsider the notion of code, somewhat emarginated by current film studies after its heyday in Metzian semiology, and importantly redefined in Umberto Eco's *A Theory of Semiotics*. In the systemic formulation of classical semiology, a code was construed to be a system of oppositional values (Saussure's *langue*, for example, or Metz's code of cinematic punctuation) regardless or up-stream of the meanings produced contextually in enunciation and reception; in other words, 'meanings' (Saussure's signifieds) were supposed to be subsumed in, and in a stable relationship to, the respective 'signs' (Saussure's signifiers). So defined, a code could be envisaged and described like a structure, independently of any communicative purpose and apart from an actual process of signification. For Eco, on the contrary, a code is always a significant and communicational framework linking combinatorial elements (on the expression plane) with semantic elements (on the content plane) or with behavioural responses; and a sign is not a fixed semiotic entity but a 'sign-function', the mutual and transitory correlation of two 'functives', the elements of the correlation: a sign-vehicle (expression, the physical component of the sign) and a 'cultural unit' (content, meaning), the latter being a unit in a semantic system of oppositional values. In the historical process, 'the same functive can also enter into another correlation, thus becoming a different functive and so giving rise to a new sign-function'.[24] As socially established, operational rules that *generate* signs (whereas in classical semiology codes *organise* signs), the codes are historically related to the modes of sign production; it follows that the codes change whenever new or different contents are

culturally assigned to the same sign-vehicle or whenever new sign-vehicles are produced. In this manner a new text, a different interpretation of a text — any new practice of discourse — sets up a different configuration of content, other cultural meanings that in turn transform the codes and rearrange the semantic universe of the society that produces it.

Going back to the cinema, the avant-garde, theoretical dilemma about the politics of abstract vs. 'anthropomorphic' forms of representation can be re-phrased as follows: what must come first, a change in the form and matter of expression (the structural—materialist position), or a change in the form and matter of content (a position argued by some feminists and suggested in Mulvey–Wollen's *Riddles of the Sphinx*)? If the signifier alone is at work in signification, the answer can only be one, taking us back around the mulberry bush of the argument, to the inevitability of women's oppression, at least in cinema; here artistic practice and social practice must part their ways ('what does one make as a woman film-maker?'). If both functives of the sign-function, the content of the representation and its expression, its representing, are involved in signification, there is no specific answer — each can affect and effect the other and artistic practice can become, for women, a practice of social change.

Ironically, and in spite of its disinterest in 'the subject of semiosis', a semiotics of the modes of sign production may serve to pose the question of subjectivity in historical terms, to approach the subject through the operations (the modes of sign production) of the material, technological, cultural apparati that construct it. Again ironically, in view of the alleged feminine discomfort with technology, it is by posing cinema as a social technology (as a process characterised by the interplay of the social and the technological in the production of signs and meanings for and by a subject who is their term of reference and constant intersection) that one can pose, one cannot in fact *but* pose, the radical questions of feminism; for the latter invest the basic premise of a materialist theory of the cinema, and inform the very possibility of its development. Hence the important stakes that a feminist critique and film theory have in one another, and their belligerent relationship in this book as elsewhere.

NOTES

1. 'Motivate' here is to be understood not as intentionality or design on the part of individuals who promote those discourses, but rather in the sense in which Marx describes the social determinations by which the capitalist, for example, is not a 'bad' person but a function in a specific system of social relations.

2. C. Lévi-Strauss, *Structural Anthropology* (Harmondsworth: Penguin, 1972) p. 61; my emphasis.

3. C. Lévi-Strauss, *The Elementary Structures of Kinship* (London: Eyre & Spottiswoode, 1969) p. 496.

4. Elizabeth Cowie, 'Woman as Sign', *m/f* no. 1 (1978) 52 and 57.

5. *The Elementary Structures of Kinship*, p. 496. This passage is echoed in the following, by J. Lacan: 'In the Real, women — with all due deference to them — serve as objects for the exchanges ordered by the elementary structures of kinship. These exchanges are perpetuated in the Imaginary, whenever the opportunity offers itself, whereas what is transmitted in parallel fashion in the Symbolic order is the phallus.' *Ecrits* (Paris: Seuil, 1966) p. 565, quoted by Anthony Wilden, *System and Structure* (London: Tavistock, 1972) p. 292. Wilden's book develops the argument that both Lacan and Lévi-Strauss operate a confusion in logical typing between discursive orders; see in particular the chapter entitled 'The Critique of Phallocentrism'.

6. 'The unconscious ceases to be the ultimate haven of individual peculiarities — the repository of a unique history which makes each of us an irreplaceable being. It is reducible to a function — the symbolic function, which no doubt is specifically human, and which is carried out according to the same laws among all men, and actually corresponds to the aggregate of these laws. . . . As the organ of a specific function, the unconscious merely imposes structural laws upon inarticulated elements which originate elsewhere — impulses, emotions, representations, and memories. We might say, therefore, that the preconscious is the individual lexicon where each of us accumulates the vocabulary of his personal history, but that this vocabulary becomes significant, for us and for others, only to the extent that the unconscious structures it according to its laws and thus transforms it into language'. *Structural Anthropology*, pp. 202–3. In this essay, entitled 'The Effectiveness of Symbols', Lévi-Strauss describes a Cuna incantation to facilitate childbirth performed by the shaman. The same metaphors return in the language of Lacan's description of the *fort-da* game, establishing a double link in the chain of psychoanalytic discourse: 'It is with his object [the spool, the object little a] that the infant leaps the boundaries of his domain transformed into holes, shafts, and with which he commences his incantation'. J. Lacan, *Le Séminaire IX*, quoted by Constance Penley, 'The Avant-Garde and its Imaginary', *Camera Obscura*, no. 2 (Fall 1977), p. 30.

7. G. Rubin, 'The Traffic in Women: Notes on the "Political Economy" of Sex', in Rayna R. Reiter (ed.), *Toward an Anthropology of Women* (New York: Monthly Review Press, 1975), pp. 191–2.

8. J. Lacan, 'Pour une logique du phantasme', *Scilicet*, no. 2/3 (1970), p. 259, quoted by John Brenkman, 'The Other and the One: Psycho-analysis, Reading, the *Symposium*', *Yale French Studies*, 55/56 (1977), p. 441.

9. S. Heath, 'Difference', *Screen*, vol. 19 no. 3 (Autumn 1978), pp. 52, 54, 66. See

also L. Irigaray's critique of this seminar in 'Cosi fan tutti', in *Ce sexe qui n'en est pas un* (Paris: Minuit, 1977), pp. 84–101.

10. Y. Lardeau, 'Le sexe froid (du porno au delà)', *Cahiers du cinéma*, no. 289 (June 1978), pp. 49, 52 and 61.

11. Ibid., pp. 51, 54.

12. S. Heath, 'The Question Oshima', *Wide Angle*, vol. II no. I (1977), p. 55.

13. See, for example, S. Heath, 'Narrative Space', *Screen*, vol. 17 no. 3 (Autumn 1976), pp. 68–112.

14. Postscript to 'The Question Oshima' reprinted in Paul Willemen (ed.), *Ophuls* (London: BFI, 1978), p. 87. The thought is further developed in the following passage: 'The order of the look in the work of the film is neither the thematics of voyeurism (note already the displacement of the look's subject from men to women) nor the binding structure of a classic narrative disposition (where character look is an element at once of the form of content, the definition of the action in the movement of looks exchanged, and of the form of expression, the composition of the images and their arrangement together, their "match"). Its register is not that of "out of frame", the *"hors-champ"* to be recaptured in the film by the spatially suturing process of "folding over" of which field/reverse-field is the most obvious device, but that of the edging of every frame, of every shot, towards a *problem* of "seeing" *for the spectator.*' 'The Question Oshima', p. 51.

15. Judith Mayne, in 'Women and Film: A Discussion of Feminist Aesthetics', *New German Critique*, no. 13 (Winter 1978), p. 86.

16. Christian Metz, 'The Imaginary Signifier', *Screen*, vol. 16 no. 2 (Summer 1975), pp. 51 and 52.

17. S. Heath, 'Questions of Property', *Ciné-tracts*, I, 4 (Spring–Summer 1978) 6.

18. Ruby Rich, in 'Women and Film: A Discussion of Feminist Aesthetics', p. 87. Rich here refers to Laura Mulvey, 'Visual Pleasure and Narrative Cinema', *Screen*, vol. 16 no. 3 (Autumn 1975), pp. 6–18, and to Pam Cook and Claire Johnston, 'The Place of Women in the cinema of Raoul Walsh', in Phil Hardy (ed.), *Raoul Walsh* (Edinburgh: Edinburgh Film Festival, 1974), pp. 93–109.

19. A small example of how the industry accomodates culture-specific variations: the titling of *An Unmarried Woman* in France is *Une femme libre* (A Free Woman) and in Italy *Una donna tutta sola* (A Woman All Alone), the reference to legal status changing to heavily connoted references to sexual aggressivity and social jeopardy.

20. R. Coward, ' "Sexual Liberation" and the Family', *m/f*, no. 1 (1978), p. 17.

21. For example, Laura Mulvey's 'Visual Pleasure and Narrative Cinema'.

22. Ann Kaplan (ed.), *Women in Film Noir* (London: British Film Institute, 1978); Patricia Mellencamp, 'Spectacle and Spectator: Looking Through the American Musical Comedy', *Ciné-tracts*, no. 2 (Summer 1977), pp. 27–35.

23. L. Irigaray, *Speculum, de l'autre femme* (Paris: Minuit, 1974), pp. 7–162. On filmic enunciation see the short pieces on *Jeanne Dielman*, *La femme du Gange* and *What Maisie Knew* by, respectively, Janet Bergstrom, Elisabeth Lyon and Constance Penley in *Camera Obscura*, no. 2 (Fall 1977), pp. 114–36.

24. U. Eco, *A Theory of Semiotics* (Bloomington: Indiana University Press and London: Macmillan, 1976), p. 49.

Notes on the Contributors

Jeanne Thomas Allen teaches in the Department of Communication Arts, University of Wisconsin–Madison, and is a contributor to Tino Balio (ed.), *The American Film Industry*, *Ciné-Tracts*, etc.

Barbara Anderson is at the Department of Communication Arts, University of Wisconsin–Madison; she has contributed articles to *Journal of the University Film Association*, etc.

Joseph Anderson teaches in the Department of Communication Arts, University of Wisconsin–Madison; he has contributed articles to *Journal of the University Film Association*, *Speech Monographs*, etc.

Dudley Andrew teaches in the Film Division, University of Iowa; his publications include *The Major Film Theories* and *André Bazin*.

Jean-Louis Comolli is a member of the editorial board of *Cahiers du Cinéma*; he is a Paris-based film-maker, his films, to date, including *La Cecilia*, *Totò: Une Anthologie*.

Teresa de Lauretis teaches in the Department of Italian, University of Wisconsin–Milwaukee; she has contributed articles to *Ciné-tracts*, *Film Quarterly*, etc.

Mary Ann Doane teaches in the Semiotics Program of the English Department, Brown University, Providence, R.I.

Sandy Flitterman is a founder member of the *Camera Obscura* collective, and is a contributor to *Ciné-tracts*, etc.

Peter Gidal is a London-based film-maker, his films including *Room Film 1973*, *Condition of Illusion*, *Silent Partner*, etc.; he has published articles in *Millennium Film Journal*, *Studio International*, etc.; he teaches at the Royal College of Art.

Douglas Gomery teaches in the Department of Mass Communications, University of Wisconsin–Milwaukee. He has contributed articles to *Film Reader*, *Quarterly Review of Film Studies*, etc.

Stephen Heath teaches at Jesus College, Cambridge, and in the Department of Fine Arts, University of Wisconsin–Milwaukee.

Inez Hedges teaches in the Department of Romance Languages, Duke University, Durham, N.C., and is a contributor to *Sub-stance*, *Tri-Quarterly*, etc.

Susan J. Lederman teaches in the Psychology Department, Queen's University, Kingston, Ontario; she has published articles in *Perception*, *Perception and Psychophysics*, etc.

Christian Metz teaches at the Ecole des Hautes Etudes en Sciences Sociales, Paris; his publications include *Essais sur la signification au cinéma* (2 vols, volume I in English as *Film Language*), *Langage et cinéma* (*Language and Cinema*) *Essais sémiotiques*, *Le Signifiant imaginaire*.

Laura Mulvey is a London-based film-maker; she co-directed (with Peter Wollen) *Penthesilea* and *Riddles of the Sphinx*; and has had articles published in *Screen*, *Spare Rib*, etc.

Bill Nichols teaches in the Department of Film Studies, Queen's University, Kingston, Ontario; he is editor of *Movies and Methods*, and has contributed articles to *Film Quarterly*, *Screen*, etc.

Aimee Rankin, film-maker, lives in California; she co-directed (with Steven Fagin) *Woman/Discourse/Flow*.

Jacqueline Rose teaches in the School of Cultural and Community Studies, University of Sussex: articles by her have appeared in *m/f*, *Screen*, etc.

Kristin Thompson is at the Department of Mass Communications, University of Wisconsin–Madison and Wisconsin Center for Film and Theater Research; Co-author (with David Bordwell) of *Film Art: an Introduction*, and has published articles in *Ciné-tracts*, *Film Reader*, etc.

Maureen Turim teaches in the Department of Cinema, State University of New York at Binghamton: articles by her have appeared in *Film Studies Annual*, *Wide Angle*, etc.

Peter Wollen is a London-based film-maker; he co-directed (with Laura Mulvey) *Penthesilea* and *Riddles of the Sphinx*, and has published articles in *New Left Review*, *Screen*, etc.

Index